The Flower and the Green Leaf

Glasgow School of Art in the time of Charles Rennie Mackintosh

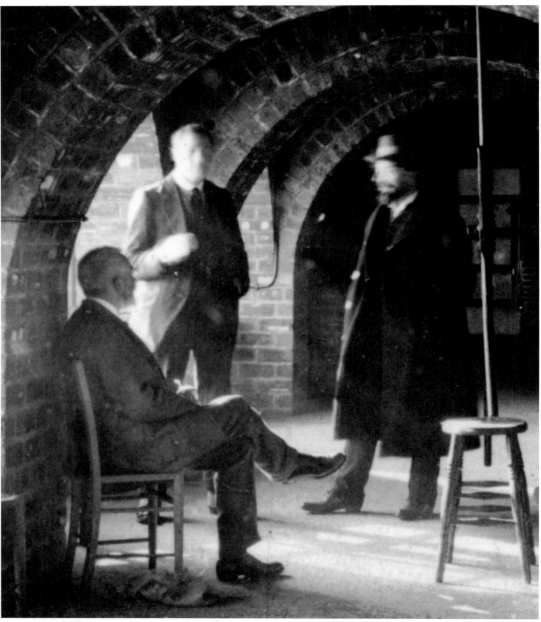
Unknown photographer, Glasgow School of Art Staff in Conversation in the 'Loggia' of the Mackintosh Building, c.1910. The three senior members of the Painting staff here are Maurice Greiffenhagen, seated on the left, James Dunlop (?) in the centre, and Paul Artôt. GSAA

The Flower
and the Green Leaf

Glasgow School of Art in the time of Charles Rennie Mackintosh

Edited by Ray McKenzie

Luath Press Limited

EDINBURGH

www.luath.co.uk

First published 2009

Hardback ISBN: 978-1-906817-26-8
Paperback ISBN: 978-1-906817-27-5

The paper used in this book is
recyclable. It is made from low
chlorine pulps produced in a low
energy, low emissions manner from
renewable forests.

Printed and bound by
Bell & Bain Ltd., Glasgow

Design by Tom Bee

Typeset in 9.5 Quadraat by
3btype.com

Art is the flower. Life is the green leaf.
Let every artist strive to make his
flower a beautiful living thing.

CHARLES RENNIE MACKINTOSH

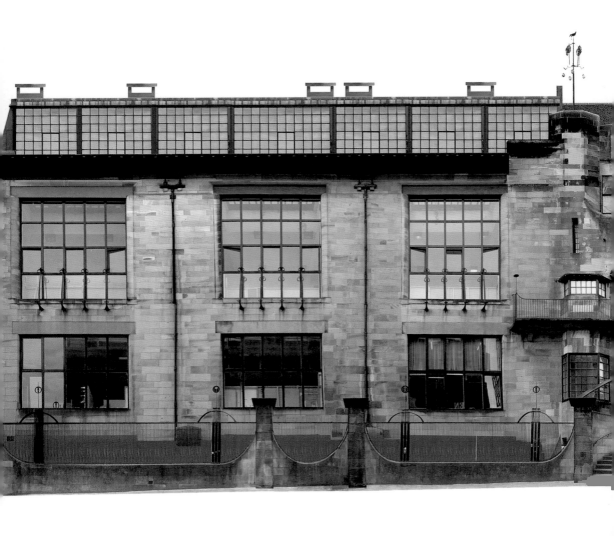

Composite digital photograph of the north
façade of Glasgow School of Art.
Digital Design Studio.

Contents

Foreword

The centenary of a building as admired as Charles Rennie Mackintosh's Glasgow School of Art Building must be a cause for celebration. It is, after all, included in every major architectural reference book, where its profound influence on early 20th-century design is readily acknowledged. It is also visited by tens of thousands of people on student-guided tours every year, and has frequently provided the backdrop for feature films, documentaries and photo-shoots. Even the famous Japanese footballer, Yakamura, when he joined Celtic Football Club, had his official photograph taken on the steps to the Mackintosh Building. So well-loved is the Mack, as it is affectionately known, that a public survey commissioned by the Royal Institute of British Architects in 2009 voted it Britain's favourite building of the last 175 years.

The Mackintosh Building, however, is much more than an architectural masterpiece. Over the century since its completion in 1909, much has been written about the building, but rather less attention has been paid to the lives and careers of those who were shaped and inspired by it, many of whom were no less original, influential and successful than Mackintosh. So what could be more fitting in a book to mark the centenary than to link the two and take as our focus the first generations of students to study in the newly completed Mackintosh Building, and to reveal the society in which they lived? The result is a fascinating account.

The Glasgow School of Art physically outgrew the Mackintosh Building many years ago and its 1700 students are now scattered across Glasgow's Garnethill in buildings, which, to use the current jargon, are no longer fit for their purpose. A new estate is envisaged, with the Mackintosh Building very much its working heart, and the first phase of this process will be the redevelopment of the entire site on the opposite side of the road. To build a companion to the Mackintosh – to create a new building which, to stand its ground, must be respectful without being subservient – is no small challenge. And that challenge is not just about façade. The Mackintosh Building works as well today as it did 100 years ago because the architect understood how to design interior spaces that people love to be in: cathedral-like studios infused with soft north light; shaded nooks and crannies where students can reflect in silence or indulge in animated conversation; glass corridors that reveal breathtaking views across the city; an intricate wood-panelled library with rippled light penetrating through tall, majestic windows.

Light, often in short supply in Glasgow, is Mackintosh's most deftly used material. So it is fitting that Steven Holl (New York), the architect selected as a result of an international architectural competition to design the new building, is also known for his sophisticated and poetic use of light. Like Mackintosh, Steven Holl designs buildings of striking beauty in which people want to spend time. His new building for Glasgow School of Art will open in 2013. Time will tell whether the challenge has been met.

Seona Reid
Director

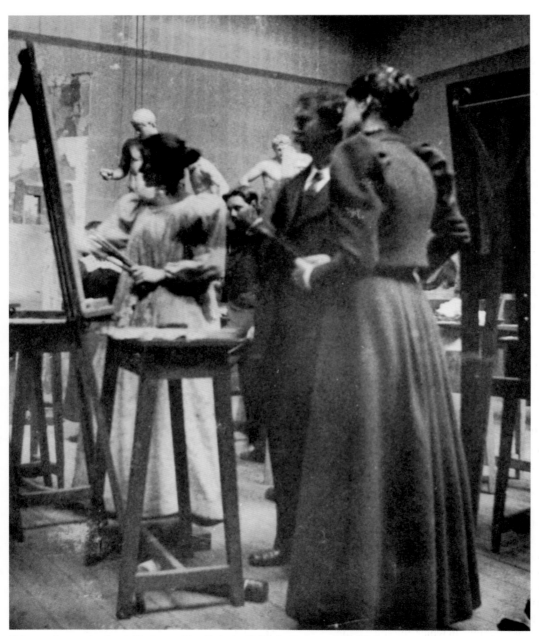

Unknown photographer, Francis Newbery and Ann Macbeth with Painting Students, c.1910. GSAA

Preface

In most people's minds the name 'Glasgow School of Art' is synonymous with the masterpiece of proto-Modernist architecture that rises on the crest of Garnethill – that distinctive grid of parallel streets framed on one side by the city's busy commercial centre, and on the other by the more relaxed environs of its residential West End. An 'iconic' building if ever there was such a thing, it is loved and admired the world over for the audacious originality of its exterior design, the life-enhancing beauty of its internal spaces and the brilliance of the architectural imagination that brought it all into being. Even the story of its creation has taken on the quality of a folk legend, with the mundane narrative of a committee of worthies struggling to balance budgets and enforce deadlines spiced up by the drama of a young genius doing battle with the forces of conservatism. For these and a variety of other perfectly under-standable reasons, the building that was designed by Charles Rennie Mackintosh in 1897, radically altered by him a decade later and brought to triumphant completion in December 1909 has become so identified with the educational institution it was intended to serve that we no longer make a distinction between the two. Not for nothing do we find it being referred to by commen-tators as a 'temple' of art. This is not to invest it with a quasi-religious sanctity, but rather to suggest that, as with a temple or a church, the physical structure of the building itself and the organisation that occupies it are effectively one and the same.

But of course Glasgow School of Art is not a building at all. The edifice known universally as the 'Mackintosh Building' – or more familiarly by those who use it every day as 'the Mack' – is only one of a number of structures, dotted variously around the Garnethill campus, in which the educational establishment more properly known as Glasgow School of Art conducts its business. It is an establishment with a history that stretches in one direction back to the 1840s – more than two decades before Mackintosh was born – and in the other to the present day, encompassing a period that has seen it undergo many fundamental changes both in its organisational structure and its approach to the teaching of art and design. It has also vastly outgrown the community for which Mackintosh was required to provide accommoda-tion, with many of the premises that have been built or acquired in the meantime bearing the names of other distinguished contributors to the School's history, such as Eugène Bourdon, Francis H. Newbery and Sir Harry Jefferson Barnes. And yet nobody, except perhaps a cynic or a practical joker, would direct a visitor's attention to the Newbery Tower in response to an enquiry regarding the whereabouts of 'Glasgow School of Art'.

Why, then, does the world persist in equating the Mackintosh Building with the School? On one level the reason is obvious. As an architectural conception it is so outstanding that it simply obliterates all the competition, dominating its surroundings in a way that no other building in the vicinity can hope to emulate, even those that are physically more imposing. It is the crowning achievement of Mackintosh's remarkable career, and an acknowledged benchmark in the history of world architecture. But there is another and more relevant reason. As will be shown in the pages that follow, the Mack was built at a critical time in the history of the School itself, providing not just a home for its staff and students, but also a symbolic expression of the radically new approach to art education that was beginning to be practised within it. For more than half a century prior to this the School had operated under the constraints of a system devised in London and imposed by central

authority. In 1901 it was granted independence as a
Scottish Central Institution with the freedom to
devise and implement its own curriculum. The new
building and the new pedagogic regime came into
being at the same moment, and as a result of the
same educational philosophy. Is it such a surprise
that they fit each other like a hand in a glove?

The story of the building – its genesis, its inter-
rupted progress, its status as Mackintosh's 'master-
work' – has been told many times, and told very well,
by others. Inevitably, some of the details of these
earlier accounts will have to be repeated here.
But the main concern of this study is with a very
different story, one that has not been narrated
before except in a very partial and fragmented way.
This book is about the first generation of students
who received their education in the Mackintosh
Building – the very students for whom it was designed
and by whom it was first occupied. It is about the
opportunities that were open to them, the staff who
taught them and the aspirations they all shared as
part of an integrated educational community. Above
all it is about the experience of those cohorts of
emergent practitioners who had the privilege of
undertaking their studies in the finest art school
building in the world when it was still brand new.
It is an attempt, among other things, to imagine what
it might have felt like to be a student working in an
atmosphere in which the smell of fresh plaster, newly
seasoned timber and recently applied wood stain
mingled in the more pervasive excitement of a great
educational adventure and a truly new beginning.

History, according to the familiar saw, repeats
itself, but not necessarily as tragedy and certainly not
always as farce. The publication of this book is timed
to accompany the opening of a major exhibition that
has been organised to mark the 100th anniversary of
the official inauguration of the Mackintosh Building
on 15 December 1909. Under the slightly different
title of *The Flower and the Green Leaf: Glasgow School of Art
in the early twentieth century*, the show will enable us to

see for ourselves many of the works of art and
design that are discussed and illustrated in this
publication. But the exhibition, like the book, is
only one part of a more extended programme of
commemorative events that will run through to the
summer of 2010, the purpose of which will not only
be to reflect on the past but also to project into the
future. In June 2008, the Scottish Funding Council
agreed in principle to allocate £50 million towards
the first phase of the most ambitious programme of
estates development the School has undertaken
since the construction of the Mackintosh Building
itself. The jewel in the crown of this initiative is a
commission to design a bespoke new structure that
will rise *de novo* on the site of the three buildings –
the Newbery Tower among them – that currently face
the Mack from the opposite side of Renfrew Street.

So once again the School finds itself on the
threshold of a major change. As Professor Seona
Reid has noted in her Foreword, the architect of the
new building will be Steven Holl, whose proposal
was selected from a slate of alternatives submitted
by seven shortlisted international architectural
practices. At this early stage it is impossible to
predict what the final appearance of the building
will be. But as the process of working up the design
begins in earnest, one thing can be agreed upon.
The historical symmetry suggested by the current
situation seems almost too good to be true.
Having occupied the Mackintosh Building for
exactly a century, the School is now in a fair position
to assess the ground it has covered and the achieve-
ments it can claim for itself. But it does so in the
knowledge that another, equally exciting phase of
its history is about to begin, and that the
educational – as well as the architectural –
consequences of the present initiative are likely to
be no less far-reaching. The adventure goes on.

Ray McKenzie
Glasgow School of Art
September 2009

Acknowledgements

This volume is the outcome of a collaborative effort and could not have been produced without the assistance of many individuals and organisations. I would like to begin by thanking the contributors for their patience in responding to my numerous and persistent editorial queries on matters both great and small, and for their unflagging commitment to a project that seemed simple enough at the outset but quickly grew in scale and complexity. I take full responsibility for any shortcomings in the outcome presented here.

I would also like to thank, on their behalf as well as my own, the many members of staff at the School of Art who have been unfailingly generous with their time, expertise and collegial goodwill: Seona Reid, Director; Susannah Waters and Peter Trowles, Archives and Collections; Jude Boyd, David Buri, Duncan Chappell, Andrew Lochhead and Catherine Nicholson, Library; Lyn McLaughlin, Teaching and Learning Resources; Grainne Rice, Exhibitions; Scott Parsons and Hannah Wardle, Development and External Relations; Eileen Reid, Wider Access Development; Denis McCormick, David Falconer, Michael Kelly, Robert McLean and their former Chief of Staff, Bill Mason, Estates Department; Alistair Storey and Andrew Harvie, Finance Office; and of course Ken Neil and all my colleagues in the Department of Historical and Critical Studies.

In addition, the project has been greatly aided by the following for the provision of information, access to research resources and permission to reproduce visual material: Douglas Annan, T. & R. Annan & Sons; Mme Ado Baltus; Sally Clegg and the staff of Possilpark Library, Glasgow; Elizabeth Cumming; Griffin Co, Roy Macdonald and Ann Steed, Aberdeen Art Gallery; Diane Gallagher and Agnes Gillies; Hugh Gentleman; Glasgow Royal Infirmary; Vivien Hamilton, Hugh Stevenson, Winnie Tyrrell and Jane Whannel, Culture and Sport Glasgow (Museums); Margaret Harrison, University of Strathclyde Archive; Fiona Hayes; Yvonne Hilliard; Lisella Huton; Michelle Lazenby; Barclay Lennie; Elaine MacGillivray and Irene O'Brien, Glasgow City Archive and Special Collections; Margaret McCance; John McIntyre; Ruari McNeill; Graham Nisbet and Pamela Robertson, Hunterian Art Gallery, University of Glasgow; North Ayrshire Museum; Anton Prnic; Johanna Roberts; Daniel Robbins, Leighton House Museum, Royal Borough of Kensington and Chelsea; Enda Ryan, Mitchell Library, Glasgow; Isabelle Six, Musée d'Ixelles, Brussels; Anna Smith, Wellcome Library, London; David Stark, Keppie Design; James Craig Stirling; David Weston, Glasgow University Library, Special Collections; Michael Wolchover, A Slight Shift Architectural Photography; Anne Wynne.

I am particularly indebted to Lionel Van Maldergem for his critical intervention in the project at a very late stage, and for his unstinting efforts in liaising on our behalf with the owners and custodians of relevant work in Belgium.

Finally the sincere thanks of all concerned must go to Gavin MacDougall and his colleagues at Luath Press for supporting the initiative from the beginning and for seeing it through to the end.

Abbreviations

The following abbreviations will be found in use throughout the main text, the endnotes and the list of illustrations.

Annual Report	*Annual Report of the Glasgow School of Art* (session indicated by date)
Calendar	*The Glasgow School of Art Calendar* (session indicated by date)
CSG(M)	Culture and Sport Glasgow (Museums)
DOS	Department of Science
GCASC	Glasgow City Archive and Special Collections
GPSB	Govan Parish School Board
GSA	Glasgow School of Art
GSAA	Glasgow School of Art Archives and Collections
GSAL	Glasgow School of Art Library
GSB	School Board of Glasgow
GULSC	Glasgow University Library Special Collections
NAS	National Archives of Scotland
NLS	National Library of Scotland
Prospectus	*The Glasgow School of Art... Prospectus. Diplomas, Bursaries, Scholarships and Prizes* (session indicated by date)
RGI	Royal Glasgow Institute of the Fine Arts
RIBA	Royal Institute of British Architects
SED	Scotch (later Scottish) Education Department
USA	University of Strathclyde Archives
Vista	*The Vista: the Quarterly Magazine of Glasgow School of Architecture Club*

Chapter One

'The Renfrew Street Panopticon':[1]
Francis Newbery and the reinvention of Glasgow School of Art

GEORGE RAWSON

Prior to moving to its new premises on Renfrew Street, the School had occupied part of the McLellan Galleries, known more commonly at that time as the 'Corporation Buildings', on Sauchiehall Street. There it rented from the City Council the first and second floors and an attic storey at the eastern end of the block. With their badly ventilated gas-lit rooms and south-facing windows, these had since the early 1880s been regarded as inadequate accommodation for a modern school of art, and prompted the School to initiate a campaign for new,

I.I A portrait of Fra Newbery shortly before the completion of the first half of the Mackintosh Building.

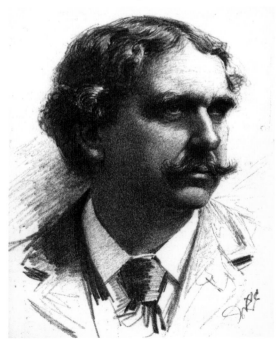

purpose-built premises. When its ambitions were realised with the completion of the first stage of its new building in 1899, it could not only contemplate running its classes in what was probably the best-equipped school in the country,[2] but also stood at the beginning of a new century when it would pioneer new approaches to art education.

By this date its Director, Francis Henry Newbery (1855–1946), had been in the post for 15 years [FIG. I.I]. Fra Newbery,[3] as he was universally known, firmly believed that everyone was a potential artist. Children, he observed, liked to scribble and make mud pies, and delighted in dressing up. Primitive societies all produced art, and modern people collected pictures. Was not all this evidence of a common 'art instinct'? Contemporary society tended to suppress this innate propensity, but if Newbery had his way it would have been celebrated: each town would have a street that the local populace would be encouraged to adorn with graffiti.[4] Yet Newbery was no believer in the myth of the 'undeveloped genius'.[5] If the art instinct existed it was necessary to 'educe' it, a term that Newbery liked to use because its Latin root suggested the action of 'drawing out', while its modern usage was associated with education.

But how did one educe, or educate, an innate propensity? One placed its owner in a rich environment under knowledgeable and sympathetic guides. In his 20s, Newbery had honed his skills as an art teacher in London where, at the Grocers' Company's School, he had worked under Herbert Courthope Bowen, an early British champion of the educational theories of Friedrich Froebel, and a proselytiser of the view that the purpose of

education was not to cram students with information, but to help them discover their inborn abilities.[6] The art instinct could only be educed and moulded, however, by someone who had discovered and refined their own creative abilities, or, as Newbery put it, discovered their 'artistic individuality'.[7] Only such people could describe themselves as artists.[8]

Newbery's views on this point were confirmed when he became a student at the National Art Training School (later the Royal College of Art) in South Kensington, in about 1877, and was taught for the first time by practising artists. He had previously worked under men whose qualification to teach art resided merely in the possession of the relevant government certificates, and whose teaching method was based on the mechanical process of making copies of engravings and other two-dimensional images. Now he came under the tutelage of Edward Poynter (1836–1919), one of Britain's leading painters, who had studied in Paris. As Principal of the School, Poynter had recruited a group of French émigré artists, including the painter and etcher Alphonse Legros (1837–1911) and the sculptor Edouard Lanteri (1848–1917), all of whom taught by demonstration, which Newbery regarded as a much more effective method of initiating students into the mastery of their craft. Newbery would borrow Poynter's aphorism 'example is always better than precept',[9] and it is significant that one of the first actions he took after being appointed as head at Glasgow in 1885 was to give a lecture, complete with demonstrations, to the governors, staff and students, showing the character and content of the teaching regime he hoped to establish.[10] An essential corollary of this was his belief that a good teacher was one who had been immersed in the European artistic tradition, which he would then be able to pass on to his pupils. This was important for Newbery, because whether a student understood the tradition or not it would still have a beneficial influence on his work. All the same, it was better that he did understand it so that he could, via the exercise of his own developed individuality, contribute to the continuation of that tradition, which Newbery regarded as a living organism, not a dead corpse to be kicked aside.[11]

In 1901 the School had come under the aegis of the Scotch Education Department (SED), as the first Central Institution for higher art education to be set up in one of Scotland's major cities.[12] The SED itself had been established in 1872 to oversee the development of the new local school boards, but its responsibilities had been gradually increased until it had taken over the Scottish funding of art education from the London-based Department of Science and Art (DSA). Under the new regime the School received an annual block grant, matched by money from local sources, in place of its previous hand-to-mouth income from the London Department, which had been based on its performance in annual examinations and a 'National Competition' in which all United Kingdom schools of art had participated. The DSA's centrally administered 'National Course of Instruction' was also abandoned in favour of a curriculum initiated by the School itself, which was incorporated into its annual prospectuses and subject to periodic inspections by independent specialists appointed by the SED.

The new curriculum, which was drawn up by Newbery, reflected his experience as a teacher under the DSA, his openness to contemporary European practice and his own art educational philosophy. Under the SED's regulations students were required to pass an entrance examination or to hold educational qualifications recognised by the Department.[13] Only day-class students were excepted, but these had to pass through the School's preparatory classes before being enrolled on the course. Newbery divided the School, for the

first time, into four specialist departments: Drawing and Painting, Modelling and Sculpture, Design and Decorative Art, and Architecture. The course in the first three was subdivided into four 'Groups', which were graded in accordance with ability. Groups I and II comprised the 'Lower' and Groups III and IV the 'Upper School'. The passage from one group to another was based on attainment rather than the time spent in it. When a student completed the prescribed studies for a group, his or her portfolio was examined by a jury composed of the relevant department's staff and the Director, and if it was deemed good enough a certificate was awarded and the student was allowed to pass to a higher group.[14] With its focus on ability and attainment, the School was prepared to allow the most able students to enter directly into Group III, taking a minimum of two years to complete the course. By the same token, some students could take up to 10 years to progress from Group I to Group IV.[15]

The highest qualification granted by School under the new system was the Diploma, which entitled the holder to use the letters Dip.GSA after their name [FIG. 1.2]. This was not an automatic award; it was described by Newbery as 'representing the finest flowering of the culture of the School' and, in order to maintain its standard, he claimed to be satisfied if it was awarded to no more than two students in any year.[16] Many students would never reach Group IV at all, and only those who had completed it were eligible to be put forward for examination. On the presentation of the relevant group certificates candidates were required to execute Diploma works, which were then judged by the head of department, the Director, other selected artists who might also be on the School's governing body, and an external assessor appointed jointly by the governors and the SED.[17] Even then they might not attain the required standard. For example in 1907, when the Diploma was awarded for the first time,

there were 11 candidates, only six of whom were successful.[18] Between then and 1914 only 128 students achieved the award.[19] From 1909 the Diploma course was restricted to day students, while a less arduous course, still based loosely on the group system, was available in the popular evening school.[20] Students who possessed the Diploma could also apply for travelling scholarships, enabling them to study in art centres across Europe.[21]

It is unlikely that the majority of those attending the School intended to complete the full Diploma course. In most cases students had to pay their own fees, which were set at a lower level for evening than

1.2 Allan D. Mainds, Glasgow School of Art Diploma, c.1907, copper etching.

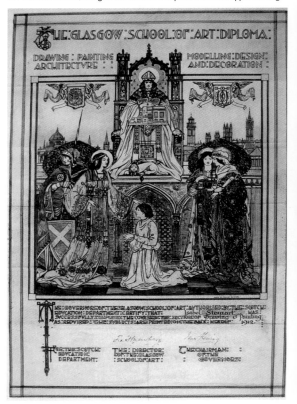

for day students. During the 19th century the School's main activity was its evening classes, which had been attended by mainly male students working in industries and professions where drawing and design were essential elements: architecture, the textile industry, the decorative trades. Day classes had mainly catered for middle-class students, the majority of whom were female. Hence the School, if it was to make its Diploma course available to a wider range of students, had to find ways of financing their attendance, especially during the day. Before 1908 a number of free studentships, maintenance scholarships and annual bursaries were provided by various bodies, including the School's governors; most, but not all, of these were available for evening students. In that year's Education (Scotland) Act, however, the system had been regularised to a certain extent, requiring students to apply to their local Secondary Education Committees for funding, and the School was able to record that 200 out of 720 students were receiving some kind of grant. But this still left 258 day and 262 evening students paying their own way.[22]

The Groups allowed for a good deal of cross-over between the four disciplines. As the highest aspiration of the painter or the sculptor was the production of works for an architectural setting, it was necessary for them to understand architecture. A knowledge of architectural styles was also seen as essential for the designer, as architecture had helped to define the different styles of ornament. For their part, the architects themselves worked in three dimensions, so a course in modelling was considered useful for them. All students, however, were required to be good draughtsmen and the discipline of drawing from the human figure, Newbery argued, helped the student to develop an intuitive understanding of symmetry and proportion, an essential acquirement for the architect as much as for the fine artist.[23]

Drawing, in the early stages of the course, was based mainly on the study of casts of architectural ornament [FIG. 1.3], a practice derived from the government's insistence in the 1840s that the students it supported were to be trained as designers and not as fine artists, and that they should be taught to draw from ornament rather than the figure. At the same time, however, while promoting accuracy and 'well-searched' drawing, Newbery had abandoned the practice, still common in England, of insisting that the students began the learning process by drawing from 'flat copies' (engravings of ornament), which he believed discouraged the development of individuality.[24] In line with accepted academic practice, drawing from the Antique cast was an important part of the course, along with a thorough study of anatomy for painting and modelling students.

In 1900, embarking on a policy of supplying the highest obtainable teaching expertise, the School began to look beyond Britain for its staff, and to bring the teaching of the figure up to the standards of continental Beaux-Arts schools it recruited professional artists from Belgium (see Chapter Four). This unique internationalist approach, based perhaps on Newbery's own experience as a student under foreign artists, also saw the School appointing heads of Modelling and Sculpture from the Netherlands and the USA, and of Design and Decorative Art from France, as well as establishing one of only three Beaux-Arts architectural courses in Britain, uniquely under a French professor.[25] The design course would also seek to draw on the achievements of the English Arts and Crafts movement. Artist-craftsmen such as Alexander Fisher and Arthur Gaskin were brought in to advise on the enamelling classes, and one of the most versatile, Robert Anning Bell, became Head of Design in 1911 (see Chapter Six). The professional standing of heads of department was an important element in their employment. Indeed, their attendance was required for only part of the academic session,

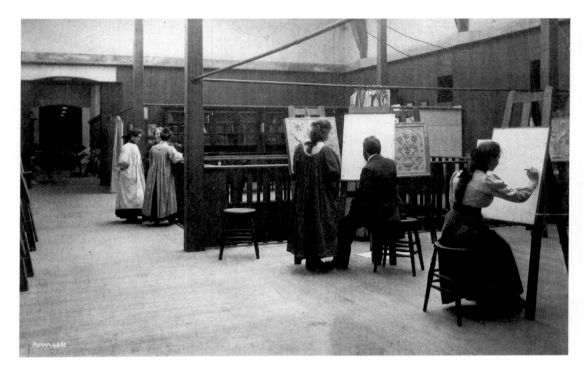

1.3 The Museum, Glasgow School of Art, with students drawing from the cast of ornament, c.1900. The instructor is probably J. J. F. X. King, who taught this class, and in the background is the library, for which he was also responsible. At the top of the stair, facing the camera, stands De Courcy Lewthwaite Dewar, instructor in enamels, with two students.

as during the remainder of the year they were expected to pursue their careers as artists.

The School's ability to appoint prestigious artists onto its staff derived, in part, from the nexus of friendships that Newbery and his governors had been able to establish through the city's position as a major centre of art and industry. Newbery was a highly accomplished networker and a gifted publicist who ensured that the School's activities were reported in the local, national and international press. One example of this was his friendship with Gleeson White, the editor of the *Studio*, a leading art and design journal that was read across Europe.[26] Through its Board of Governors, the School was also in touch with, and had a voice on, the committees of major institutions in Glasgow: the City Council, the Chamber of Commerce, the Institute of Engineers and Ship-builders, the University, the Glasgow and West of Scotland Technical College and the Glasgow Institute of Architects. The Chairman of the Board, Sir James Fleming, was a particularly effective governor, as well as being a prominent member of the Liberal Party, with influence on several educational bodies [FIGS 1.4 & 3.7]. He had been the prime mover in collecting funds for the School's new building. The governors also included several other influential figures with connections in London and on the continent. The architect John James Burnet, for example, had contacts in Paris and knew important figures in the London art

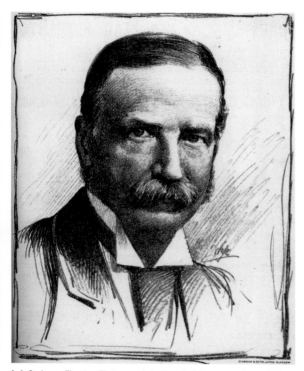

1.4 Sir James Fleming, Chairman of the Board of Governors from 1887 to 1914.

Instruction, Newbery, in order to apply his student-centred approach to the best advantage, had set up the Glasgow School of Art Club, which was open to day and evening students, both past and present. As well as having its own venue where students could meet socially, the Club encouraged individual artistic endeavour by running monthly competitions and a vacation sketching scheme, leading to an annual exhibition that was also a social occasion.[29] [FIGS 1.5 & 1.6] This was judged by Glasgow's leading artists, was reviewed in the local press and contemporary art journals, and became one of the key events of Glasgow's artistic calendar. Newbery's purpose was to encourage students to develop their own ideas away from the classroom. As he put it: 'The School of Art was divided into two classes – one for tuition and discipline, the other the imaginative which was above all teaching. They called the work exhibited "holiday work" but it was the hardest work of the year and the soundest'.[30] The association with the School's alumni, several of whom were successful artists, helped students to see themselves as members of a wider artistic community. This had a liberating and confidence-building effect on their work, which fed back into the daily life of the School. The 1894 exhibition had been the first showcase of the School's craft productions, when the new Glasgow Style made its appearance. The Club would act throughout the period as a centre of social activity, and its exhibitions as a laboratory where ideas could be tested before being presented to wider national and international audiences.

The School's craft studios also played an important role, and by providing facilities for the production of small-scale artefacts for domestic use – such as embroidered collars and table runners, *repoussé* mirrors and sconces, painted glassware and tea services – immediately began to attract women from the day classes. Students, who had previously recorded their fathers' profession or written 'art

world such as the sculptor George Frampton, who was able to avail the School of the expertise of his circle in appointing staff.[27] Newbery was a friend of the German architect Hermann Muthesius, who provided him with introductions to artists and educationists in the Germanic countries. These resulted in reciprocal visits by heads of schools between Germany and Austria and Glasgow in order to review teaching methods. The European success of the Glasgow Boys opened other doors: their appearance at the 1897 Venice Biennale, for example, had acted as a precursor to the exhibition of decorative art work by School's staff and alumni at the next Biennale in 1899.[28]

Before 1901, working under the bureaucratic uniformity of the DSA's National Course of

student' in the 'occupation' column of the School's registers, now wrote 'designer'.[31] Whereas some prominent Arts and Crafts *aficionados*, such as William Richard Lethaby at the Central School of Arts and Crafts in London, were inimical to middle-class women as students, regarding them as amateurs who were taking up places in craft workshops that should be reserved for men working in local artistic trades,[32] Newbery had eradicated the attitudes associated with amateurism from his students, putting in their place an enquiring and perceptive professional approach. When asked about the attendance in the School of 'the *dilettante* young lady who would decorate tambourines and milking stools with impossible sunflowers', he replied that she had 'been entirely weeded out. She got no encouragement and is now, so far as the school is concerned, non-existent.'[33]

Newbery saw no distinction between women and men as potential artists. One of the chief barriers to progress was the general lack of availability of nude life classes for women, without which they were unable to compete with men in the prestigious practice of figure painting. Glasgow had throughout most of its history been one of a minority of schools to offer life classes. Although it is not altogether clear whether nude classes had always been open to women, records of work sent to London for examination under the DSA regime indicate that women were working from the nude from at least 1887, after which their numbers increased each year.[34] Other areas not traditionally open to women had been: architecture, where they

were admitted from 1904;[35] sculpture, where Phyllis Archibald, one of the earliest candidates to obtain the Diploma, worked as a stone carver on buildings (a profession considered too physically demanding for women); and furniture design, which women began to study in 1915.[36] Glasgow also had an unusually high proportion of women on its staff for the period. In 1910 they accounted for 12 out of a total staff of 39, most of them working in the crafts.[37]

One of the consequences of the School's new designation as a Central Institution was that it was able to serve more effectively as a co-ordinating point for art education in primary and secondary schools throughout what was called the 'Western Division', an area encompassing all the Scottish local authorities from Wigtown to Sutherland. The development of this important adjunct to the School's main activities is discussed in detail in Chapter Eight, which reveals the extraordinary

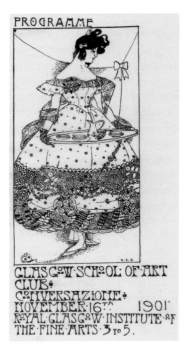

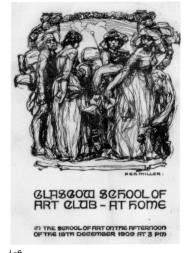

Left
1.5 Dorothy Carleton Smyth, Programme for Glasgow School of Art Club 'Conversazione', 1901.

1.6 Archibald Elliott Haswell Miller, Programme for Glasgow School of Art Club 'At Home', 1909.

'virtuous circle' that soon began to emerge once the School had taken the leading role in the training of art masters and mistresses whose pupils, in more than one instance, subsequently became GSA students themselves. All that needs to be noted here is that this was an aspect of its function that the School took very seriously, and in which its achievements won national recognition. In December 1911, for example, it mounted an exhibition of art and craft work produced by schools in the Western Division that was seen by 14,000 visitors. Professor Michael Sadler, the Vice Chancellor of Leeds University and one of several leading educationists who lectured at the event, hailed the show as being 'without exaggeration the most interesting collection illustrating the new movement in Art in the School that had been brought together certainly in the United Kingdom'.[38]

But the achievement of Central Institution status did more than simply entrench the School more firmly in the wider pattern of pre-tertiary art education practices in the west of Scotland: it also brought with it a new kind of ambition regarding the intellectual content of its courses. Newbery's own aspiration was for the School to be recognised as the equivalent of a 'university for the arts', and accordingly initiated a discussion with the University of Glasgow about the possibility of awarding degrees in art.[39] This proved to be abortive, but the development of various collaborative teaching initiatives between the two institutions throughout the first two decades of the century gave the Diploma course an academic grounding that went well beyond anything that had been provided under the old regime. In this regard it is worth noting that many of the senior staff at this time were not only leading practitioners but also recognised authorities on the historical, technical and theoretical aspects of their respective disciplines, and with major publications to their names. James Dunlop led the way with his *Anatomical*

Diagrams for the Use of Art Students [FIG. 4.3], which was first published in 1899 and had run into four editions by 1918. Ann Macbeth and Margaret Swanson's *Educational Needlecraft* [FIGS 8.8a & 8.8b] appeared in 1911 and was also reprinted many times over the subsequent decades, while 1912 saw the publication of Peter Wylie Davidson's *Educational Metalcraft* as well as *The Technics of Painting* by the Belgian émigré Georges-Marie Baltus (1874–1967) [FIG. 4.13]. Baltus was in fact a central player in Newbery's bid to raise the intellectual stakes of the Diploma programme, as will be seen from the discussion of his publication record in Chapter Four. His main role, however, was as a lecturer in the history and techniques of art, and between his appointment in 1905 and his return to Belgium at the outbreak of the war he was responsible for deepening the students' understanding of the historical traditions of art, as well as exposing them to the critical debates that animated its production in their own time. We have yet to discover any first-hand evidence of his abilities as a teacher, but there is much to suggest that he was an outstanding performer. He was certainly rewarded handsomely enough for his efforts: the fee for his first course of six lectures was £60, and he later negotiated a six-month contract as 'Professor of History and Technic of Painting' for an astonishing 200 guineas.[40] A glance at some of the subjects of his lectures also suggests that they were more than a mechanical 'textbook' art history, but an imaginatively conceived and challenging engagement with a range of current controversies. A series of public lectures he delivered at the University in the winter of 1913, for example, included sessions with titles such as 'Art and the Critics: The several ways of misunderstanding the purpose of art', followed by 'The Modern Confusions in Art: An episode of individualism, instinct worship and revolt of democracy'.[41] It would be hard to imagine anything more remote from the familiar stereotype of the Art

School history lecturer grinding mechanically from the Ancient Greeks to the present day to a dwindling class of increasingly somnolent students.

For their part the students themselves also had a role to play in this drive to give the Diploma a measure of intellectual credibility, and one of the last major initiatives Newbery steered through before his retirement was the introduction of mandatory written examinations in art history for all Diploma candidates. Predictably, this provoked a storm of protest from the students, who viewed the development 'with apprehension, both personal and general', claiming that the process of cramming it entailed would 'reduce some of us to a state of nervous prostration from which all our work would inevitably suffer'. In a lengthy petition delivered to Newbery in November 1916, they conceded that 'information acquired from lectures and practical application is valuable', but went on to express their concern that 'information acquired hurriedly for the purpose of answering set questions in writing is apt to depart from our brain cells very shortly after being shut in.'[42] The petition was signed by 59 students, among whom was the 21-year-old Agnes Miller Parker (1895–1980), who went on to become one of the most distinguished British printmakers of the 20th century [FIG. 4.31]. The protest, however, fell on deaf ears and the examinations went ahead as planned.

Perhaps one of the reasons Newbery was so keen to develop the lecture programme and its attendant examinations was because with the completion of the new building the School at last had its own purpose-built lecture theatre [FIG. 1.7]. Though not as spectacular as some of the other spaces in the School, such as the Library, it nevertheless has an austere beauty that is quite unique, and one can well understand why Newbery was so keen to make full use of it in forging links between the School and the wider community. That it was designed as a public venue as well as a facility for the School is clear from its location next to an external entrance and corridor that could be isolated from the main part of the institution. Here lectures were given not only by Baltus and his GSA colleagues but by visiting academics; in addition there were talks and recitals by celebrities from the theatrical community, such as Lillie Langtry and the Shakespearian actor manager Sir Frank R. Benson. Major literary figures such as George Bernard Shaw and W. B. Yeats were also invited to lecture.[43] Using other spaces in the building, the staff and students also put on entertainments, employing their artistic skills to advantage. In 1903 Newbery had decided to make a

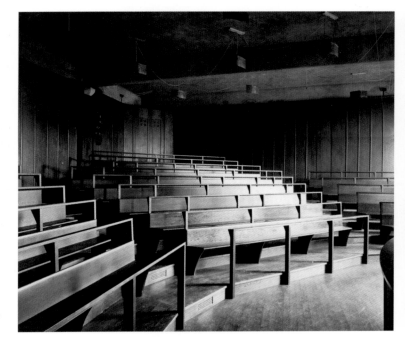

1.7 The Lecture Theatre, Glasgow School of Art, 1910.

change from the School's annual fancy dress ball and wrote a *Masque of the City Arms*, based on the legend of St Mungo, Glasgow's patron saint [FIGS 1.8 & 2.7]. For this entertainment, which was partly a pageant and partly a series of *tableaux vivants* performed to verse written by Newbery and specially composed music, the staff and students designed and made over 100 costumes and several stage sets.[44] In 1909, to mark the opening of the completed building, Newbery produced another masque, *The Birth and Growth of Art*, on a stage designed by Charles Rennie Mackintosh and with scenes and costumes by members of staff.[45] This event was produced in the large architecture room at the western end of the building, a space that was subsequently used for balls and theatrical performances. These ranged from plays by Shakespeare to concerts and demonstrations of historical and folk dance, as well as *tableaux* based on, amongst other subjects, Glasgow's history, *The Rubaiyat of Omar Khayyam* [FIG. 1.9] and Tennyson's *Idylls of the King*. During the Great War these were used to raise money for refugees and war charities [FIG. 1.10].[46]

In addition, the School was also a major venue for exhibitions. The formal opening of the School in 1909 included three exhibitions, which featured the work of past students, of current staff and art teachers trained in the institution, and of Diploma students and members of the School of Art Club.[47] In 1911 Newbery started the Artist Teachers' Exhibition Society as a showcase for the work of many of the teachers who had been trained in the institution.[48] Two years later the School hosted an exhibition of architectural drawings from the École des Beaux-Arts in Paris, and in 1916 a show of British and European posters, as well as an exhibition of historical embroideries from major collections.[49] It also participated and won awards in major international exhibitions, including the *Exposition Universelle* in Paris in 1900, the International Exhibition of Modern Decorative Art in Turin in 1902, the St Louis World's Fair in 1904, and the International Exhibition of German Art Workers and Teachers in Hanover in 1910. At St Louis, American commentators were:

unanimous in saying that 'the work of the Glasgow School of Art is unsurpassed in Great Britain and that the general excellence of Great Britain in the teaching of Art … can hardly be called in question'.[50]

Towards the end of this period its staff, students and alumni participated in two British Arts and

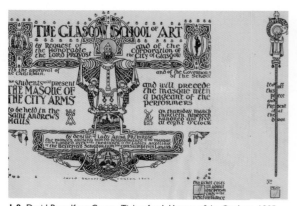

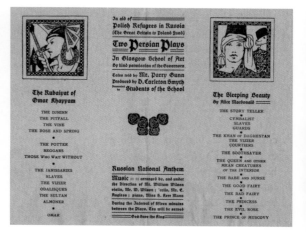

1.8 David Broadfoot Carter, Ticket for *A Masque of the City Arms*, 1905. *Right*
1.9 Unknown designer, Programme for *Two Persian Plays*, 1917.

Crafts shows at the Ghent International Exhibition in 1913 and at the Pavillon de Marsan in Paris in 1914 [FIG. 6.17].[51]

The Paris exhibition would be the last international showing of the School's work. It opened in April, but in August when it still had two months to run, Germany invaded Belgium, precipitating the Great War and signalling the end of an era. The School's strong international ties with Germany and Austria were broken and staff and students left to join the armed forces. As the war continued student numbers fell from 1,357 in the 1913/14 session to 585 in 1916/17. By this time, 400 staff and students had enlisted and 34, including Eugène Bourdon, the Professor of Architecture, had been killed.[52] With little work in Glasgow, the School's architect, Charles Rennie Mackintosh, left for the south early in the war, and its able chairman, Sir James Fleming, died in 1915. Newbery summed up his feelings about the situation in a letter to his friend, the Glasgow Boy D. Y. Cameron, in October 1916:

> Only force of will enables one to carry on Art or Art education. The brightest colours that Art can assume at the present time, not only fail to attract attention but like a gaily dressed woman at a funeral, mankind wonders that she shows herself at all!

He tried to encourage himself by imagining that the figure of Hope, found by Pandora at the bottom of her box of woes, was an artistic product. If that were so, then art and hope were closely allied and it was the artist's task to continue working and hoping.[53] But Newbery was putting on a brave face. In October 1914, only three weeks into the new School session, he suffered a severe mental collapse, which his wife, Jessie, put down to exhaustion and the effects of the war.[54] Although he had been able to resume his duties in February the following year, in April 1917 he had a more serious breakdown that effectively ended his career. He resigned in May 1918,[55] bringing to an end an

association with the School of 33 years, during which he had transformed it from one of the foremost art training institutions in the United Kingdom into one of world stature.

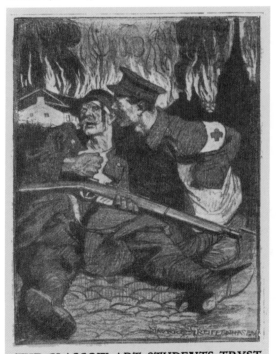

1.10 Maurice Greiffenhagen, Programme for Glasgow School of Art 'Students Tryst for Belgium and the Red Cross', 1915.

THE GLASGOW ART STUDENTS TRYST FOR BELGIUM AND THE RED CROSS IN THE SCHOOL OF ART FRIDAY & SATURDAY, 29th & 30th JANY.

Chapter Two

'Beloved City of My People': Glasgow at the dawn of the 20th century

RAY MCKENZIE

> *It is curious to note how most of the great triumphs*
> *of Art have been won in cities, and in cities, too,*
> *whose life was oftentimes of the busiest and most*
> *complex description.*
>
> Francis H. Newbery[1]

One of the most memorable of the decorative details on the exterior of the Mackintosh Building – and surely one of the loveliest of all the architect's sculptural creations – is the iron finial that rises from the turret above the eastern entrance on Dalhousie Street [FIG. 2.1]. Like its near twin on the roof of the north façade, it consists of a cage-like structure impaled on a vertical rod that terminates

in a bird launching itself into flight. In the hands of a lesser artist, the use of a bird escaping confinement to signify the idea of creative liberation might have seemed obvious to the point of being banal. Here it is carried off with a visual eloquence that stamps it with the authority of a genuine poetic metaphor.

But Mackintosh is doing more in this design than proclaiming the collective aspiration of the staff and students at work in the building below. On closer examination it turns out that the bars of the cage are overlaid with stylised leaves, transforming them into the branches of a tree, while inside the enclosure, suspended like the clapper of a skeletal bell, is a large iron sphere. A bird, a tree, a bell – these are unmistakeable as the symbols of the city's historic coat of arms, with its associated nursery rhyme that celebrates the

Left
2.1 Charles Rennie Mackintosh, (designer) and George Adam & Son (attrib., fabricators), finial on east gable, Glasgow School of Art, wrought iron, c.1898.

2.2 Charles Rennie Mackintosh, detail of drawing of east elevation, Glasgow School of Art, pencil, ink and watercolour, March 1897.

bird that never flew, the tree that never grew, the bell that never rang and the fish that never swam. If the fish is absent on this occasion, it is only because Mackintosh changed his mind during the process of working up his final design, and, for his own reasons, allowed it to swim away. But it can be seen quite clearly in his original sketch for the east elevation dating from March 1897, which incidentally shows a more conventional rendering of the arms in relief on the south gable [FIG. 2.2]. The latter was never executed, but the architect's commitment to the imagery of the Glasgow arms is confirmed by the presence of all four of its components in the sculptural bracket projecting over the interior staircase in front of the Director's office [FIG. 2.3]. This is Mackintosh's way of reminding us that the School was more than just an art educational establishment that happened to be located in Glasgow. It is an affirmation that it belonged to Glasgow in a more fundamental way, that the identity and interests of the School were inescapably bound up with those of the city it served.

And it is right that he should acknowledge the city in this way. We know already that the Board of Governors was dominated by members of the Glasgow business community (see Chapter One), with the pottery manufacturer James Fleming [FIG. 1.4] at the helm for much of the period covered by this book. Many of his fellow board members – most notably the shipowner William Burrell – were also great collectors and patrons of art. Their presence in the School was a vital link with the world of economic production, which was in turn closely bound up with the fortunes of art and design. For the students themselves, however, the location of the School in Glasgow brought with it a number of other benefits. Studying art in a great city like Glasgow at the start of the 20th century involved much more than merely attending classes and producing work for examination. With its

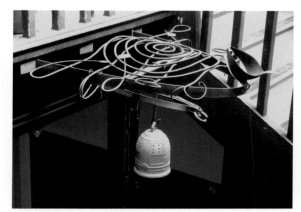

2.3 Charles Rennie Mackintosh (designer), bracket representing the Arms of Glasgow, main staircase, Glasgow School of Art, wrought and cast iron, c.1898.

teaching staff led by internationally renowned artists, its spacious studios and state-of-the-art equipment, there is no doubt that the School provided a learning environment that was ideally suited to the needs of the students in its care. But the process of learning does not start and stop at the studio door. James Joyce was fond of saying that his real education had taken place in the 'University of Life'. Life in Glasgow during its transition from the Victorian to the Edwardian period was a uniquely vibrant and exhilarating affair, and for a young person with an ambition to make a career in art or design there can have been no better place to be. Institutional resources were available in abundance, thanks to the School's successful fund-raising endeavours. But the students also had at their disposal the larger and much more varied resource that came into play when, having completed their formal studies for the day, they stepped out into the street to be carried away by the stream of energy that only a thriving modern city can provide.

What kind of place was Glasgow at this time? There cannot have been many among the 661 fledgling artists and designers[2] filing through the

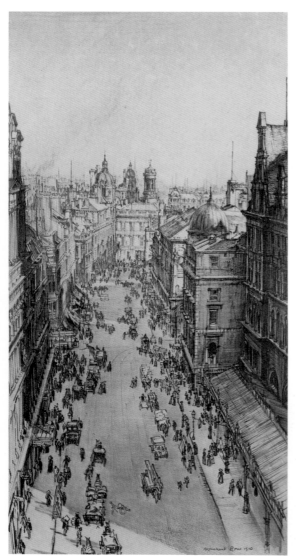

2.4 David Muirhead Bone, *Gordon Street Looking East*, lithograph, c.1911.

door of the newly completed east wing of the School on 21 December 1899 who were unaware that they were living in the most successful British city of modern times [FIG. 2.4]. They might even have sensed that they were on the threshold of what has been described as the 'most prosperous decade of its history'.[3] Wherever we care to look for the evidence of that prosperity the message is always the same – everything was being done on a larger scale, at a faster pace and with a more lucrative outcome than ever before. In 1900 there were nearly a million people resident within the city's newly expanded boundaries – the largest population it will ever have. With coal production heading towards its peak in 1913,[4] industrial and commercial output were at an all-time high, setting new records in both the quantity and quality of the goods being produced and generating new expectations in the standards of affluence they brought with them. The statistics relating to shipbuilding alone are staggering. It has been estimated that at the turn of the century something like half the ships afloat in the entire world had been built on the Clyde,[5] a good percentage of these owned by shipping lines that had their head offices in Glasgow [FIG. 2.14].[6] No less impressive was the volume and diversity of the cargo they carried with them to destinations across the globe, ranging from soft goods for domestic use – the textiles, carpets and wallpapers that were designed and manufactured in record-breaking quantities by Glasgow artisans – to those other masterworks of heavy engineering, the great steam locomotives that made their own contribution to the transport infrastructure of the world. The real secret of the city's success, however, lay in the fact that it operated as an integrated economic organism, with all the different branches of commerce and industry feeding into each other in a complex network of mutual support. The 'greatness of the city depends', as one contemporary commentator put it:

not upon an isolated industry, but upon a congeries of magnificent commercial enterprises, each carried out on a scale of magnitude quite unparalleled in the annals of modern industry.[7]

It is clear to us now that the appearance of economic invulnerability that came with this was an illusion – that the seeds were already being sewn for the catastrophic downturn that would begin with the outbreak of the First World War.[8] But it is doubtful that anybody was aware of this at the time, least of all the students taking the first steps towards playing their own part in this great economic adventure. For them, as for the majority of the people of Glasgow, the outlook of the city was one of unprecedented confidence, sustained by the belief that the good times would go on forever.[9]

Nor was that confidence confined to the world of commerce; cultural activity was equally buoyant at this time. Despite the deep-rooted assumption that a production-orientated city like Glasgow would have neither an interest in nor the time for objects as impractical as paintings and sculptures, the idea that it was a place in which art could be both appreciated and produced had been gaining ground since the middle of the 19th century. The Glasgow Institute of the Fine Arts had been established in 1861 as a showcase for Scottish and continental art, and from the beginning had attracted record numbers of visitors. The opening of its own bespoke premises on Sauchiehall Street nearly 20 years later was to raise its profile even further [FIG. 2.5], and with the achievement of its Royal Charter in 1896 it was finally recognised as a worthy competitor to both the Royal Scottish Academy in Edinburgh and its more prestigious sister institution in London.[10]
But even against this background of steady progress, the transition to the 20th century brought with it a dramatic quickening in the pace of change. In 1895 there were four private art dealers in Glasgow; a decade later there were no fewer than 32.[11] Many of them, moreover, did much more than just buy and sell. The well-established firm of T. & R. Annan & Sons, for example, was equally influential as a publisher, and with their lavish co-production of Baldwin Brown's *The Glasgow School of Painters* in 1908,[12] many Glasgow-based artists found that after years of struggle their work was finally beginning to achieve national recognition. Just how thorough was the change that had taken place in their fortunes can be gauged by comparing the two standard texts on Scottish art that appeared at different points in this period. In Robert Brydall's *Art in Scotland* of 1889 not a single one of the 20 artists associated with the Glasgow Boys is listed in the index, despite the huge local success that many of them had enjoyed over the previous decade. By contrast,

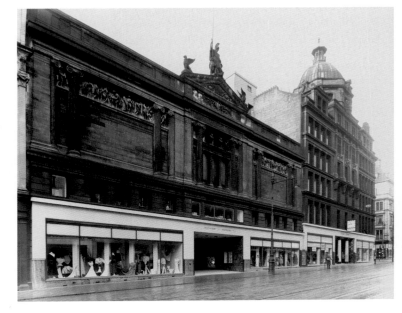

2.5 John James Burnet, Royal Glasgow Institute of the Fine Arts, Sauchiehall Street, Glasgow, 1879–80 (demolished 1967).

when James Caw published his *Scottish Painting Past and Present* in 1908, he had something to say about every one of them.[13] In less than 20 years the art scene in Glasgow had changed beyond recognition, and was now registering loud and clear on the radar of official Scottish art history.

If the burgeoning of private and commercial galleries provides one indication of the growth of the arts, another measure of their new status is the support they were now receiving from more official quarters. There is no doubt that the single most significant event in relation to the visual arts in Glasgow at this time was the opening of Kelvingrove Art Gallery and Museum in May 1901, which saw the city's municipal art collection transferred from its cramped premises in the McLellan Galleries on Sauchiehall Street to a magnificent, red-sandstone fantasy castle in the city's most beautiful park [FIG. 2.6]. Built largely with the profits from the International Exhibition of 1888 – Glasgow's first proper bid to be recognised as a player on the stage of world art – it was the centrepiece of the follow-up event 13 years later, which for its own part set a new British standard in the scale and abundance of the artistic treasures it placed on display.[14] And just in case there was any lingering

doubt about the seriousness with which the city was now taking its responsibilities as a supporter of the arts, the entire sculpture programme at the entrance was designed to promote the image of Glasgow as a city in which such activities could flourish. Dominating the north porch is George Frampton's colossal bronze representation of *St Mungo as the Patron of Art and Music*, which presents the city's legendary founder framed by exquisite female muses emblematic of literature and the performing arts [FIG. 2.7]. The association of civic patriotism with the world of artistic creativity is continued in the three pairs of carved spandrels that decorate the surrounding canopy, where lines of vaguely medieval Arts and Crafts maidens blow trumpets and strike cymbals in a ritualised acknowledgement by the British Empire that Glasgow is indeed a city where art is made to happen [FIG. 2.8].[15]

In the meantime, the day-to-day experience of living in the city was also undergoing radical transformation. Several major technological innovations were introduced at around this time that helped to establish Glasgow as a forward-looking city in the truly modern sense, bringing with them the accelerated tempo that would define the essential condition of urban life in the 20th

2.6 J. W. Simpson and E. J. Milner, Allen Kelvingrove Art Gallery and Museum, Glasgow, 1892–1902, photographed shortly after completion.

2.7 George Frampton, *St Mungo as the Patron of Art and Music*, bronze, 1900, Kelvingrove Museum, Glasgow.

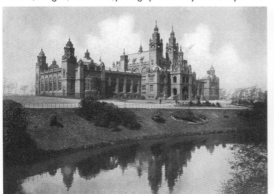

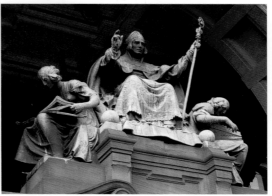

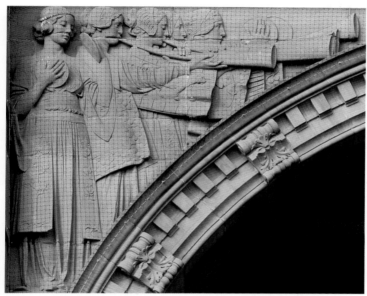

2.8 George Frampton (modeller) and William Shirreffs (carver), *The Empire Salutes Glasgow*, Locharbriggs sandstone, *c.*1900, Kelvingrove Museum, Glasgow.

confront the many new challenges that the 20th century would undoubtedly bring.[19]

Not only did this raft of technological innovations enable people to move around and communicate with each other more quickly and more efficiently than ever before; they also changed the character of urban experience in a multitude of other, more subtle ways. Over and over we find commentators of the time noting how pedestrians had to cope with a range of distinctive new noises on the street, so that the familiar din created by newsvendors, oyster sellers and buskers now had to compete with the more insistent clanging of the electric trams – referred to locally as 'skoosh cars' because of the dramatic rush they created as they sped by. And with the new noises came new olfactory sensations. Returning to Glasgow after several years' absence, the writer Frederick Niven noticed how the once pervasive aroma of oats from the nose-bags of the trace-horses that used to pull the trams was already beginning to give way to the more acrid smell of petrol and exhaust fumes as the motor-car – what he describes as a 'flaunting luxuriance upon tyres' – began its slow but relentless appropriation of the city's streets.[20]

The fact that we have to turn to the work of a writer to gain an insight into the multi-sensory complexity of urban experience is perhaps not surprising – sounds and smells are not, after all, the natural province of the painter or the print-maker.[21] Where the visual arts do come into their own, however, is in their response to another feature of the Glasgow scene that made a decisive

century. A new underground railway system had been opened in 1896, the third in the world after London and Budapest, introducing the people of Glasgow to a novel mode of travel that we have since learnt to call commuting.[16] It was the first city in Britain to install a municipal telephone exchange, enabling the business community in Glasgow, and soon after domestic users, to benefit from this marvel of modern communication long before it was embraced elsewhere.[17] To add to the vast number of traditional theatres, music halls, concert venues and other places of entertainment that already existed in Glasgow, the cinema made its appearance in the early years of the century, with the number of dedicated venues growing annually until there were a staggering 100 'picture houses' in Glasgow by 1917, many of them a stone's throw from the School.[18] All of this, together with the electrification of the street lighting and tramway systems in the 1890s, ensured that Glasgow was properly wired up to

impact on its appearance at this time – the swathes of black fog that we know enveloped the city on an almost daily basis. The strongest evidence of this is in the work of David Muirhead Bone (1876–1953), whose prolific output of topographical drawings and prints includes numerous views in which we have to struggle to make out the subject through a miasma of atmospheric filth: trace-horses reduced to equine ghosts, ferry-boats disappearing into the fog-bound silence of the river, the whole of the West End dematerialised into a translucent silhouette [FIGS 2.9, 2.10 & 2.12]. For the writers of the period too, the pervasiveness of the fog was one of the city's most striking features. John Buchan was among the first to use the now familiar gastronomic simile to characterise the quality of the air as he remembered it from his days as a student, though for him it was only one aspect of the more general meteorological misery that the long-suffering Glaswegian had to endure when industrial pollution, like everything else in the city, was approaching peak production:

> There was the weather – fog like soup, drenching rains, winds that swirled down the cavernous streets, mornings that dawned bright and clear over snow.[22]

Clear mornings there might have been, but when the fog did descend it was often so impenetrable that pedestrians were scarcely able to see the pavement under their feet. Even those who preferred to stay at home in such conditions apparently could not escape it, the fog often achieving such a 'profound and pressing' density that it leaked into their rooms through the window.[23] To have to breathe air laden with such volumes of soot was surely bad enough, but when it was combined with rain the result was a lethal cocktail that was capable of dissolving the very stone out of which the city was built. The City Chambers, for example, was so badly affected by airborne pollution that many of its sculptural details had to be re-carved in 1901, less than 15 years after it was completed.[24] As it happens,

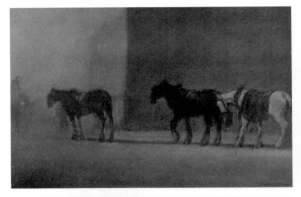

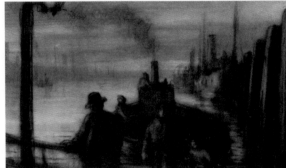

2.9 David Muirhead Bone, *Trace Horses on a Foggy Day, St George's Place*, pastel, c.1911.

2.10 David Muirhead Bone, *Kelvinhaugh Ferry*, lithograph, c.1911.

the team of sculptors commissioned to carry out the restoration included one of the School's own students, William Reid Dick. He can be seen in a contemporary photograph standing on the scaffold high up on the George Street façade, a lump hammer at the ready in his hand and – rather ironically under the circumstances – a cigarette in the corner of his mouth [FIG. 7.13]. Quite apart from its effect on the city's physical fabric, the prevalence of this early form of 'acid rain' must have made life in Glasgow a particularly unpleasant experience, stinging the eyes and coating the pavements with a greasy black paste. The impact all this had on public health is beyond imagining.

But there were compensations, and for those who looked at the city through the eyes of an artist the fog had a unique aesthetic appeal. Frederick Niven, who had been a student at the School before he became a novelist, identified the fog as one of the things he loved most about the city. Many years later he recalled how 'the smoke-laden atmosphere, pernicious to the bronchial tubes, seem[ed] part of its charm', sinking into a nostalgic reverie when his memory summoned up 'those foggy nights when sirens wailed up and down river and the street lamps were amber blurs, and even indoors there was an attempt at nimbus round the chandelier'.[25] For Muirhead Bone, expressing himself with his pen this time rather than his lithographic crayon, the fog had the power to stimulate reflections of an even more romantic kind:

> One blesses the smoke haze … for mellowing and softening the waves of light till the whole town seems a mere golden memory of a poet's architecture, like the walls of Turner's Carthage or the palaces of Claude.[26]

He might well have gone on to add the Thames-side warehouses of Whistler, who a decade or so earlier had used the pollution haze of London to work a similar magic on the modern industrial landscape, transforming factory buildings into 'fairy palaces' and smokestacks into Renaissance bell towers.

On the other hand, those who took the trouble to peer through the mist of romantic escapism discovered a city that still bore the marks of an earlier and much grimmer phase of its history, with all the terrible inequalities that came with the *laissez-faire* ethics of unbridled capitalism. For the journalist and editor J. A. Hammerton, to take a stroll along Sauchiehall Street in the afternoon or early evening in the 1890s was to be confronted by the social contradictions of the city in a particularly shocking form. As the closest equivalent in *fin de siècle* Glasgow to the Parisian *boulevardier*, his eye was naturally attuned to the appearance and behavioural mannerisms of the affluent bourgeoisie

as they practised the recently invented art of window-shopping, and his account is peppered with thumbnail sketches of newly fashionable types:

> Frequently you will notice a young lady with the bloom of youth upon her cheek, but a strange indefinable air of importance about her, as she critically inspects the fancy shop windows, her mother by her side. She examines minutely the display of an art furnisher, and tells mamma that she would awfully much like to get that ornamental cabinet for John's papers and things, as they are always going astray.[27]

Elsewhere he found young girls:

> walking about in groups of three or four, manifestly eager to enjoy the 'fun' of bandying inane small talk with the 'Johnnies', who puff weedy cigarettes, or suck the handle of their shilling walking sticks.[28]

But as a more general 'student of character' he was also receptive to the contrast between the 'stylishly dressed, gaudily attired' beneficiaries of the booming economy and the various manifestations of 'abandoned humanity' with whom they were forced to share the pavement. He seems to have been particularly outraged by the commercial exploitation of 'sandwich men', the 'poor … wretches who, for a shilling a-day, will bear around a cumbersome board before them and behind, telling the giddy crowd that they should hie to this or that theatre'. While recognising that these 'hopeless creatures' had almost certainly brought impoverishment upon themselves – more often than not '*via* the drinkshop' – he confessed himself 'unable to appreciate the spirit that can trade upon a fallen brother's poverty'. To this 'obnoxious concomitant of civilisation' he also added the 'organ grinders … fiddle scrapers, the harpists, the flautists and the vocal villains', as well as the newsboys and flower-sellers for whom the pavement was less a source of social pleasure than a place in which to scratch a meagre living, as it was for those other female street workers, whom he does not identify explicitly but merely refers to euphemistically as 'the painted creatures … whose lives are records of shame'.[29]

But if Hammerton saw Sauchiehall Street as encapsulating the economic contradictions of the city, he would have found an equally fertile source of social observation, albeit with a slightly less cosmopolitan emphasis, had he extended his promenade a little to the north and climbed one of the steep streets that connects what he dubbed 'Our Strand' with the more predominantly residential area known as Garnethill. It is here also, had he made the journey only a few years later, that he would have found the social mix enhanced by a new and rather more exotic arrival in the form of the student of art and design. With the completion of the first section of the Mackintosh Building in 1899 the image of the School would henceforth be very much bound up with the area in which it was now located, benefiting not only from the scenographic potentials of its hilltop site [FIG. 2.11], but also from the distinctive social culture that flourished in the streets around it. It is true that the School was already on the fringe of Garnethill when it occupied rooms in the south-east corner of the Corporation Buildings, which had its main frontage on Sauchiehall Street. But the accommodation there was very makeshift, and with its entrance tucked inconspicuously round the corner on Rose Street [FIG. 2.13] the School's identity was entirely swallowed up by a building designed for purposes other than the teaching of art. The move up the hill to Renfrew Street not only gave the School a powerful presence of its own, but also placed it more firmly in the centre of this topographically unique part of the city. The architect James Salmon acknowledged as much when he referred to the School as the 'Renfrew Street Panopticon'.[30] Even today, the School's staff newsletter goes by the name of the *Garnet*.

More than a century of urban change, including a wave of particularly brutal post-war demolition, has transformed the appearance of Garnethill, but enough remains for us to gain some idea of the sort of place it was at the time the staff and students settled into their new premises. Occupying an area stretching roughly between Hope Street and St George's Road on its east–west axis, and bounded on the north by New City Road, Garnethill has always been a pleasingly improvised mixture of the domestic, the commercial and the civic, encompassing one of the city's leading theatres, two shopping arcades, a synagogue, two Roman Catholic churches, a cancer and a dental hospital, two paediatric clinics, three schools, a Salvation Army shelter and the premises of a philosophical society, in addition to some of the finest residential terraces in Glasgow. By the time the School of Art made its home there it was already being referred to as the 'Montmartre de Notre Glasgow',[31] with a reputation for a mildly bohemian seediness – the kind of place where 'resting' actresses and opera singers might be found residing until better times came along.[32] For a student of art and design, however, having all this on the doorstep brought certain obvious advantages, as did the fact that the run-down tenements in the adjacent district of Cowcaddens provided by far the cheapest rented accommodation in the whole of Glasgow.[33] For a variety of reasons – social, cultural and economic – the School could not have chosen a better address for its new home than 167 Renfrew Street.

General information relating to the conditions under which the students led their lives can be easily acquired by consulting the appropriate historical records – the guidebooks of the time, such as Stratten's *Glasgow and its Environs*, as well as the extensive body of vintage photographs preserved in Glasgow City Archive. We are also particularly fortunate that three young but very gifted writers, among them the printmaker Muirhead Bone, took it upon themselves to produce a detailed account of the city for the benefit of the many thousands of tourists who flooded into the city in 1901 for the International Exhibition in Kelvingrove Park. *Glasgow in 1901* is one of the most vivid books on

Glasgow ever written, and provides a unique insight into the tenor of life in the city during this heroic phase of its cultural and industrial ascendancy. It is worth noting, however, that only one part of the book makes an explicit claim to objectivity as a documentary record – the middle section entitled 'Glasgow of Fact'. For the rest, the book is divided equally between sections dealing with 'Glasgow of the Imagination' and 'Glasgow of Fiction', as if to acknowledge that a city is as much a cultural construct as a creation of stone and mortar, and that an account of the lives of its inhabitants does not have to be factual in order to be true.

As it happens, the period of transition from the late Victorian to the early Edwardian age is remarkably rich with novels and stories that are set in Glasgow, and in which the physical presence of the city is as important to the story as the human dramas that take place within it. In one or two cases, moreover, the School itself features as a prominent part of the *mise-en-scène*: in Catherine Carswell's novel *Open The Door!*, for instance, which chronicles the author's time as a university student in the early years of the new century, and her love affair with Maurice Greiffenhagen [FIG. 4.18], the School's Head of Painting.[34] Though disappointing in its treatment of student life, its great strength lies in the clarity with which it conjures up the local topography, using street names and familiar landmarks such as the synagogue and the cancer hospital to aid our mental navigation of the place in which the narrative unfolds. In one particularly critical moment in the story we find the central character, Joanna Bannerman, pacing up and down Hill Street in search of her lover, who eventually appears silhouetted against the sky 'on the topmost point of the grey stone ridge'.[35] [FIG. 2.12.]

Of all the fictional recreations of the School at this time, however, the most detailed and richly suggestive is Frederick Niven's *Justice of the Peace*, which was first published in 1914, but covers the

Top
2.11 David Muirhead Bone, *Building the School of Art, Renfrew Street*, lithograph, c.1911.

2.12 David Muirhead Bone, *From Garnethill, Looking West*, lithograph, c.1911.

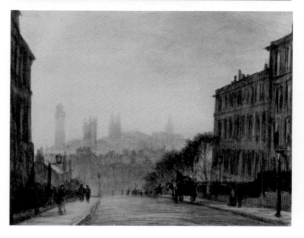

period leading up to and just beyond the completion of the eastern half of the School. In his preface to a later edition, Hugh Walpole claimed that there was 'no other novel in the English language in which Glasgow is so marvellously rendered', reserving particular admiration for his treatment of the:

> close streets, the smoky air, the sky thick with moving cloud, the tea-shops with their surging customers, the strange mixed whirl of Art and Presbyterianism.[36]

It has to be said that Justice of the Peace is not unique in this regard – many of Niven's other Glasgow novels, such as A Tale That is Told (1920) and The Staff at Simsons (1937), combine the same skilful realisation of character with a use of circumstantial detail that make them all indispensable in any attempt to recreate in our imagination the Glasgow of this period. In the case of Justice of the Peace, however, there is the added advantage for us that the art component of the 'mixed whirl' is focused very precisely on Glasgow School of Art, and at just the time it was approaching its heyday under the directorship of Francis Newbery.

The author of Justice of the Peace has made a brief appearance in these pages already, but perhaps he should now be properly introduced. The son of a prosperous Glasgow muslin manufacturer, Frederick Niven (1878–1944) was one of the most successful Scottish writers of his generation, with a prolific output that encompassed poetry, journalism and travel writing, as well as contemporary and historical fiction. One of the distinguishing features of his style as a novelist is his tendency to interweave the invented narrative with elements of autobiography, clearly intending many of his characters to be read, at least by those in the know, as projections of his own career and personality. And so we find that the hero of Justice of the Peace is a young artist named Martin Moir, who defies his father's intention that he should join him in the family textile business and decides to pursue his passion for art by enrolling in the evening class at the School. The similarity to

Niven's own experience is too close to be a coincidence. He too had been expected to follow his father into the textile trade, but was allowed to attend the School as an evening student on a 'trial' basis between 1893 (the last year in which Mackintosh studied at the School) and 1895.[37] Interestingly, Niven himself was undecided at this time as to whether he wanted to be a painter or a writer, and the process through which he eventually chose to go down the path of literature is very clearly documented in his autobiography, Coloured Spectacles, which appeared in 1938. 'Well do I recall', he wrote:

> the evening on which Francis Newbery, the Head of the Art School in those days, set me a task for the next night and I asked if I might postpone it until the night after, explaining that on the night which he was arranging for me I had to read a paper on Keats to a literary society. He stared at me and, 'Who is Keats?' he asked with a gravity mitigated by a twinkle he could not wholly obliterate. 'Was he a painter? What I mean,' he continued, 'is that the sooner you decide whether you are going to draw or write, the better.'[38]

It is here also that we have an early confirmation of Newbery's exceptional ability as a teacher, as well as evidence of his belief that art education is a process of 'educing' the talent that is already latent in the student.

> He was a great instructor. 'I am not here,' he would at times remind us, 'to put art into you, only to bring it out if it is in you.' He also taught me to see.[39]

But the decision to transpose memories such as this into a work of fiction is important for us today because it gave Niven an opportunity to present his experiences as a much more fully formed 'slice of life', fusing precise historical details with a psychologically compelling sense of what it was actually like to be a student at this time. We know, for example that many of the evening students had to work in full-time day jobs in order to support themselves. In the case of Martin Moir this was a matter of grinding away in the back room of a jeweller's shop on Renfield Street, polishing silver for 25/- a week.

It also meant that he had to spend £1 of that princely income renting a room in a 'tributary street off New City Road':

> in the house of a maker of rupture-trusses and artificial limbs, whose wife – according to the idiom – took in lodgers.[40]

This left him with precious little for meeting all the other expenses that came with being a student of art, such as purchasing the rolls of 'rough-surfaced paper', the 'small stone bottle containing a glossy black fluid called Ebony Stain' and the 'sheaf of slender pens' that provided his hosts with evidence of his mysterious avocation. Even so, he was still able to lunch out on a daily basis as a relief from the 'fried eggs, poached eggs [and] scrambled eggs' that 'alternated without comment for breakfast' and the boiled eggs that were served up every night for tea. He was, apparently, 'easy to feed'.[41]

But the novel reveals more than the quotidian details of an art student's daily life. By embedding his account of it within the context of the family chronicle that constitutes the novel's main narrative Niven is also able to provide a forceful insight into the way in which art was perceived by those not directly involved in it, confirming the suspicion that despite the growing acceptance of art in Glasgow, a deep-rooted philistinism still prevailed.[42] As far as his parents were concerned, Martin's aspiration to be an artist was not only tantamount to economic suicide, but flew in the face of their basic moral values as upright bourgeois citizens. It is a familiar enough theme in the mythology of 19th-century art, not least in its more romanticised manifestations, but it is interesting that the perception of a career in art as being fraught with economic and moral risk was still so strong at a time when the School was doing all it could to expand the opportunities for young people to enter the profession. Niven drama-tises the theme in the following exchange between Martin and his father as they discuss the young man's future:

'I want to be an artist.'

'Oh!' very quick and very definite. 'An artist! If you had said anything but that! Gad! – artist is out of the ques-tion. Man, it's starvation! I should feel criminal if I did not prevent that! Your mother, of course, is entirely opposed to the idea of art... As one man to another... I assure you that art, to use an expression I have heard in the ware'us, is a mug's game.'[43]

As a business man and manufacturer, the elder Moir turned out to be less resistant to the general idea of a career in art when it was explained to him that there was such a thing as 'applied art', which could be said to belong as much to the world of commerce as that of visual creativity, and it was on this basis that Martin was allowed to enrol at the School. His more puritanical mother, however, remained adamantly opposed to the idea, largely on the grounds that all artists were congenitally corrupt and art schools the breeding ground of depravity and vice. A particular focus for her opposition was the use of the female nude in the life class, which she regarded as an 'indignity to womanhood'.[44] The epitome of late Victorian prudery, and already involved in various moral crusades such as the 'Abolition of Barmaids League',[45] she remains unmoved even by her son's later success, and indeed vents her frustration by demanding in a letter to the *Glasgow Herald* that 'the question of the Artist's Model should be looked into' as a matter of urgent civic duty. 'It is criminal', she asserts in an even more morally charged reprise of her husband's initial objection:

> that in these days women should be inveigled into studios and made to strip themselves to be painted by men. I know there is a worse fate in store for poor girls – and I do not blame the girls; they have chosen the lesser evil in offering themselves bravely to this indignity instead of to a worse... I do not speak without a certain knowledge of these poor creatures who have been dragged to what artists call – oh irony – the throne.[46]

If *Justice of the Peace* offered nothing more than these small but telling details of the social background to

the art scene in late 19th-century Glasgow, it would still be one of the most valuable contributions to the literature of the city of this time. But in fact it goes very much further than this, providing us with what amounts to an eye-witness account of student life at the School in the last years of its occupancy of the old premises, and therefore during the period when the Mackintosh Building was being planned. As a 17-year-old *ingénue*, exposed for the first time to the esoteric world of art education, his response to what he found on passing through the door on Rose Street [FIG. 2.13] was a mixture of wide-eyed wonder and an 'inexplicable sense of having come home'.[47] He notes the stone-floored corridors illuminated by 'hissing gas-jets', the whitewashed walls 'on which were hung framed drawings, executed in red chalk, in charcoal, in pencil',[48] the doors opening off into rooms designated variously for classes in 'Elementary', 'Perspective' and 'Antique', as well as the Lecture Theatre, which, owing to the general shortage of accommodation, also had to double as a studio for the life-class. Feeling very much 'like a schoolboy going to school for the first time',[49] he was particularly struck by the appearance and manners of the heterogeneous assortment of youthful humanity that were to be his fellow students, all of them energised with the unique confidence of young artists who find themselves 'on the threshold of it all':[50]

> As he came to the first landing he found a slight milling there of the arriving students, suggesting that the School was well filled. Varied were the types, varied the faces. There were young men – very young men, mere 'boys' in his estimation – boys in spectacles looking half timid, half sullen, with unpleasant down on their chins, as though their mothers, objecting to them growing up, had prohibited shaving as yet, and occasional clippings with scissors from the sewing basket, had rather pathetically failed. There were older boys, men indeed they seemed in his eyes, who had a bearing as if they were at home in the place; they mounted gaily three steps at a time; they saluted loiterers on the landing and strolled on. There were

2.13 The Rose Street/Sauchiehall Street corner of the McLellan Galleries (or 'Corporation Buildings'), including the entrance to GSA on the right. The dome was added by J. J. Burnet's firm when they converted it to Trerons' 'Magasin des Tuileries' in 1904, after the building had been vacated by the School.

men who looked as if clothes did not interest them. There were extreme dandies. But heedlessness in the matter of apparel, or meticulous attention to apparel, seemed, here, valueless as indications of caste. Pressed-pants chatted with Baggy-knees... Here was a society in which, if his first sensings were right, he could be sociable.[51]

He goes on:

> As he reached the second landing he looked up suddenly, sharply as a deer in the forest; for he was being observed. There was a group of young men upon this landing looking down, several of them with elbows and hands on the rails, chins on their hands, bending so that the picture struck Martin as 'rather weird' – or half weird, half droll. Seeing his sudden consciousness of their scrutiny they either immediately averted their gaze, or gave him the faintest sign of friendliness, to be discerned only by one fitted to

receive it. He took quick stock of them. There was one with bantering eyes, red hair, close cropped, pointed red beard; so young was he that he could not, despite his beard, delude the onlooker into thinking him more than a stripling... He evidently answered, perkily and beamingly, to the name of Smith. There was another, who showed, at the top of a very disreputable suit of tweeds, a massive head, with long, golden, dishevelled hair. There was a little ugly black-haired man, hands deep in pockets, looking very grim. There was a tall, cameo-faced, willowy person, with hair longer than Rubenstein. There was an extremely cheeky and charming young man, whose face was the face of a bad little cherub, hair perfectly normal, save that across his forehead it came down in the manner of a bang.[52]

It is among this motley crew, with hair so varied on head and chin, that Moir begins his studies, soon settling into the routine of drawing both from the Antique and the life model. The latter turns out to be a surprisingly regimented affair, with the students taking their places to begin work on a barked instruction for the model to 'Pose!', and continuing until the same voice – presumably belonging to a studio assistant – announces that it is time for her to 'Repose!'[53] While the School's annual reports from the 1890s give us a fairly accurate idea of what was taught in the School during this transition period, Niven's fictional account brings it all much more convincingly to life, enriching the historical facts with an authentically subjective realisation of actual student experience.

More than anything, the School he portrays is one that was dominated by the powerful figure of Fra Newbery, whom Niven does not at first identify by name, but refers to variously as 'the Big Man' and 'the Chief'. He makes his debut as no more than a 'sonorous voice' that Moir overhears while standing outside his office in the corridor,[54] but when he emerges a few moments later, the young artist is immediately struck by the charismatic force of his physical presence. The fact that Newbery turns out to be a gifted and effective teacher, with a

shrewd eye for an individual student's potential, should not surprise us – we know this from reliable testimony elsewhere. What Niven's account does, however, is to flesh out the details of how he occupied himself on a day-to-day basis, as well as his particular style of operating as the head of an important educational establishment. He seems to have had complete freedom in his management of the admissions procedure, offering a place to Moir on the strength of a small portfolio of drawings and allowing him to begin attending classes at once. Far from being a remote 'administrator' of the School, he interacted freely with the students in the studios themselves, taking infinite pains over the work of the individual pupils in his charge and regularly offering advice on difficulties they might be encountering outside the School. He organised social evenings in which the more promising students were introduced to established artists, both local and from overseas. It was even suspected – though Niven makes it clear that this was never confirmed – that he occasionally helped the more impoverished applicants gain entry to the School by paying their fees from his own pocket.[55] Even though the fees were, in Niven's opinion, 'absurdly small',[56] such a gesture is altogether consistent with the boundless generosity of this extraordinary headmaster.

The conclusion of Moir's time as a student at the School in the mid-1890s is clearly intended by Niven to equate with his own decision to abandon the study of art and devote himself to literature, and it is at this point that the real narrative of the author's life and the imagined narrative of his fictional alter ego begin to diverge. While Niven went on to become a professional novelist, Martin Moir presses on with his ambition to make a career as a painter, which he eventually does, and with no less success. The rupture in the story, however, is managed by the clever device of sending Moir across the channel to complete his studies in Paris, and it is here, not

in Glasgow, that he begins to make his reputation as a professional artist. By the time he returns to Glasgow in the early part of the new century he has been transformed by Niven into a thinly veiled portrait of his friend, the printmaker Muirhead Bone, who, in another twist in this complex interweaving of real and fictional plots, had only recently left Glasgow to live in London.[57] Like Bone, he is passionate about Glasgow – described by Niven in his auto-biography as the 'beloved city of my people'[58] – and devotes himself to the production of a series of 'Clyde Etchings' that are intended to do justice to the truly heroic quality of a great industrial and shipbuilding metropolis [FIG. 2.14].[59]

But his absence from Glasgow also gives him a new advantage as an artist, allowing him to see it with completely fresh eyes, and to register with a greater clarity the many changes that had taken place while he was away. He is amazed by the dramatic increase in the levels of noise on the street, commenting more than once on the newly intensified 'rattle and buzz of the city',[60] with its thundering lorries and clanging 'electric cars'.[61] By his own admission, however, the biggest surprise was the relocation of the municipal art collection from the McLellan Galleries to the recently completed Kelvingrove Museum [FIG. 2.6], a development of which he had apparently been unaware until his return. 'The greatest shock of change that he received', the narrator tells us, was:

> in Sauchiehall Street. Where were the pictures of the city? He enquired anxiously, and was proudly told of the new galleries in Kelvingrove Park, and hurried thither, and seeing the stone [sic] Saint Mungo blessing those who entered, saluted him, for Glasgow's sake.[62]

The city's art collection, however, was not the only thing that had recently vacated the building on Sauchiehall Street, as by this time the School had been in its new bespoke premises on Renfrew Street

for several years. It is his father, the eponymous Justice of the Peace, who raises the subject over a reflective cigar in the comfort of his club:

> 'Well, Martin, have you been up to the… School of Art?'
>
> 'No, I haven't.'
>
> 'Ah! We have a school to be proud of. Fra Newbery has made something of it!' This with an accent of: 'I am well up with our art news!'
>
> 'He's a good man,' said Martin, 'with a genius for teaching. I hear Greiffenhagen has something to do with it now. I saw talk of it in a journal somewhere.'… 'Newbery is the director, Greiffenhagen is one of the professors,' said Mr Moir, 'Anning Bell is another. Caird tells me that Anning Bell is a big man there too, a fine draughtsman. They have visiting masters as well, just as you told me in your letters from Paris they have over there at the schools.'[63]

Whether Moir senior was aware of the significance of all these developments, and the advance this represented over the organisation that had been left behind at Rose Street, is difficult to say. Perhaps it was no more than a naïve attempt to convince his now famous son of the distance he had travelled in his appreciation of art since the days when he had regarded the profession as a 'mug's game' and all aspiring artists as destined for starvation. Either way, the fact that the School is so clearly part of the 'art news' of the city testifies to Newbery's success in raising its profile, and the role he had carved out for himself as one of the city's most prominent public figures.

By this time Frederick Niven had long since abandoned his own aspiration to become an artist and would soon be leaving Scotland to settle in Canada, with a new life and new landscapes to provide subject matter for his novels. Even his fictional creation, Martin Moir, will shortly after-wards meet a premature death, long before his promise as an artist would be fulfilled. But the conclusion of one narrative is often no more than a pretext for the start of another. The School of Art

conjured so vividly by Niven in his novel is essentially the one that remained rooted in the late Victorian period, in its old premises and with its teaching still dominated by the South Kensington system.

All that was about to change, and it is to the chronicle of the new School of Art, the one identified with Mackintosh's 'masterwork' on the summit of Garnethill, that we must now turn.

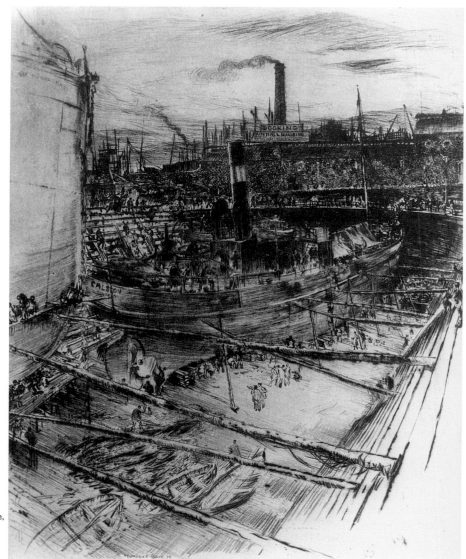

2.14 David Muirhead Bone, *Drydock*, drypoint etching, 1899.

Chapter Three

The Performing School of Arts: building Charles Rennie Mackintosh's masterwork

JOHNNY RODGER

It is understandable that many people who take a serious view of architecture find that the personality and legend of poor Mackintosh as a lonely, ignored and rejected genius gets in the way of a real appreciation of his buildings. A colleague of mine even suggested that I attempt to write about the design of the Glasgow School of Art building without mentioning his dreaded name. Perhaps that suggestion encapsulates rather neatly one partisan possibility in the inveterate Glaswegian dichotomy between the urban and the civic: the infamous buildings of the city and its notorious inhabitants. It has been a commonplace to assert that this city itself 'is the people' and not 'the buildings'. The corrective suggested here would seem to consist in ignoring the designer and taking account only of the cold stones. But is it possible in a study of a building that displays so much varied, irregular and multiform 'character' to ignore the design and artistic personality of its notorious author? Indeed Mackintosh himself says in one early lecture:

> The character of a style of art does not depend upon the mere material from which it has been fabricated, but upon the sentiments and conditions under which it has been developed.[1]

The School itself was completed in two stages: the eastern half in September 1899 and the western part 10 years later [FIG. 3.1]. The building faces Renfrew Street on its north side with massive square-headed lights occupying the full length of the otherwise sandstone main façade. The east and west elevations, also in sandstone, both turn back down the hill towards Sauchiehall Street, and the difference in their treatment reveals Mackintosh's development as an architect over that decade.

The east side, in snecked rubble, has a Baronial, castellated appearance with its oriel window rising into an octagonal tower, and a delicate interplay of heavy blocks of carved stone and window voids, while on the west is Mackintosh's mature *tour de force* [FIG. 3.2], with the three gridded windows rising over 60 feet across the sheer façade. The long façade facing south across the city is clad in harling, like an old Scots castle, and has windows of multiple dimensions spread in a variety of combinations across its soaring elevation.

Inside the building the studios are arranged in four storeys across the façade to gain the full north light from the massive windows and the glazed attic storey. The circulation corridors and stairs are disposed across the southern elevation [FIGS 3.3 & 3.4], warmed by the sun and distinctively patterned with light from the irregular window formations [FIG. 7.1]. What is surely most important about this building, however, is that it performs its function very well. Time and again critics and writers have commented on its appropriateness for

3.1 Charles Rennie Mackintosh, Glasgow School of Art, north and east façades, 1899–1909.

MPLETE PLANS°f THE
ASGOW SCHOOL°fART

FLOOR PLAN

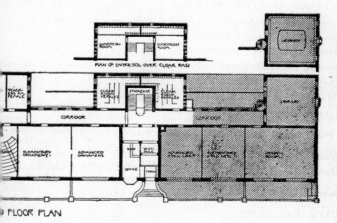

FLOOR PLAN

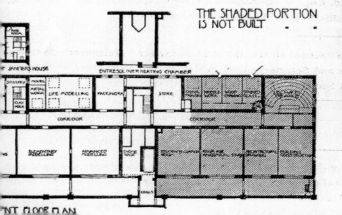

THE SHADED PORTION
IS NOT BUILT

NT FLOOR PLAN

its function, and the world-famous Dutch architect Aldo Van Eycke said that it is 'a superbly well adapted environment for art students'.[2]

But I will argue here that the understanding of Mackintosh's *oeuvre*, and of his reading of architectural history, is central to the comprehension of how this building works, and that misunderstanding Mackintosh's mode of operation was perhaps the client's greatest stroke. Glasgow School of Art is undoubtedly Mackintosh's masterwork, and indeed he developed into a mature master architect

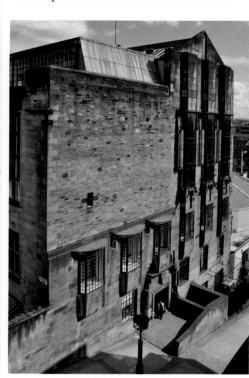

3.2 Charles Rennie Mackintosh, Glasgow School of Art, west façade, 1907–09.

Left
3.3 Charles Rennie Mackintosh, floor plans of Glasgow School of Art, 1907.

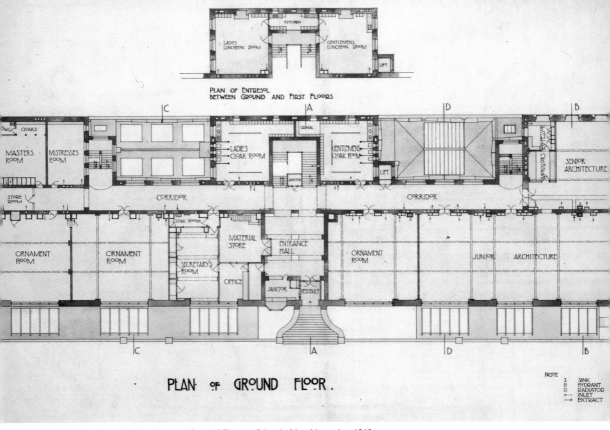

3.4 Charles Rennie Mackintosh, plan of ground floor of Glasgow School of Art, November 1910.

through building this work. But how did that come about? What made this project such a defining moment in his development?

Firstly, it is important to note that the client needed nothing more than a 'plain building'.[3] Francis Newberry, headmaster of the school then sited in a building around the corner on Sauchiehall Street [FIG. 2.13], was asked in 1896 by the Building Committee [FIG. 3.7] to prepare a block plan for the empty site they had acquired on Renfrew Street. This block plan was to show how the 'whole site might be utilized giving as far as possible the required dimensions of class rooms and relative accommodation for the working of the school.'[4] Newberry's completed plan was approved by Thomas Armstrong, the Director of the Science and Art Department at South Kensington, who was then in charge of art training across the country.[5] A schedule of 'Conditions of Competition' was then prepared and distributed to potential competitors that summer, and by October of the same year 11 sets of plans had been received from the 12 architectural firms that had been invited to compete.[6]

The entry from the Glasgow architectural firm Honeyman & Keppie, designed by their assistant Charles Rennie Mackintosh, was chosen as the winner. It is unclear (for reasons discussed below) to what extent any of the judges would have been aware that Mackintosh was the actual individual in the office responsible for the design. Nonetheless, by choosing this firm's design as the winner, a 'plain building' was ostensibly what the assessors got. In the written statement accompanying the drawings, the architect claimed that the 'useless

expenditure of money on mere embellishment has played no part' in the design, and that the 'accommodation has been arranged as far as possible according to the sizes and position suggested in the Conditions of the Competition.'[7]

In fact the winning architect also supplied a schedule with the entry, showing that the floor areas for the various types of room were almost exactly as the Conditions required, with the exception of the headmaster's accommodation and the students' lunch rooms, both of which were roughly 1½ times the dimensions stipulated. Among the very few alterations required in the disposition of the rooms was the re-location of the library from the basement (which was reserved in this version of the scheme for the School of Architecture) to the ground floor so that it would be more easily accessible to all users of the School. In this way not only did Honeyman & Keppie's plans for the building conform relatively straightforwardly to Newbery's requests, but the layout of the School was also very similar to those of other recently completed schools of art in Manchester and Liverpool, both of which had main classrooms on the north side served by a corridor on the south. The choice of winning architect was subsequently,

Top
3.5 Charles Rennie Mackintosh, drawing of 'wish-bones', identifying Honeyman & Keppie's competition entry, 1896.
3.6 Charles Rennie Mackintosh, poster design for the Glasgow Institute of the Fine Arts, 1895.

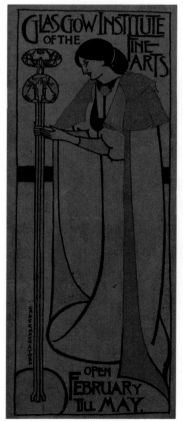

and independently, approved by Thomas Armstrong, who described the plans in a letter to the Governors as 'well suited to the requirements of your school' and 'better than what could be obtained from the other designers.'[8]

This competition win then, with plans for a 'plain building' that had won acceptance from the head of the School and the whole Board of Governors and Building Committee (containing lay figures and architects from the Glasgow 'establishment'), as well as the stamp of approval of the government-appointed controller of art education in London, presents a picture which could hardly be more at odds with the legend of Mackintosh as an ignored and rejected outsider. Yet despite this adequate fulfilment of the requirements for the School, and the satisfaction of the various bodies and judges involved, rumours that it was Newbery, Mackintosh's former teacher,[9] who promoted Mackintosh, and pushed for his drawings to be accepted, soon began to circulate and have persisted to this day.

It is true that for anyone who knew Mackintosh's work the motif of the 'wish-bones' [FIG. 3.5] and the graphic style decorating the frontispiece of the anonymous written submission would have been instantly

recognisable. And was there anyone in 1896 in Glasgow in any way knowledgeable about the art and architecture scene who would not have recognised it? After all in 1895 Mackintosh had designed the poster for the opening of the Glasgow Institute of the Fine Arts with exactly the same graphic style [FIG. 3.6], and that style had attracted enough attention to be satirised in a cartoon in the Glasgow *Evening Times*.[10] If the assessors (and governors) did not know of him they were quite out of the artistic and civic loop. If on the other hand, they knew something of Mackintosh's growing reputation, and did recognise the graphic style on the competition entry, they may either have been unsure of his real input, as an 'assistant' in a prominent firm, to the actual plans for this 'plain building', or been reassured by the fact that the scheme conformed so well and so rationally to the conditions of the competition.

At any rate, after various rounds of negotiation

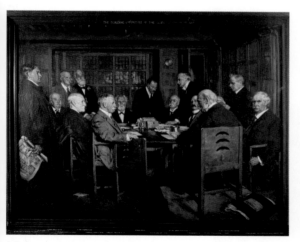

3.7 Francis H. Newbery, *The Building Committee of Glasgow School of Art*, 1913–14. Standing, from the left: Charles Rennie Mackintosh, David Barclay and J. M. Munro (all architects); Hugh Reid (railway engineer); John James Burnet (architect); John M. Groundwater (GSA Secretary). Seated: Col. R. J. Bennett; Sir Francis Powell (painter); Patrick Smith Dunn; James Mollison (Institution of Engineers and Ship Builders); Sir William Bilsland (Town Council); John Henderson (painter); Sir James Fleming; Francis Newbery.

the go-ahead to build was given by the surveyors. They recommended that only the eastern half of the building be proceeded with for the time being and costed it at £13,466.[11] John Keppie accepted instructions on 27 January 1897 to prepare drawings to 'decide what portion should be proceeded with'. The Memorial Stone was laid at a ceremony on 25 May by the Lord Provost, and a lunch menu at the Corporation Galleries included lobster, crab, *foie gras*, strawberries and pineapple and Heidsieck 1892 Champagne. The eastern part of the building was opened for the new academic year on 21 September 1899.

Throughout the period of building the first half of the School there had been no reference to Charles Rennie Mackintosh by name as the architect. Instead the firm for which he worked, Honeyman & Keppie, and in whose name he had submitted the competition entry, was given all the credit.[12] Accordingly it was John Keppie himself who had attended all the meetings with the client, and while Keppie was given a seat on the dais beside other VIPs at the opening ceremony, Mackintosh had to be content as a member of the public watching from the gathered crowd.

In the meantime however, Mackintosh's status both as an artist, designer and architect in the wider world, and specifically as the architect in charge of Honeyman & Keppie's design for the School, was changing rapidly. From the mid to late 1890s he was attracting the notice not only of patrons, but of critics, the art press and exhibition organisers. In 1897, articles on Mackintosh and his colleagues and friends had appeared in the *Studio*; in 1898 another article appeared in *Dekorative Kunst*; in 1900 he exhibited with great success in the Secession exhibition in Vienna; and he exhibited again in Vienna, as well as in Turin, in 1902. In his specifically architectural work he had been made a partner in the firm, now Honeyman, Keppie & Mackintosh, in 1901, and had completed a number of major

commissions, including the church at Queens Cross in 1897, the private houses Windyhill and Hillhouse in 1901 and 1904 respectively, the Willow Tea Rooms in 1903, the Daily Record building in 1904 and Scotland Street School in 1906.

Thus, if the assessors and some of the governors had not heard of Mackintosh when he submitted his design in 1896, then they certainly knew him, at least by reputation, when in 1906 the School decided to go ahead with completing the work on the western half of the building. For not only had Mackintosh in the intervening years been making his name as a prominent and somewhat maverick designer and architect round the city and abroad, but in 1905 he had been appointed to the judging panel for students of Design and Decorative Art at the School. But the final and definitive acknowledgement of Mackintosh as the architect of the building must be said to have come on 22 January 1907, when for the last time he attended the Building Committee in the company of John Keppie; thereafter it was Mackintosh alone who attended those meetings. This contrasts with the protocol for the building of the first stage of the building when only Keppie had attended the Building Committee meetings. [FIG. 3.7]

It is important to note that this public acknowledgement of Mackintosh as the architect came with a significant change in the client's attitude. The building of the first stage of the School had run over cost and was not in fact paid off until 1902. Were some of the governors searching around for a culprit to blame for the burden of this overspend, they might feel easier setting their sights on a junior partner rather than the Glasgow establishment figure that was John Keppie. Here was a maverick, Charles Rennie Mackintosh, whom they now knew to be in charge of their project; he was evidently no longer under the control of his senior partner, and they could also pin an overspend on him. They may have been wary and nervous regarding the future performance of their newly acknowledged architect.

Indeed the evidence of their behaviour points us towards this conclusion.

On 15 January 1907 (one week before the meeting that Mackintosh attended in the company of Keppie) the chairman of the Building Committee, Patrick Dunn, proposed to the Building Committee that the agreement with the contractors should incorporate the guarantee that:

> no alterations whatsoever should be made on same unless with the written sanction of the Building Committee.[13]

It may have been in some part in reaction to this warning, and in his reluctance to be pinned down to final designs, that Mackintosh, when officially asked a couple of months later to provide a complete set of plans, elevations and sections

3.8 Charles Rennie Mackintosh, letter on behalf of Honeyman, Keppie & Mackintosh to Building Committee, 15 March, 1907.

showing the existing part of the building and what was to be added, replied:

> We think it undesirable to commit ourselves to any elevational treatment until the general scheme of internal arrangement is approved...[14] [FIG. 3.8]

That the directors were worried, in their wish for a 'plain building' on budget, that this architect might attempt to exert his well-known wayward 'character' is clear: following a 'suggestion' by the architect and governor J. J. Burnet, they stressed their demand for 'no alterations' again at the Building Committee meeting on 22 January 1907,[15] and yet again on 10 September,[16] even as the foundations were being excavated a few metres to the west of the boardroom where the meeting took place. It seems clear now that the Beaux-Arts-trained Burnet had classically misunderstood Mackintosh's way of working.

Burnet probably has as good a pedigree as anyone who could be claimed as part of the Glasgow Edwardian architectural establishment, and it may be significant that it was he who stressed

the 'no change' requirement in the contract. His father had been a very important architect in Glasgow in the mid-19th century. At the age of 15 Burnet had gone to study at the École des Beaux-Arts in Paris, and by his late teens and early 20s he was designing big city buildings. Gomme and Walker say of him that he was 'the best known architect of his time', with 'a reputation that dwarfed Mackintosh's', and that 'his contribution... to the centre of the city' is the greatest by a single architect with the possible exception of Greek Thomson.[17] By 1906 he had completed many well-known buildings, including the Glasgow Institute of the Fine Arts [FIG. 2.5], the Glasgow Savings Bank and Charing Cross Mansions [FIGS 3.9 & 3.10], in addition to his work at the British Museum in London.

Burnet may not have studied at the School, but if membership of the Board of Governors was simply another manifestation of his 'establishment' credentials, then he could nonetheless be assured that the teaching of architecture in the School was, as we will see in Chapter Five, based on an entirely

3.9 John James Burnet, former Glasgow Savings Bank, Ingram Street, Glasgow, 1894–99. The complex sculpture programme was modelled by George Frampton, Newbery's trusted advisor in setting up the Department of Modelling, and carved by William Shirreffs, who was a star sculpture student at GSA in the 1870s.

3.10 A Beaux-Arts synthesis of architecture and sculpture: John James Burnet, Charing Cross Mansions, Glasgow, 1889. The sculpture programme, described by one critic as an 'insane wriggling and convolution', is by William Birnie Rhind, who acted an assessor in the Department of Modelling in 1902.

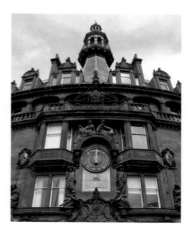

'orthodox' Beaux-Arts model. Mackintosh, on the other hand, can be viewed as a wayward and irreverent product of this system. Although Mackintosh too had been invited to serve as a judge of students' work for the first time in 1905, it is notable that during the 11 years he spent judging on and off, he served repeatedly on the panel for Design and the Decorative Arts and for Modelling and Sculpture, but it was not until the 1914/15 session, his second-last year of service as a governor, that he was asked to join the panel for Architecture. By that time not only had his partnership with Keppie been dissolved, but Mackintosh himself had already left Glasgow for England.[18] Of course Mackintosh was a polymath, and it could be that he preferred to interest himself in the other arts out-with his strictly professional life in architectural practice. But is it not likely that the School of Architecture left it so late to invite Mackintosh to serve as a judge because they viewed his unorthodox ideas and practices with mistrust? Burnet's attempt to control and restrict Mackintosh's room for manoeuvre on the design and building of the School could in that case be seen as yet another manifestation of a suspicious architectural establishment.

The Beaux-Arts tradition that dominated the School's architectural teaching depended on design organised through formal relationships of symmetry and a hierarchy of spaces, and above all on close attention to the programme, with its demand for those highly finished perspective presentations and meticulous scale drawings that are discussed in Chapter Five. It was indeed this rigorous tradition of drawing, and its remoteness from the actual materials of building, that was criticised in the report on the School by the sculptor James Pittendrigh McGillivray [FIG. 7.20] in 1905:

> My view is that the student of Architecture confines himself too closely to paper in his studies. I advocate that by means of a technical course he should be brought into personal contact with the materials for which he designs.[19]

But this criticism could hardly be said to hold for the wayward Mackintosh, the architect ignored by that very department. For Mackintosh had, among other things, a great interest in and involvement with the crafts and their materials, and he also operated with a more complex and open concept of the relationship between drawing and building. As William Buchanan says in Mackintosh's Masterwork:

> It is clear that Mackintosh regarded plans as an indication of intention rather than a solution to problems.[20]

But the real significance of this leap of faith between the plans and drawings as intention and the construction as actuality is that the design and construction becomes a performance in time, a pragmatic and proactive manipulation of spaces as they are gradually revealed rather than a robotic reading of instructions. As Andy MacMillan says in the same book, once the:

> basic plans and sections were completed, each part of the building was then subjected to examination then re-examination as detail design or building work proceeded, a process of tactical confrontation with the potential of each particular situation.[21]

For a fuller understanding of the theoretical under-pinning of this dynamic approach to design and construction we can look to Mackintosh's formative influences as an architect, and in particular at his interest in the Baronial style that flourished in Scotland in the period roughly from the 13th to the 16th century.[22] As early as 1891 Mackintosh gave a talk to the Glasgow Architectural Association in which he leant very heavily – some would say almost to the point of plagiarism – on the interpretation of the evolutionary phases of the Baronial idiom set out by MacGibbon and Ross in their book The Castellated and Domestic Architecture of Scotland.[23] Through these phases we can see the architecture adapting to historical needs and circumstance as they arise over centuries, rather than seeking conformity to a set of

exclusive and established rules of the kind we find in 'classical' architecture, with its canon of precepts regarding proportion, symmetry and so on. In his commentary on this lecture, Frank Walker points out that 'Mackintosh speaks of a versatile "grouping of parts" and a readily varied "external outline", both qualities resulting from an ability to respond to the contingent'.[24] Not only that, but through this process of building the structure itself is decoration, and a plastic poetics develops its own vocabulary and symbolic content, albeit grounded in functional necessity, such that these buildings develop as iconic images of great strength. Walker goes on to put Mackintosh's reading (and at this early stage it is still only a 'reading' rather than a performance) in the context of the 19th-century 'dilemma of styles'. To order the discussion Walker himself borrows Colin Rowe's conception of this dilemma as a problem for 19th-century architects in resolving the principles of 'composition' and of 'character', where composition refers to the rules for combining parts into an architectural whole, and character is concerned with the architectural expression of a building's symbolic or functional meaning.[25] As the 19th century was, especially in Britain, the great age of industrialisation, architects had to confront the need for new building types, such as railway stations, factories, large hotels and schools. As far as composition was concerned, the new structural materials and methods that came into being opened up a new range of possibilities, and the Beaux-Arts methodology for co-ordination of plans and sections developed to cater for buildings never seen before on such a vast scale. But when it came to the expression of their meaning – a language for the symbolic and functional content of these buildings – there was no historical precedent, and ultimately the Classical, the Gothic, the medieval and other 'styles' exploited by many 19th-century architects, lacked an adequate language of forms to express the functions required by modern society.

Whereas a Beaux-Arts-trained, Classical architect like Burnet was principally concerned with 'composition' – with the magnificently precise planning of the building, the strict and symmetrical relationship of parts to the whole, plan to section and so on – Mackintosh, through his interest in the Scottish Baronial, demonstrated an early and then abiding obsession with 'character' and a versatile sensitivity for the creation of particularised and expressive structure. Thus Burnet, rooted in his own great tradition, was clearly under a misapprehension if he thought that Mackintosh's more or less rigorous reproduction of Newbery's spatial layout in the plans meant that it was exactly those spaces that would be built; or that by placing the stricture of 'no alteration' on the plans there would be a guarantee that no wasteful 'spook' decoration would be added to the 'plain' plan as the construction work was carried out. For it is evident from what has been shown above, that for Mackintosh the drawings only signified intention. That is not to say that the drawings constituted a basic building form to be further decorated; rather they represented a structural intention in which, through the building process itself, the spatial character of the structure would be developed in a way that enabled it to adapt to particular situations as they arose, while at the same time expanding and enriching the symbolic vocabulary of the whole work.

There were at least two points in the building of the second half of the School between 1907 and 1909 when this misunderstanding – indeed conflict – in architectural approaches came to a head, and this is made clear in recorded clashes between the architect and client. The first concerns the design of the library, which in the final plans for the western section had been moved from the ground floor to occupy its present position on the first floor. It was also now to include a gallery. (Under this arrangement, the School of Architecture was reinstated on the ground floor as originally requested by Newbery

in 1896.) On August 8 1908, and despite the 'no alteration' stricture, Mackintosh made a request to the Building Committee to use oak instead of pine in the library, and estimated the difference in cost at £400.[26] The Committee requested that the decision be delayed 'until a later stage in the work'. Almost two months later Burnet asked for two sets of drawings of the library, one in oak and one in pine.[27] After a similar lapse of time Mackintosh submitted the drawings requested and the Committee said that they would give the matter further consideration.[28] At a meeting on 8 December 1908 the architect explained that the original cost of the pine had now increased by £90 or so, because he would now be building the gallery round four sides of the room – that is across the window wall as well as the other three.[29] In the meantime a dispute had started up as to the position and style of the librarian's office.[30] In late January the committee objected to Mackintosh that a glass office for the librarian was 'unsuitable', and objected also to the balcony being built across the window, as this meant that 'light would be lost'.[31] Two weeks later a letter of 2 February from Mackintosh was read to the Committee in which the architect declared that leaving out the glass office would save £36, whereas leaving out the window-side gallery would not save money at all but would cost *more* because construction on the other sides would have to be altered and its omission 'will to a great extent spoil the proportions and design of this room.'[32]

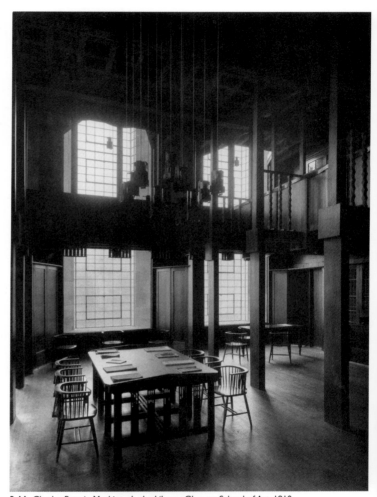

3.11 Charles Rennie Mackintosh, the Library, Glasgow School of Art, 1910.

The Committee insisted on leaving out the office but agreed to keep the balcony on the window side [FIG. 3.11]. And just as well, we might say, for the resultant delicate balance of structure and space and the subtle quality of light in this room with its tall windows, its gallery sporting carved abstractions of Ionic pillars in solid and void (echoing those in the Board Room where the committee sat), its forest

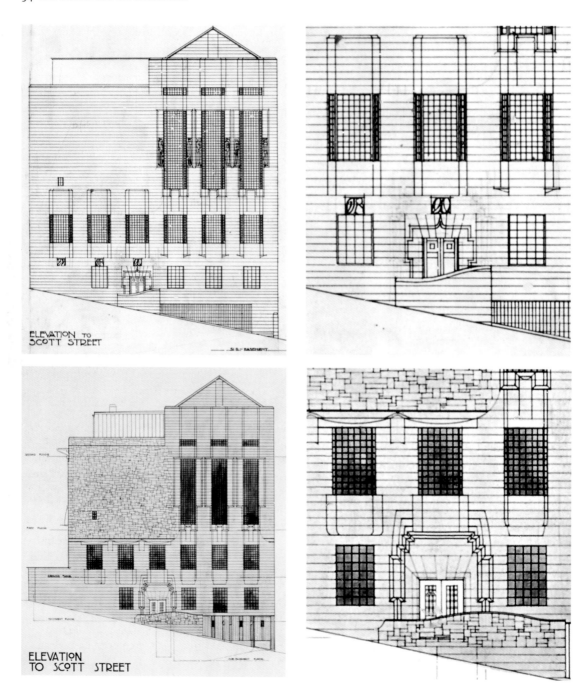

From Left to Right:

3.12a Charles Rennie Mackintosh, drawing of proposed west (Scott Street) elevation, May 1907.

3.12b Charles Rennie Mackintosh, west (Scott Street) doorway in its May 1910 version.

3.13a Charles Rennie Mackintosh, drawing of west (Scott Street) elevation, November 1910.

3.13b Charles Rennie Mackintosh, detail of doorway on west (Scott Street) elevation, November 1910.

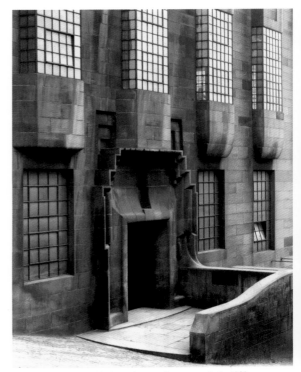

3.14 Charles Rennie Mackintosh, west doorway as built, 1909.

of uprights and its hanging lamps, are considered by many to make it one of the most atmospheric and intense spaces in Western architecture.

The second important and prominently recorded point of difference was the treatment of the west façade in general, and in particular the doorway to the basement level. Mackintosh was, as we know, reluctant to provide elevations, but if we examine the elevation of the west façade that he provided in May 1907, and compare it with the completed work we see quite a difference. [FIGS 3.12a, 3.12b, 3.13a & 3.13b] That there were indeed 'alterations' taking place on this façade, and particularly on this doorway, was brought to the attention of the Building Committee in an account of the progress of the building submitted on 7 February 1908.[33] Mackintosh was ill and did not attend the meeting, but the surveyor reported to the Committee regarding the Scott Street doorway, that he was:

> surprised to find that this work was carried out in an extravagant manner and not in accordance with plans and estimates which were submitted and signed.

The Governors' response was that they 'must decline all liability for any increase of cost', and on 27 February a letter was sent reminding the architect that the terms of their contract precluded their 'incurring any extras whatsoever without the written authorisation of the Building Committee.' The letter went on to add that 'the Governors regret the mistake you have made in this'.[34]

The Governors did not seem to be in any mood for compromise, and may indeed have felt vindicated in their repeated demands that there should be 'no alteration'. Mackintosh subsequently offered to make savings elsewhere on the building by using, for example, asphalt on the roof instead of lead. These alternative savings were at first rejected by the Board, but somehow their uncompromising mood crumbled, and we hear no more of their objections here. In the end Mackintosh had his way and the Scott Street entrance was built as a restless but super-refined essay in sculpted stone [FIG. 3.14] – an exercise in proto-Art Deco, one might say, or an ancient castle doorway, or maybe the closest-ever realisation of Goethe's definition of architecture as 'frozen music'.[35]

Perhaps the clients – the Governors and the Building Committee – had undergone a dazzling

revelation when they came to view this doorway. Did they suddenly realise that they had an architectural master on their hands, who could, and did, extemporise virtuosic spaces out of the simplest architectural ingredients? Who could conjure up a functioning whole that expressed at once an astonishing complexity *and* a reassuring integrity? Mackintosh himself haunts this building in the way the Phantom does the Paris Opera. (*The Phantom of the Opera* was a work first published in the same year that the School of Art building was completed). He emerges from the shadows in ubiquitous performance, subtle but insistent. And wearing a variety of different masks he allows this building to speak to us – but it always does so in his voice. Was it not indeed the most fitting recognition Mackintosh could receive, when subsequent to completion of the building he was among those commissioned to design the staging of the grand Masque at the official opening in December 1909? It was a low-key role perhaps, and shared with a foreground of autonomous performers – but what stage designer could wish for more?

Chapter Four

'Art is the Flower': the Department of Drawing and Painting[1]

GEORGE RAWSON AND RAY McKENZIE

The theatrical masque perfomed by the staff and students at the opening of the completed building in December 1909 was called *The Birth and Growth of Art*, and in it painting was represented symbolically as a rose.[2] Perhaps the idea of using a flower to embody this particular craft had come from Mackintosh, who had incorporated the distinctive 'roseball' motif [FIG. 4.1] into the stained glass panels in the doors of all the School's painting studios. The studios themselves occupied the whole of the first floor – the *piano nobile* – of

4.1 Charles Rennie Mackintosh, leaded glass 'roseball' motif in door to Studio 45, first floor, Glasgow School of Art.

the new building, which not only enabled them to take advantage of the steady light provided by their magnificent north-facing windows, but also subtly implied the superior status of painting, which by an unspoken convention was regarded by staff and students as the chief of all the arts. The effort by Fra Newbery to persuade the gifted silversmith Peter Wylie Davidson to become a painter confirms this,[3] as does the comment made to him by the painter James Guthrie in 1891 on seeing the young Mackintosh's sketches from Italy: 'But hang it Newbery, this man ought to be an artist'.[4] Even William Morris, that great champion of decorative design, referred to the craft disciplines as 'the lesser arts', maintaining that painting should be reserved for only the most gifted practitioners.[5]

The pre-eminence of painting was also reflected in the higher rates of pay commanded by the staff employed to teach it. In 1910, for example, the Professor of the Life School, Maurice Greiffenhagen [FIG. 4.18], received a salary of £500 for teaching three days a week over a period of six months, while his professorial colleagues in the Departments of Design and Sculpture were paid £450 and £250 respectively for teaching the same number of days throughout the whole academic year. Even the head of Architecture received £500 for full-time attendance all the year round, while Newbery, the Director of the entire School, was paid an annual salary of £800.[6] It may well be that the size of Greiffenhagen's remuneration was determined by the consistently higher number of students his department attracted. In the 1904/05 session it had 380 students on its register – 63 per cent of the total School enrolment of 598 – and the situation had not changed significantly by 1913, when it retained a 61 per cent share of the slightly higher overall intake of 763. But even this merely serves to confirm the greater importance attached to the department. However we look at it, painting was clearly the dominant medium in the School at this time.

We must not forget, of course, that Newbery was himself a painter of some distinction, and prior to 1900, when he had very limited resources at his disposal, it had fallen to him to run the life classes, which he did with help from the Glasgow Boy Thomas Corsan Morton, who also taught landscape painting. Preparation for the life class had been in the hands of Newbery's Deputy, James Morton Dunlop, who was otherwise in charge of drawing from the Antique and the study of anatomy [FIGS 4.2 & 4.3]. All this

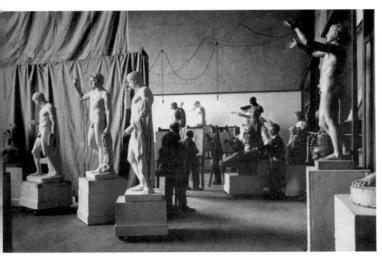

4.2 The Antique Studio (Room 38), Glasgow School of Art, c.1900. James Morton Dunlop is in the centre, with his back to the camera; James Gray is on the right.

would change in the new century when Thomas Armstrong, the government's recently retired Director for Art, submitted to the SED a 22-page report setting out the measures required for the School to maintain its position as one of Britain's leading art-training institutions. To improve the teaching of the figure he recommended that a special master should be appointed for the life class, and that he should be:

> a skilful and well-trained draughtsman, having had recent experience in making such figure drawings as are done in life schools... He should be able to draw well from the living model as well as from the antique, and should occasionally work before his class.[7]

In itself this was not an especially ambitious requirement, but it was a welcome move in the right direction, if only for allowing Newbery to withdraw from many of his front-line teaching duties and devote more time to the business of running the School. More importantly, Armstrong's modest suggestion, once it had been approved, gave Newbery the pretext to establish a fully-fledged Department of Drawing and Painting, precipitating

in turn a series of further appointments that would enable him to realise his cherished ambition of bringing the School into line with the best art institutions in Europe. In May 1900, the post of life-class master was accordingly advertised in journals published in London, Brussels, Paris and Amsterdam.[8] Academic draughtsmanship, but also figurative composition, were areas of work that were particularly well taught in the continental Beaux-Arts system, the centre of which was Paris, and so it was to the French capital that Newbery made his way with a deputation of governors in October of the same year. Here they were able to visit the city's *Exposition Universelle*, the most significant event in the art world that year, in which a display by a group of their own students had been awarded a gold medal.[9] With characteristic efficiency, Newbery used the visit as an opportunity to do some scouting for continental sculptors in anticipation of the similar International Exhibition that was being planned for Glasgow in 1901, and which he was helping to organise (see Chapter Seven). More to the deputation's immediate purposes, however, they were able to examine the figurative work of the one of the most talked-about European artists of the day, the Belgian Symbolist painter Jean Delville (1867–1953), whose extraordinary canvas *L'Amour des Ames* [FIG. 4.4] was on display, together with the sketches for his cycle of three large mural paintings of *The Triumph of Civilisation*, destined to be installed shortly afterwards in the Royal Museum of Central Africa at Tervuren, on the outskirts of Brussels. They were sufficiently impressed by all of this to take steps to arrange a meeting with the artist

through the agency of the sculptor Charles Van der Stappen (1843–1910), the head of the École des Beaux-Arts in Brussels,[10] where five years earlier Delville had won that most prestigious of all academic awards, the *Prix-de-Rome*.[11] There appears to have been little doubt in Newbery's mind that Delville was the man he was looking for.

And the governors were no less enthusiastic about Delville's appointment, as is evident in the readiness with which they were prepared to meet the detailed and somewhat exacting conditions he himself imposed before accepting their offer. To begin with, the proposed salary of 5,000 francs (£200) was quite inadequate, given that the programme he was expected to teach would require a:

> great expenditure of energy and vitality especially as I give a course... with all my conscience and all my artistic talent so as to render to your youthful students real and true service. My only care is to be able to give those courses a high artistic character and in order to do this I must keep myself in good condition from all points of view. If you will largely increase my salary I am your man for I feel myself capable (and I say it without vanity) to exercise a strong influence on your students and to give a new push to your academic teaching.[12]

As part of the regime to keep himself 'in good condition' he expected the School to help him find a furnished apartment with three rooms in a 'quiet and healthy place and with plenty of fresh air',[13] as well as a studio and a supply of models so that he could begin work right away on a large canvas, doing the sketching work while he was in Glasgow in the winter. There was also the expense involved in bringing his wife and children – two girls and a boy, aged '6¼, 5, & 2 years respectively' – over from Brussels, as well as the cost of running a studio. By his calculations, a minimum of £320 would be necessary to make coming to Glasgow worthwhile. There were some eyebrows raised by the size of the increase he was demanding, but otherwise the governors acceded to his requirements without complaint.[14]

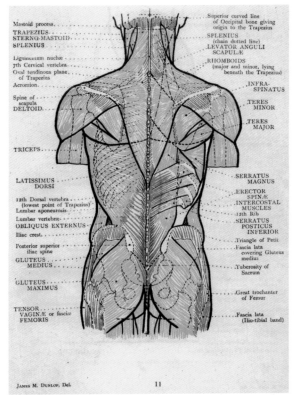

4.3 James Morton Dunlop, illustration from *Anatomical Diagrams for the use of Art Students*, London, 1899.

The appointment was certainly a bold move. As a leading member of the Belgian Symbolist movement, Delville had exhibited regularly in the 1890s with the *Salon de la Rose + Croix*, and it may be that the governors were reminded of the work of Mackintosh and The Four, whose 'Spook School' paintings and graphic designs of the same period had been influenced by the style of other continental Symbolists, such as Jan Toorop and Carlos Schwabe. The difference is that Delville was much more deeply immersed in the esoteric philosophy that drove the Symbolist project, and much more committed to the idea of the artist as a shamanistic

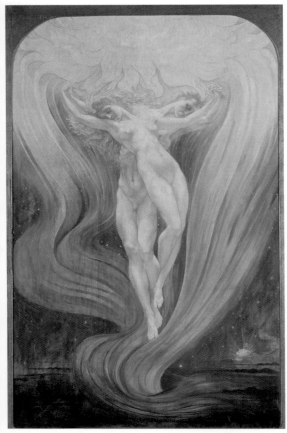

4.4 Jean Delville, *L'Amour des Ames*, tempera on canvas, 1900.

gestating for his written manifesto on the role of the artist in the modern world, and which appeared in 1910 under the title *The New Mission of Art: a study of idealism in art*.[16] The mission was indeed an elevated one, and for Delville the primary means through which it was to be achieved was the depiction of the naked human figure. 'The *nude*', he declared:

> is the *alpha* and *omega* of aesthetics. All the science possessed by the artist is summarised in it. It is fitted to summarise the most profound emotions of the soul.[17]

Not surprisingly, the nude features heavily in almost all of Delville's major paintings, and the burden of his teaching was to use the life class to impress upon the students the true seriousness of the artist's vocation. As a committed Theosophist, and drawing much of his inspiration from the idealism of Platonic philosophy, he conceived art as a process of striving towards Beauty, which he defined as the 'Synonym of Truth', and which for him constituted the very essence of existence, the embodiment of the universal harmony through which the equilibrium of the cosmos is maintained.[18] The task of the artist is to penetrate surface appearances and extract this spiritual essence from the material world:

> Nature is not art, but art is concealed in Nature like a supernatural treasure. Genius lies in seeing the glitter of this treasure through the physical density of matter... The spirit [of the artist] seeks or guesses at the spirit of Nature, which is the secret beauty of things, the essential image beneath the image of substance, the subjective form under the objective form, the unseen in the seen.[19]

For the successful realisation of Beauty in a work of art three attributes had to be present: 'Spiritual Beauty', in the form of a 'lofty conception or idea'; 'Plastic Beauty', the perfection of the forms extracted from nature; and 'Technical Beauty', the 'realizing of the two previous principles in a perceptible form'.[20]

figure with a responsibility for the spiritual salvation of mankind. The painting *L'Amour des Ames* that had so impressed Newbery and his travelling companions – and which Delville exhibited at the RGI in 1904[15] – is no mere decorative fantasy. It is a manifestation of his belief in 'palingenesis' – a concept derived from the then fashionable doctrine of 'Theosophy', and which involves the survival and perfectability of the soul as it strives towards the Truth. Delville worked at the School from 1900 to the end of 1905, and it was during this time that the ideas were

Delville was evidently in earnest when he promised the governors that his course would have a 'high artistic character' – so much so, indeed, that one wonders whether Newbery got rather more than he had bargained for when he set this remarkable Belgian mystic among his students. Newbery's own rather more pragmatic understanding of art had been set out very clearly a few years earlier in his introduction to a book on the Glasgow Boys, whose painterly experiments were successful, he claimed, precisely because they '[attempted] neither revolution nor revelation'. 'These Scottish artists', he went on, 'desire to be neither prophets nor preachers, nor do they attempt that which Art should ever have left to the pulpit – namely, the task of conversion.'[21] And yet all the evidence suggests that Delville was both a welcome and beneficial presence in the School, and that his convictions regarding the social role of the artist were as central to his contribution to the School as his undoubted mastery of pictorial form. Even his less than perfect command of English turned out to be no impediment to his effectiveness as a teacher, although this did involve the School in the additional expenditure of ten shillings per week for the services of an Italian named Fernando Agnoletti to act as his interpreter.[22] Interestingly, this was commented upon by the sculptor James Pittendrigh Macgillivray [FIG. 7.20], who was commissioned to inspect the School in 1904, and who felt distinctly uncomfortable with the fact that the course – like so many others in the School at the time – was being run by an artist who shared neither the culture nor the language of the students he was teaching (see Chapter Seven).[23] This view, with its implicitly nationalistic overtones, was repudiated, however, by one contemporary commentator, who saw the language barrier as having a positive pedagogic value of its own:

Foreign professors of recognised ability in their respective branches of art have now been placed in charge of the higher departments [of the School],

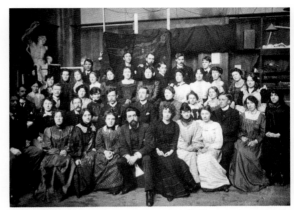

4.5 Drawing and Painting class, with Jean Delville (front row centre) and Fra Newbery (extreme left); Annie French is sitting on Delville's left, c.1904.

and their influence is evident, especially in the figure composition work, which is of an unusually high order of merit. Inability to converse with students in their own tongue is here seen to be no drawback, and the very silence of the tuition is an eloquent testimony to the universal language of art in its appeal to the understanding, and furnishes an additional proof, if that be required, of the fact that the voice is best replaced by the hand in art education.[24]

All this was perfectly in line with Newbery's profound belief in the value of teaching by demonstration and example rather than by explanation. Some years later, he was forced to discipline another member of the painting staff, James Huck, whom he described as having a 'weakness for talking and theorising', claiming that the drawbacks of this 'non-educational procedure' were evident in the inferior quality of his students' work.[25] No such charge could be levelled at Delville. However limited his powers of verbal expression may have been, he seems to have had a positive and beneficial impact on the work of his students, some of whom were producing allegorical works in a Symbolist vein that were mature enough to be reproduced in the pages of the Studio [FIG. 4.6].[26] Delville encouraged his students to make life-size

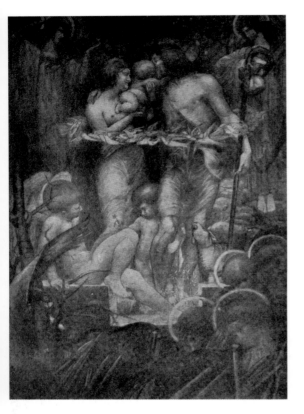

studies from both the model and the Antique, the results of which were often so striking they were singled out for special commendation by Sir Robert Rowand Anderson, when he inspected the School for the SED in 1906 [FIG. 4.7].[27] A group of life drawings by Delville's students exhibited in December 1904 were described by a reviewer in the *Glasgow Citizen* as 'very powerful', although there were adverse comments from some visitors who were concerned about the effect of such work on public morals.[28] Doubtless it was not just the unusual size of the drawings but also the air of 'decadence' that almost always accompanied the Symbolist treatment of the nude that was the cause for disquiet. Overall, Delville appears to have been a powerful force in the School, and perhaps it is no surprise to read in Clifford Bax's biographical note in *The New Mission* that when the painter returned to Brussels in 1905, 'a large number of his former pupils went oversea [*sic*] to follow him.'[29]

The School's obvious satisfaction with Delville's performance, and the helpful advice that had been given by Van der Stappen in his recruitment, prompted Newbery to enlist the aid of both a short time later when he began a search for another master to improve the teaching of the Antique classes. This turned out to be Paul Artôt (1875–1958), who was appointed in September 1902, after Newbery, in a second round of continental head-hunting, had interviewed him in Florence [FIGS 4.8, 4.11 & 4.12].[30] Artôt not only knew Delville but was also a member of his Symbolist circle,[31] and was no less deeply committed to the representation of the nude, producing work that is characterised by the same challenging combination of spiritual and libidinal potency [FIG. 4.9]. It was, however,

Top
4.6 David Broadfoot Carter, *Composition: 'Peace'*, reproduced in the *Studio*, November 1903.

4.7 William MacArthur, *Two Male Nudes Driving a Wheel*, pencil on paper. The drawing is signed and dated 9 February 1906. In March of the same year, the architect Rowand Anderson inspected the School and singled out for special commendation a 'group of nude figures driving a wheel before them'.

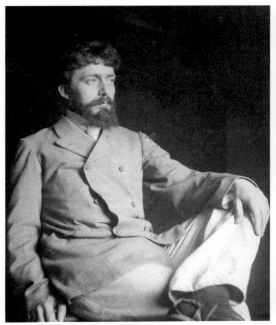

4.8 Paul Artôt, c.1904.

primarily as a master of painting and drawing
method that he made his contribution to the
development of the department. As an artist trained
in the techniques of fresco and tempera painting,
and an admirer of the precise, linear style of the
French neo-Classicist Jean-Auguste-Dominique
Ingres, Artôt guided the students in the production
of elaborately shaded drawings using chalk pencils
rather than the more conventional charcoal.[32]
[FIG. 4.10] This approach, which was designed to
respond to the subtlest nuances of form, served as a
perfect preparation for Delville's classes, and the
arrangement seems to have worked so well that the
Governors were soon able to report to the SED that
the appointment of both new professors had been
'an unqualified success'.[33]

Some sense of the overall shape of the drawing
and painting programme can be gained by reviewing

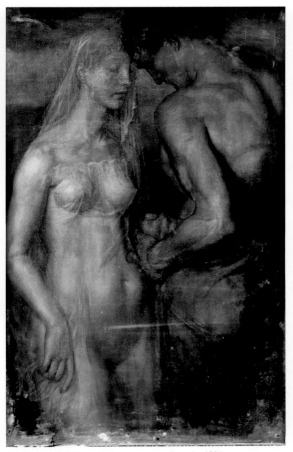

4.9 Paul Artôt, *Crépuscule*, tempera on cardboard, c.1906.

the various stages through which the students were
expected to pass – the 'Groups' referred to in
Chapter One. Drawing from life and the Antique
were absolutely fundamental to the process, and in
this respect the course remained broadly similar to
pre-1900 practices.[34] And like under the old regime
the approach was progressive. Students in Group I
began by drawing ornamental reliefs, learning to
represent them firstly in outline and then in light
and shade. They would also draw flowers and

4.10 Paul Artôt, *Portrait of a Boy*, red chalk, n.d.

foliage and other natural objects, as well as the interior and exterior of buildings. Painting was restricted to still-life subjects composed of 'simple objects', and all the practical work was supported by lectures on geometry and perspective.

It was not until Group II that the students were introduced to the drawing of the figure from the cast [FIG. 4.2] and, concurrently, to its anatomical structure, which was explained with reference to the surface forms of examples from the Antique and from life. Painting continued to include still life, but the students were now also expected to paint interiors, which until then they had only drawn. The lectures in Group II were devoted to the history of architecture and the principles of ornament, thus grounding the students in the decorative function of painting in relation to architecture.

Group III continued the course in drawing from the Antique, but now combined this with life studies from the full-length figure and from the head. The anatomy course was also taken further through the study of variations of form corresponding to the movements of the life model. Drapery studies were undertaken, as well as still-life, interior and landscape painting, and studies from the living animal. On Morton's retirement this class was taken over by Artôt, who supervised the study of animals ranging from poultry, via horses from the local tram depot, to camels, elephants and zebras from the municipal zoo, all of which were brought to the School and housed in the animal room at the eastern end of the basement.[35] The lectures in this Group covered the history of painting and of sculpture.

Finally, in Group IV, while drawing from the life remained a central activity, the painting classes were

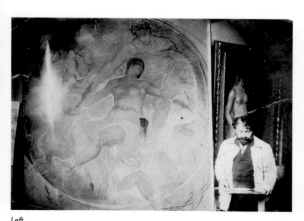

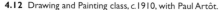

Left
4.11 Paul Artôt in his studio in Glasgow, c.1907. His painting *Crépuscule* can be seen in the background.

4.12 Drawing and Painting class, c.1910, with Paul Artôt.

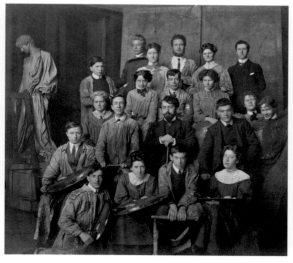

extended to embrace the human figure, the living animal and draperies. As the most advanced part of the course, Group IV also concentrated on figure composition, both for easel pictures and for large-scale decorative schemes. The status of composition as the culmination of the painting course was spelled out in the School's *Prospectus* for 1903/04:

> Composition is itself perhaps the most important part of an artistic education, because it is the synthesis, or gathering up of all knowledge previously gained, and it has for its end the development of the higher faculties which, sooner or later, every artist must possess.[36]

In the actual teaching of composition, no less than the representation of the life model, the approach embodied an understanding of the visual arts as a single, unified field of endeavour, a concept that mirrored both British Arts and Crafts and continental Beaux-Arts ideology.[37] But this was underpinned by the equally firm conviction that painting was a craft as much as an art, and this was enforced by the introduction of technical studies in the properties of painting materials, including lectures on the chemistry of pigments and practical classes in the various processes of painting, such as tempera, fresco, distemper, casein and waterglass. These classes would become the responsibility of another Belgian from the Delville circle, Georges-Marie Baltus [FIG. 4.13], an artist and lecturer on art, who had originally come to Newbery's attention when he was beginning to consider strengthening the teaching with the introduction of art history lectures in 1905 (see Chapter One).[38] As well as being a personal friend of Artôt [FIG. 4.14], Baltus was also a close associate of the German sculptor and theorist Adolf von Hildenbrand, whose daughter Sylvia he married and whose influential treatise, *The Problem of Form in Painting and Sculpture*, he translated into French in 1903.[39]

Baltus was initially recruited on a part-time basis, but his wide knowledge of the history and theory of art, as well as his extensive experience in different painting techniques [FIG. 4.15], clearly made him a great asset to the department and his post was eventually made full-time in 1909.[40] He remained on the staff until the outbreak of the Great War, by which time he had published a practical treatise of his own, *The Technics of Painting*, though this was a primer aimed principally at younger artists.[41]

Although the broad structure of the curriculum, nurtured with such care by Newbery, remained more or less consistent during this period, there were some important changes in the senior staff and these inevitably brought with them significant shifts of emphasis in the teaching style – clear evidence of Newbery's willingness to respond to the advice of his professors. When Delville resigned in December 1905, for example, he was succeeded by Maurice Greiffenhagen (1862–1931), an Englishman from London who had been trained in the Royal Academy Schools. As a portraitist and allegorical painter, he produced work that was very different from that of his Belgian predecessor, combining late Pre-Raphaelitism with Spanish influences in a way that had been well received at the Royal Academy and the New English Art Club since the 1880s

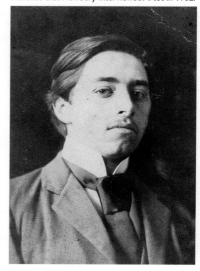

4.13 Georges Baltus, c.1904. The photograph, by Alinari, was taken in Florence, where Baltus and Artôt were often guests at the villa of the German sculptor Adolf von Hildebrand. It was also in Florence that Newbery interviewed Artôt in 1902.

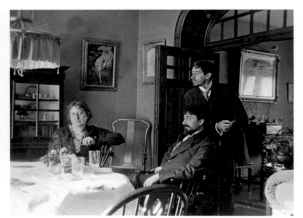

4.14 Paul and Louise Artôt with Georges Baltus, in their apartment at 19 Avenue Maurice, Brussels, c.1910. Louise Artôt was the daughter of the Dutch painter Hendrik van der Hecht.

Right
4.15 Georges Baltus, *Titania*, tempera on canvas, 1913.

[FIGS 4.16 & 4.17]. He was also a prolific illustrator and graphic designer, and a draughtsman of great ability.[42] Significantly, Greiffenhagen had been chosen from a field of candidates suggested by the School's contacts in London and Belgium,[43] and which included another Belgian, Emille Motte, who had in fact been recommended by Delville. As the head of the École des Beaux-Arts at Mons, he came with impeccable pedagogic credentials, and yet Newbery found his work to be 'correct, academic, but not very inspired' and felt that he was not 'an artist capable of stimulating his pupils to still greater efforts'.[44] The departure of Delville left some very large shoes to be filled, but in the end it was Greiffenhagen, who had very limited experience as a teacher, to whom the post was given [FIG. 4.18].

Among the changes made by Greiffenhagen to the curriculum was an attempt to diversify the student experience, and to accelerate the learning process by introducing more advanced elements at an earlier stage. Under his watch Group I included anatomical studies and modelling, the latter a

subject that Delville (in defiance of the advice of Macgillivray) had maintained was unnecessary.[45] Working from the living model was also begun earlier, with studies from the head in Group I, followed by details such as hands and feet in Group II, all leading as before to the study of the whole figure from life in Group III. Composition was also encouraged from Group II onwards, and was taught in true Beaux-Arts fashion through the setting of weekly subjects that were then presented for criticism. By the time the students were in Group III they were required to submit composition sketches indicating the colour scheme for critical feedback, and after carrying out whatever improvements might be suggested by the Professor, they would then, under supervision, work these up to full-scale cartoons employing models, drapery studies, architectural features and landscape backgrounds from nature. The cartoons were then developed into paintings.[46] By this time composition had became a mandatory requirement for all students submitting for the Diploma. The School's deference to Beaux-Arts practice in this aspect of its

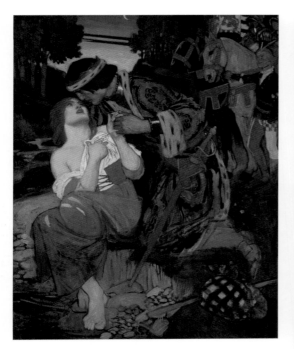

work is confirmed by Mackintosh's plans for the building extensions of 1907, which clearly indicate a series of spaces set aside for Diploma composition work. These are referred to as *loges*, a word derived from the French practice of providing special facilities for students presenting for examination, in particular for the *Prix-de-Rome*.[47]

Although Greiffenhagen had some ability as a master of decorative figure composition Newbery employed him in this area in collaboration with successive professors of design, W. E. F. Britten and Robert Anning Bell, both of whom had experience in working on major buildings. Baltus, with his expertise in mural techniques, also taught the subject. For Newbery, however, this rather haphazard approach to the teaching of composition was unsatisfactory, and in October 1913 he appointed a new professor with specific responsibility for the composition classes of the Diploma students.

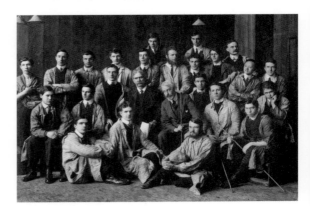

Top Left
4.16 Maurice Greiffenhagen, *King Cophetua and the Beggar Maid*, oil on canvas, c.1920–25.

4.17 Maurice Greiffenhagen, *Portrait of a Lady*, chalk on paper, n.d.

4.18 Drawing and Painting class, c.1910, with Maurice Greiffenhagen.

This was Frederick Cayley Robinson (1862–1927), a well-established English artist who had evolved – through his study of artists as diverse as Andrea Mantegna and the modern French muralist Puvis de Chavannes – a style of firm but exquisite linearity that could be adapted equally well to book illustration, easel painting and large-scale decorative schemes. At the time of his appointment he had recently scored a major success with his designs for the costumes and stage sets for a production at the Haymarket Theatre of *The Blue Bird* by Maurice Maeterlinck – yet another member of the Belgian Symbolist circle – and was in the process of carrying out a cycle of four large mural panels with the generic title *Acts of Mercy* in the entrance of the Middlesex Hospital in London [FIGS 4.19 & 4.20].[48] Newbery made no secret of his profound admiration for this 'fine Artist with a fine and distinguished style', and rightly regarded his appointment as a major coup for the School.[49]

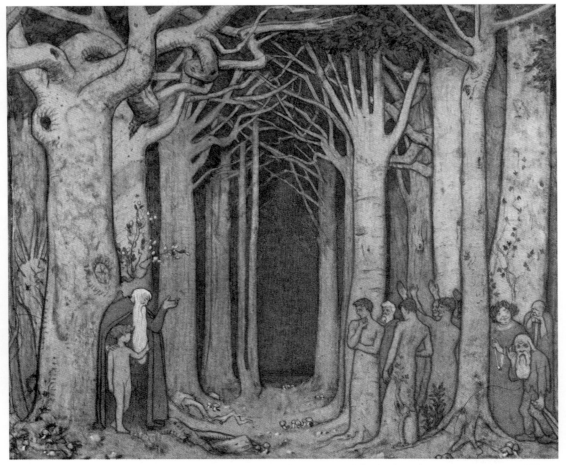

4.19 Frederick Cayley Robinson, *The Oak Addresses the Spirits of the Trees*, from Maeterlinck's *The Blue Bird: a fairy play in six acts*, London, 1911.

As it happens, the arrival of Cayley Robinson came at a critical moment for the Department of Drawing and Painting, and was part of a radical shake-up that Newbery initiated after identifying a number of weaknesses in the course provision, the details of which he outlined in a report to the School's Staff Sub-committee in October 1913.[50] It is clear from this, as well as other contemporary documents, that a number of staffing issues were coming to a head at this time, and that some serious blood-letting at a senior level was going to be needed to put matters right. The most high-profile casualty was the Professor of Sculpture, Johan Keller, who was dismissed in April for alleged incompetence (see Chapter Seven). In the Painting Department, the difficulties were focused principally on Paul Artôt, who, as we have seen, was appointed in 1902 in the first wave of expansion after the School achieved independence from South Kensington.

All the evidence suggests that the then 25-year-old painter performed perfectly well to begin with – well enough for the Governors to agree to his request for an increase in his salary from £200 to £250 within a year of his appointment, with a further addition of £30 agreed in May of the following year.[51] By 1909, however, things had started to go very wrong for him, and although it is difficult for us now to identify precisely why Newbery felt it necessary to have a 'serious talk' with him in October of that year,[52] the upshot appears to have been a decision to confine his teaching solely to the Antique class, with his contribution to the Life School limited only to the evening students. This seems to have brought about a noticeable improvement in his performance, as is clear from the somewhat ambiguous assessment of it by Newbery in March 1910:

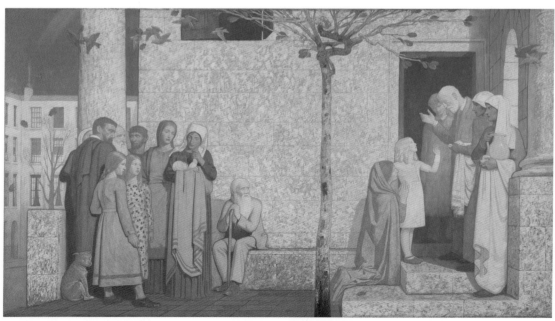

4.20 Frederick Cayley Robinson, *Acts of Mercy: the Doctor*, oil on canvas, 1916.

With Mr Artôt's work I am pleasantly disappointed. I had expected to see it as usual poor, unachieved and wanting in strength, and direction, but the bulk of the studies showed that a distinct effort had been made to obtain a direct result and the effort had been successful. With one or two qualifications I should speak of his portfolios as sound, progressive and informed, and the Members of the Jury share my opinion.[53]

According to Newbery, he was a 'new man' as a result of these arrangements. But the improvement was only temporary, and after another request for an increase in his salary in 1911 was turned down,[54] the relationship between Artôt and his employers seems to have descended into bitterness and recrimination, culminating in a letter from the governors in June 1913 demanding his resignation.[55] For his part, Artôt was deeply hurt by the way the matter was handled by the School, and with some

justice. The letter was sent to his apartment in Avenue Maurice, Brussels [FIG. 4.14], while he was working in Florence and it was not until he returned to the Belgian capital in September that he realised that for the past three months he had been without a job. He was, in effect, dismissed *in absentia*, and without notice after nearly a decade of service – rather like being fired by text message today.[56] As an example of its management of what we nowadays call a 'human resources' issue, this was not the School's finest moment.

One of the curiosities of this episode is that Artôt was beginning to achieve a measure of recognition as an independent artist at just this time. In February 1912, for example, he exhibited at the 12th Salon of the *Cercle Pour L'Art* in Brussels, where his painting *Les Poissons Rouges* [FIG. 4.21] so impressed the King and Queen of the Belgians that he was invited to the Royal Palace to discuss arrangements for its purchase.[57] The event was reported in the Scottish press in an article headlined 'Honour to Glasgow Artist', accompanied by a fine portrait from the studio of Lafayette.[58] Buoyed up no doubt by this upward turn in his professional fortunes, he put in a request to the governors in May of the following year to have his contribution to the daily slog of the Antique Class reduced so that he could make a bigger contribution to the teaching of composition, a subject he had embraced with enthusiasm almost since his appointment on the grounds that it stretched his students' imagination.[59] By this time, however, Newbery had already made his own evaluation of the weaknesses of the composition class and decided on the course of action that would lead to the appointment of Cayley Robinson. As we know from the passage quoted above from the 1903/04 *Prospectus*, the School's official view of composition was that it was the 'synthesis, or gathering up of all knowledge previously gained' – the culmination, in other words, of the advanced students' entire programme of study. In principle,

4.21 Paul Artôt, *Les Poissons Rouges*, oil on canvas, c.1911. The painting was purchased by Albert I, King of the Belgians, in 1912, but re-acquired by the Artôt family in the 1960s. The very fine frame was made by John Gibson of 112 Bothwell Street, who studied gilding and modelling at the School from 1895 to 1898. He also regularly made frames for Fra Newbery.

this is exactly as it should be, but in practice it meant that tuition in the subject did not begin until the point in the academic calendar when Greiffenhagen had completed his teaching for the year and was returning to London to resume his own work as a portrait painter. This posed a very special dilemma for Newbery. On the one hand he recognised the importance of allowing senior staff to maintain their professional practice, and expected them to work in the School for only six of the nine months in the academic year.[60] But he was also by now aware that there were serious deficiencies in this arrangement. 'Composition', he wrote in his report to the Governors in October 1913:

> is delayed until Mr Greiffenhagen leaves about the middle of April, and then the whole of the upper Life classes fall on to my hands. Compositions are begun, worked upon, hurried through, patched up and presented to the Judges in the month of June. Last session Mr [Anning] Bell and I spent hours in the composition studios. The best students were successful: those who were weak failed and in these latter cases it was because the students were incapable of carrying out their own ideas and had a poor conception of what composition really means. I feel this haphazard execution of what is really the summing up of the students' knowledge and talents is not sound organisation. Compositions should not be done at the fag end of a session, nor should they be hurried through in a manner similar to that of cramming for an examination. They should be part and parcel of every student's training and done in a traditional and workmanlike way.[61]

One of the reasons Newbery was so insistent on this – and so honest about what he saw as the failings of the course – was because he regarded large-scale decorative figure composition as potentially the most effective way for the School to contribute to the artistic life of the city. The fact that there was an expectation that the School should provide decorative schemes for public buildings is implicit in the address by Sir Francis Powell at the School's Annual Public Meeting in 1902, the first to take place after achieving independence as a Scottish Central Institution. It was right, he claimed, that the City Council should support the new School with a subvention of £1,000, because it was the duty of the city to 'enable merchants to avail themselves of the best and most beautiful art to produce decorations'.[62] As far as large-scale public schemes were concerned, the School had scored a notable success in the previous year, when two of its former students, John Dall and David S. Neave, painted the 32 figures that decorated the inside face of the great dome of the main temporary hall of the 1901 International Exhibition in Kelvingrove Park [FIG. 4.22]. The process of producing and installing the canvases for this commission, which included colossal angels with a wingspan of 23 feet, was a newsworthy event in itself, and along with the equally audacious plaster sculptures by another former student, Albert Hodge, in the space below, provided a very visible confirmation of the civic role the School could play when the opportunity arose.[63] [See FIG. 7.20 & Chapter Seven]

4.22 John Dall and David S. Neave, dome paintings for the Glasgow International Exhibition, 1901, oil (?) on canvas, from *Glasgow Daily Mail*, 18 February 1901.

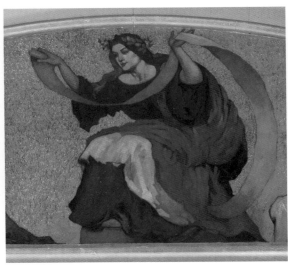

Left
4.23 William Findlay, River Clyde, oil on canvas (?), 1911, Banqueting Hall,
City Chambers, Glasgow.
4.24 David Forrester Wilson, *Glasgow Unfolding her Plans for the Future*
(detail), oil on plaster (?), 1911, Banqueting Hall, City Chambers, Glasgow.

Even more in the public eye was the School's
contribution to a series of decorative schemes for
public buildings that followed each other in quick
succession about 10 years later, beginning with a
pair of commissions in 1911 to complete the cycle
of wall paintings in the Banqueting Hall of Glasgow
City Chambers that had been begun in 1899.
These included four personificiations of the rivers
of Scotland in panels over the doors of the west wall
by William Findlay, who had studied at the School
in the 1890s, and an allegorical representation of
'Lady Glasgow' in the lunette above them by
Greiffenhagen's assistant David Forrester Wilson
[FIGS 4.23 & 4.24].[64] The subject matter here,
more correctly known as *Glasgow Unfolding Her Plans
for the Future*, is a particularly forceful example of the
School channelling its creative energies to civic and
patriotic ends.[65] But by far the most complete
manifestation of this impulse to contribute to the
public culture of the city is the School's response to
an invitation in 1913 to provide mural decorations
for two of the buildings in Glasgow's network of
local branch libraries, one at Possilpark and the
other at Langside. The outbreak of the First World

War prevented the latter – a 21-foot panel by
Greiffenhagen depicting the Battle of Langside –
from being carried out until 1921 (see Chapter Six),[66]
but the Possilpark scheme was brought to
successful completion in January 1914 [FIG. 4.25].[67]
A modest enough achievement when compared to
such schemes as the Banqueting Hall, it was never-
theless an important breakthrough for the School,
and the panels in it were described by Newbery as
'the first pieces of work that have been carried out
as compositions should be treated.' Significantly,
this remark was made in the context of the report by
Newbery that has already been cited, and through
which he attempted to reform the composition
classes. 'Composition', he goes on, 'implies some
suitable subject to be treated and some place to be
decorated with the result', and it is evident that he
regarded this as its proper role, in contrast to the
more regular run of work by students who 'cover
canvases with aimless motives painted to go
nowhere'.[68]

The scheme, which remains *in situ* to this day,
was carried out by six of the School's senior students
under the joint supervision of Greiffenhagen and

"POETRY" BY TOM GENTLEMAN

"ART." BY HELEN JOHNSTON

"ASTRONOMY" BY ALMA ASSAFREY

4.25 'Mural Decorations in a Glasgow Public Library', *Studio*, April 1914.

Anning Bell – an arrangement that effectively replicated the teacher/pupil relationship of the studio in the context of a public space, and which might therefore be regarded as a form of 'applied pedagogy'. The original commission was for four square panels with pairs of nearly life-size allegorical figures embodying the broad cultural themes of *Astronomy*, *Geography*, *Poetry* and *Commerce*, not unlike the exterior sculpture programmes that the School's former Head of Modelling, William Kellock Brown, had provided for many of the branch libraries a few years earlier.[69] These were then supplemented by two slightly more slender single-figure panels completing the cycle with representations of *Science* and *Art*. The allocation of the subjects was distributed evenly among female and male students, two of whom – Tom Gentleman (the creator of *Poetry*), and Archibald McGlashan [*Geography*, FIG. 4.26] – were later to emerge as distinguished professional artists in their own right. Stylistically, the figures are in a

blandly generalised Classical idiom, striving with only moderate success to imitate the lyricism and elegance of such late Victorian masters of figurative decoration as Edward Burne-Jones, with perhaps a hint of the lofty idealism lingering from the former days of Jean Delville. Just how rooted the scheme is in the School's commitment to the grand Classical tradition is confirmed by Helen Johnston's representation of *Art* [FIG. 4.27], in which a female figure in a toga holds a miniature copy of the *Winged Victory of Samothrace*, the full-size plaster version of which would be acquired from the Louvre and installed in the School's Museum later in the same year. Despite the conservatism of the style – or perhaps because of it – the scheme was judged by all hands to be a success. At the official unveiling on 26 January, the Lord Provost D. M. Stevenson praised the project as the fulfillment of an ambition to decorate 'the minor public buildings of the city by advanced and capable students of the School of

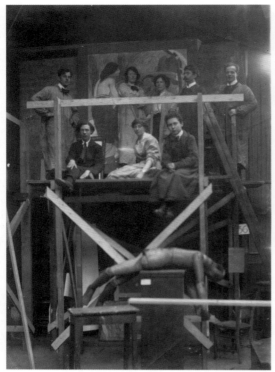

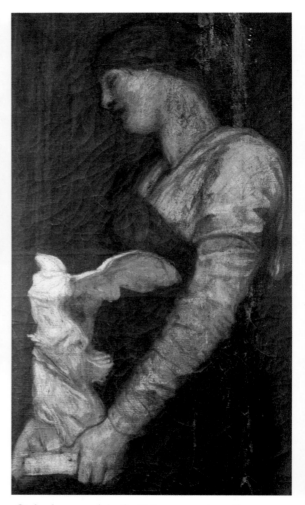

Left
4.26 Archibald McGlashan (on the left), with his cartoon of *Geography* for Possilpark Library, early 1913. Josephine Cameron, the painter of *Science*, sits in the centre.

4.27 Helen Johnston, *Art* (detail), oil on canvas, 1913, Possilpark Library, Glasgow.

Art'. In an echo of the speech by Sir Francis Powell in 1902, he saw it as a belated:

> first step in the direction of the elevation of the standard of public taste and in a small way towards the realisation of the 'City Beautiful'.[70]

The only shadow to pass over the project was the death shortly afterwards of Alma Assafrey, the student responsible for *Astronomy*, who perished along with more than 1,000 others when the *Empress* *of Ireland* was sunk in the St Lawrence river after being rammed in heavy fog by the Norwegian coal steamer *Storstad*. She had boarded the Canadian Pacific Railway vessel at Quebec, and was bound for Liverpool, from where she presumably intended to return to Glasgow to resume her studies.[71]

If the Possilpark Library scheme appears to our eyes today to be rather backward-looking in its style and treatment, we must accept that the Painting

Department under the joint regime of Newbery and
Greiffenhagen was – in common with art education
practices everywhere at this time – deeply traditional
in its outlook, and still committed to many of the
more conservative teaching methods that had been
inherited from the South Kensington and continental
Beaux-Arts systems. This included making copies
of existing paintings, in the belief that the secrets of
both composition and sound technique could be
acquired by the close scrutiny of the work of the old
masters.[72] Copying from the pictures in the city's
own collection had always been encouraged, but it
became a major feature of the work of students
who won the School's travelling scholarships.
Such students were required to submit an itinerary,
and with Newbery's guidance identify the various
artistic capitals of Europe they intended to visit.
Newbery made it a rule not to recommend an art
centre to a student unless he had visited it himself,[73]
which enabled him to give very specific advice on
what students should study, and to steer them
towards those artists whose style and technique
were likely to be of most benefit to their own artistic
development [FIG. 4.28]. Like many of his
contemporaries he took the view that painting had
not progressed since the time of Titian, Rembrandt
and Velázquez, and studies were generally focused
on the work of acknowledged masters such as these.[74]
Curiously, he discouraged his students from visiting
Paris, taking the view that the art then being produced
in the French capital would have a destabilising
effect on students who were not yet fully formed as
artists.[75] Whilst finding the work of the French
Impressionists interesting for the evidence it showed
of 'life and struggle', he doubted that they 'had the
necessary back bone to carry a new movement';
in his estimation they had 'lost the balance between
technique and art'.[76] At the same time he was
equally critical of the solutions being offered by the
contemporary continental avant-garde, betraying an
even more insular conservatism when he dismissed

Top
4.28 Archibald McGlashan, *Eve* (study after Titian's *The Fall of Man*, c.1570,
in the Prado, Madrid), oil on canvas, 1914.

4.29 Francis H. Newbery, *A Cord*, oil on canvas, c.1912.

4.30 Robert Sivell, *My Parents and Family*, oil on canvas, 1920.

Futurism as little more than a passing fad that had nothing to offer artists in Scotland.[77]

Newbery's own paintings demonstrate a wide range of influences, including Rembrandt, Velázquez, the French Barbizon School and Whistler – all of them from the 19th century or earlier [FIGS 4.29 & 3.7]. And yet he was not uncritical of his own work and that of his British contemporaries, feeling that it had reached something of an *impasse*, and that if it continued to base itself on 'imitation' it would be rendered redundant by the imminent development of colour photography. As a solution he believed that it was necessary, somehow, to break through 'convention' towards 'the expression of emotion through colour'.[78] Precisely what he meant by this is unclear, though it is likely he was thinking of the

work of the Post-Impressionists, whose achievements were known to the students through the regular lecture programme provided by Baltus,[79] as well as visiting speakers such as Michael Sadler, an early British champion of the French movement.[80] It is also evident from press reports that some of the students were exhibiting work in a Post-Impressionist idiom and gaining some success with it.[81]

The general direction in which the teaching of painting was moving by the time Newbery retired can be gauged from the press coverage of the inaugural exhibition in 1919 of the Glasgow Society of Painters and Sculptors, a group made up of former students. Referring to the exhibitors as 'iconoclasts of a mild order' with no inclination towards the then current trends of Cubism,

Futurism and Vorticism, one reviewer noted their indebtedness to Newbery, whom they themselves acknowledged as 'a guide, councillor and friend'.[82] 'Probably the most encouraging note in the exhibition', the writer went on elsewhere:

> is the revelation of personal independence. It must hearten Mr Fra. H. Newbery, once the volatile chief of the Glasgow School of Art, in his retirement that the value of individuality in artistic expression, which he consistently urged, has been so courageously applied ... Doubtless the spectator inspecting the bold lines of some of the figure pieces will instinctively murmur 'Greiffenhagen' and before a rollicking bit of loaded impasto, 'Newbery'... But, allowing for the influence of teachers and environment there is still individuality.[83]

The leading members of the group were James Cowie, William McCance, Archibald McGlashan, Agnes Miller Parker and Robert Sivell, all of whom were brilliant artists but scarcely members of the avant-garde [FIGS 4.30 & 4.31]. Even so, we should not be too quick to dismiss the approach of Newbery and his professors as irredeemably reactionary, particularly when it is viewed in a British context. The catalogue of the Whitechapel Art Gallery's 1914 exhibition *Twentieth Century Art: a Review of the Modern Movement*, which was mainly concerned with recent developments in British painting, identified four major modernist groupings. Along with the Vorticists, the Bloomsbury Group and the coterie of Walter Sickert, it also acknowledged the existence of a number of painters who

Top
4.31 William McCance, *Portrait of Agnes Miller Parker*, pencil and charcoal on paper, 1920.

4.32 Archibald McGlashan, *Day*, painting (untraced).

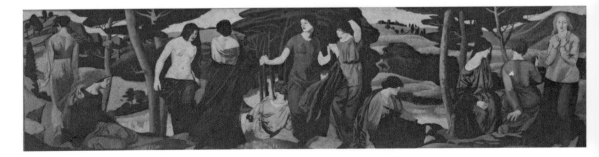

4.33 Archibald McGlashan, *Landscape with Figures*, painting (untraced).

created 'imposing decorative designs' influenced by Puvis de Chavannes and Augustus John.[84] Such a categorisation describes the Glasgow students with some accuracy. The work of Archibald McGlashan and Robert Sivell at this time was heavily indebted to Augustus John and even had resonances, fostered no doubt by Cayley Robinson, with Puvis [FIGS 4.32 & 4.33]. By the 1920s, moreover, James Cowie and William McCance were producing much more distinctively original work, fusing late Cezanne with a more personal reading of the academic tradition in the case of Cowie, creating a synthesis of Cubism

with a machine aesthetic in that of McCance [FIG. 4.34]. What is common to both, however, and so prophetic of developments that were to follow, is their ability to draw energy from the European Modernist mainstream while remaining firmly grounded in a recognisably Scottish cultural tradition.

The fact that two such very different artists should have emerged from a common educational experience is perhaps the greatest testimony to the effectiveness of the educational philosophy practised by Newbery and his staff, and a vindication

of their commitment to the notion of 'individuality'. Through all the vicissitudes of the Painting Department during this period, through all the shifts of emphasis that occurred under the successive influence of Delville, Artôt, Greiffenhagen and Cayley Robinson, what remained at its core was an irreducible belief in the student as a unique individual, for whom education was no more than a process of finding a personal voice. And what this implied in turn was an acknowledgement that painting must be studied first and foremost as a craft. Newbery was quite clear about this, and left no room for doubt on the matter in his introduction to Baltus' *Technics of Painting*. 'It is a truism', he wrote:

> that artists are born and not made, and that Art cannot be taught. The question is not one of Art, but of workmanship... To teach a student that an essential part of his business is to understand the properties, qualities and uses of his means and materials for expression, is to teach the major part of that which is called Art education, and to train him thoroughly in this way is to ensure that... he will not depart from it.[85]

If the students were right when they identified painting as a rose in the masque of 1909, it would follow that the educational process – the 'influence of teachers and environment' referred to above – is the soil from which it grows. Newbery would not have objected to the analogy. Ever the pragmatist, with a thoroughly grounded understanding of what is and what is not possible in the delicate matter of 'educing' the talents of fledgling artists, he could look back over a full decade of success as evidence of just how rich and fertile that soil really was.

4.34 William McCance, *The Engineer, his Wife and Family*, linocut, 1925.

Chapter Five

Tradition and Evolution: Glasgow School of Architecture under Eugène Bourdon

ROBERT PROCTOR

From the front line of the First World War, with men dying around him under fire, Captain Eugène Bourdon, Professor of Architectural Design at Glasgow School of Architecture, was writing letters to his colleagues. Concerned that nothing should interrupt the steady course of teaching while military duties prevailed, he set about delivering instructions and encouragement. Programmes of designs were sent to his assistant, Professor Alex McGibbon at Glasgow School of Art; and to Professor Charles Gourlay at the Glasgow and West of Scotland Technical College he gave assurance that access to the Art School library would continue. In these letters, however, there is also a tone of urgency, as if Bourdon's absence did not merely leave his men in disarray, but also opened up his regiment to a threat of attack from outside. To Gourlay he wrote: 'The more you will be kind enough to follow my own way the better it shall be, because in a school, as in everything else, the main point is to have the tradition unbroken.'[1] And to McGibbon:

> You are quite right when you propose that no other than yourself and Wylie take part in the actual teaching and that 'forceful' outsiders come only at the end and by way of critics only for I fear the criticism of people not entirely in our tradition. But what would you think of former students, the like of Scott, Gunn and others? The School might get them for a week-end if in London or the Provinces and this might be a splendid idea as a link between the old tradition of the School and the new generation of students. We formed and nursed a tradition during these last 10 years and now I feel that we ought to live upon our own tradition... Photograph or lithograph reproductions of our students' former work. The present photographs are good but too small in scale and not enough known to every student. We should now make an effort in the same way as the Liverpool School with their students' book or Beaux Arts men with theirs.[2]

In this appeal to close ranks and to bring back veteran students as teachers and examples, Bourdon desired to maintain continuity with the past. Bourdon and his colleagues feared that this continuity might be destroyed by those outside the tradition. Yet this was a past that, he admits, began only 10 years before when he was appointed to his post in Glasgow. The 'tradition' that Bourdon repeatedly cites was, in other words, invented. The idea of such a tradition, and the methods for sustaining it, were Bourdon's innovations at Glasgow School of Architecture; underlying both was a view of the importance of the past in the progress of civilisation, a view which had a biological analogy and justification in a popular version of the theory of evolution.

Glasgow School of Architecture was itself only founded in 1904. This institution was formed through the merger of architecture courses at Glasgow School of Art and the Glasgow and West of Scotland Technical College. The merger happened rapidly after discussions the previous year, as both bodies acknowledged the deficiencies of their separate courses at a time when the architectural profession, represented by the Royal Institute of British Architects with its rigid examinations syllabus, demanded a high level of competence from young apprentices and students who wished to call themselves architects. Eugène Bourdon was appointed shortly after the establishment of a joint course had been agreed, when J. J. Burnet and W. Forrest Salmon, both architects and governors of

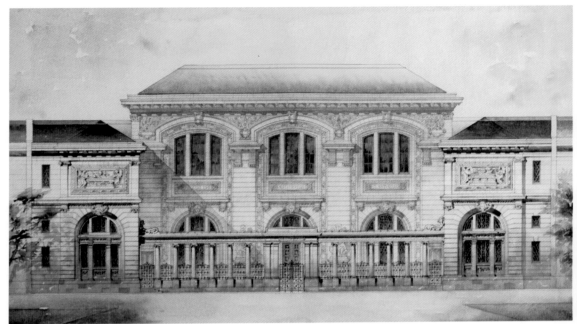

5.1 An example of Eugène Bourdon's student work at the École des Beaux-Arts, Paris: the elevation of a design for a university or school building, 1890s.

5.2 Axial planning at the École des Beaux-Arts: Eugène Bourdon, the plan of a design for a Palais de Justice, 1894.

the School of Art, travelled to France in search of suitable new staff in Architecture and Design. Bourdon was a young architect in his mid-30s who had studied at the École des Beaux-Arts in Paris, gained the government diploma, assisted Charles Girault on the Petit Palais for the Paris *Exposition Universelle* of 1900, and spent two years as a draughtsman in New York [FIGS 5.1 & 5.2].[3] He endeared himself to the Governors of the School with an enthusiastic report on the possibilities for teaching the new joint course, proposing to take 'a more immediate personal charge of Design and Composition, especially as regards advanced studies' and give 'occasional lectures on the History of Art and Composition'.[4] Bourdon was appointed jointly and his salary shared between the School of Art and the Technical College, cementing the relationship between the two without prejudice in favour of either.

Bourdon quickly began the task of fleshing out a

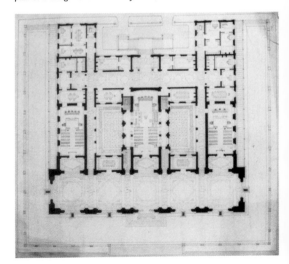

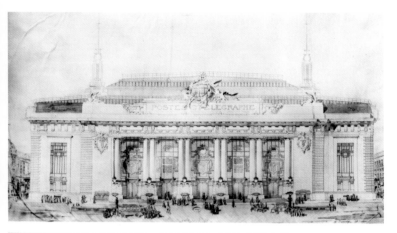

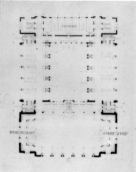
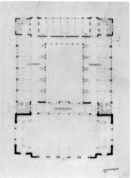

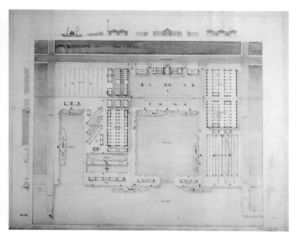

syllabus that had been roughly agreed the previous year. Between the two institutions, certain subjects were to be taught in parallel, others to be shared by all students attending at one or other location, and others to be uniquely taught in each, depending on the student's preference. Architectural design was to be taught under Bourdon's supervision, and using his set programmes, at both places, but by distinct teams of staff, so that at the Art School (led by McGibbon) the emphasis was on artistic composition, while the Technical College (under Gourlay) focused on practical matters. Courses on materials and construction and history of architecture were taught at the Technical College to all students, and the Art School reciprocated by supplying courses in drawing and modelling (in clay) from casts and nature, and the measurement and study of distinguished buildings. Art School students enjoyed the added privileges of painting; drawing and modelling from the Antique and life, including making up samples of ornament and architectural elements in clay; and decorative design.[5]

The School was organised into a junior and senior class, each of at least two years' duration. Students in different years of their study worked on

Top
5.3 A typical commercial-institutional student project at the École des Beaux-Arts, Paris: Henri Fromage, elevation of a design for Un Hôtel des Postes et Télégraphes, from *Les Médailles des Concours d'Architecture de l'École Nationale des Beaux-Arts à Paris. XVe Année (1912–1913)*, Paris, 1913.

Middle
5.4 Axial planning in École des Beaux-Arts student work: Henri Fromage's plan for the design shown in figure 5.3.

Bottom
5.5 Relevance in student work at Glasgow School of Architecture: W. B. J. Williamson, plan of a design for a Shipbuilding Yard, 1909.

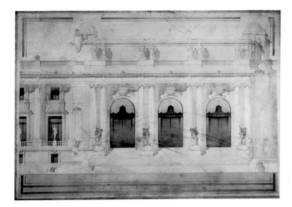

DU DESSIN D'ARCHITECTURE 41

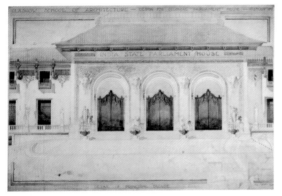

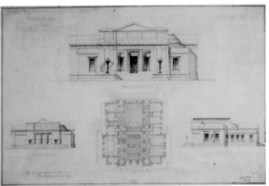

Top Left

5.6 Elevation design at Glasgow School of Architecture: Richard M. M. Gunn, design for the façade of a Colonial Parliament House, Senior Class project of 1908/09.

Middle Left

5.7 An Art Nouveau variant on the same elevation: Alex T. Scott, design for the façade of a Colonial Parliament House, 1908/09.

Bottom Left

5.8 Hierarchical and axial planning at Glasgow School of Architecture: Alex T. Scott, Design for Law Courts, Senior Class project of 1905/06.

Top Right

5.9 'It is essential in an architectural design *to begin before everything else with the axes*': page from Julien Guadet, *Éléments et théorie de l'architecture: Cours professé à l'École nationale et spéciale des beaux-arts*, Paris, 1901–04, vol. 1.

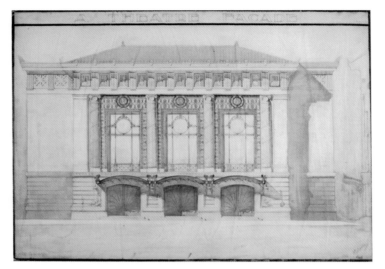

Top

5.10 Roman classicism with a French accent: William Gourlay, design for a Theatre Façade, Senior Class project of 1912/13.

5.11 A design in Scottish Renaissance style: anonymous Glasgow School of Architecture student, sections of a Scottish Hall, Senior Class project of 1912/13.

appropriately ambitious design project – although very few students, including some of the best, saw any need for the final qualification. A range of prizes and bursaries for coursework gave a competitive edge to study, and the possibility for occasional distinctions. The great advantage of this system was that students could tailor the course to their own commitments. For the majority of students, this meant working as apprentices in architectural practices, from which they were granted leave to study part-time.[6] While there was therefore no fixed time for completing the course, Bourdon recommended two years of full-time study for each certificate, discouraging students as far as he could from part-time study.[7] In fact only a small number of students had sufficient private income to study full-time, spending their summers in travel, entering national competitions, or working in offices (in 1908, the figure was 22 students attending day classes out of a total of 149 students). Perhaps most of these day students were enrolled at Glasgow School of Art, since those working at the Technical College were described as predominantly 'tradesmen and apprentices'.[8]

For all students, the emphasis throughout was on practical work, with the largest portion of time devoted to design projects. These were carefully structured according to the Beaux-Arts principle that a short, concise and clear design sketch (the *esquisse*) should be followed by a longer methodical working out of the design, and in bigger projects

the same design projects, and attended two stages of lectures in each. As at the École des Beaux-Arts in Paris, students moved from the junior to the senior class when they had attained a suitable level of experience. Unlike at Paris, however, the method was formalised with a system of points: for each completion of a course of lectures or a design project, the student was awarded marks; on accumulating the required number of marks, the move to the next stage was permitted. The completion of the first stage led to a Junior Certificate, and of the second stage a Senior Certificate. The Diploma was finally granted after a further two years of work in an architect's office, on submission of an

should be completed with studies of compositional details [FIGS 5.3 & 5.4]. An initial idea in plan (the *parti*) therefore remained embedded in the design throughout its development, and the final judgement appraised the logic and clarity of this motif, and its persistence, in the complex design:

> Planning to a programme of requirements, a rough sketch is at first laid down by the student alone. Notions upon the subject, if wanted, are previously given in a short lecture. Then, with the help given by good Examples, as shown in books, plates, photos, etc., and by short occasional lectures; under tutorial direction, the student will elaborate his sketch; he will give to this Study the greater part of the time, working at a small scale as long as possible. He will devote a maximum of two or three weeks to the finished drawings.[9]

5.12 Composition of classical elements and orders: B. Danek, student work from Glasgow School of Architecture, c.1920s.

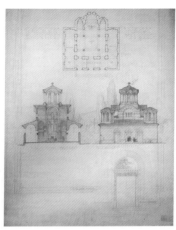

5.13 A history project: T. C. Campbell Mackie, design for a Byzantine Chapel, undated, c.1905–06.

Just as at the Paris École, design briefs were idealised subjects, usually styled as great state commissions, but often reflecting current cultural preoccupations: fountains, memorials, railway stations and libraries were standard themes; a scientific institute, a shipyard [FIG. 5.5], and, as war approached, such subjects as a 'Hall of Veterans' Home' and a 'Monument to Naval Victory' showed some concern with contemporary relevance.[10] Many of the projects seem to have been largely decorative. Very little student work was published or survives, but it is remarkable, for example, that one project entitled 'Colonial Parliament' was drawn by two students, Richard M. Gunn and Alex T. Scott, within identical outline elevations derived from a shared plan, suggesting that the design for this interesting brief consisted merely of detailing a façade [FIGS 5.6 & 5.7].[11] A sketch design by Scott for Law Courts,

however, is a rare example of work showing able and sophisticated planning, with orchestrated multiple axes, clear circulation and a hierarchy of functions, within which an asymmetrical plan is organised [FIG. 5.8].[12] Little else with such complexity survives. Needless to say, these are established Beaux-Arts techniques, as described by the Professor of the École, Julien Guadet, in his *Cours d'architecture* of 1901–03: using a grid, orthogonal axes were to be established and the principal spaces set out in order [FIG. 5.9].[13] The inevitable and desired result was always a classical and diagrammatic plan of greater rigidity than anything ever produced in the Renaissance or ancient Rome. Elevations were normally Classical, in Roman or French style, or the free Baroque treatment then fashionable in Paris, or even a conventional version of Viennese Art Nouveau; very occasionally Scottish Renaissance motifs were used, and sometimes Gothic [FIGS 5.10 & 5.11]. Such variation was itself a principle of the Beaux-Arts method: the style had to follow the building's context and purpose, but was a secondary

consideration to the plan, from which the elevations were derived; the style was chosen freely to give an appropriate 'character'.[14] Plan and elevation drawings with delicate colour washes and skiagraphy were the most important design and presentation tools, while perspectives were rarely used, suggesting that abstract geometry and formal composition were more important concerns than the mere visual appearance of a building in a context.

Meanwhile, lecture courses were also supported by design work. Lectures in construction methods and calculations were followed with realistic projects using different materials: for example in 1904–05 projects included 'Part of Stable in Half-Timber Work' and 'Part of Roof over a Railway Station' using steel.[15] The history of architecture was given as a roughly chronological series of styles, from ancient Greek and Roman, Hindu and South American, and an introduction to English Gothic, in the junior classes, to Byzantine, Romanesque, Islamic, Renaissance and modern in the senior courses. Students were not expected to write about these periods; lectures formed the basis of a stylistic and compositional knowledge, to be applied in design situations. The first assignment was a drawing of the orders and their applications, a genre of composition also used in Paris and at many other schools, and which continued in use in Glasgow until the 1950s [FIG. 5.12]. Through it students learnt the importance of modular proportion, and the geometric construction of such motifs as spiral volutes and entasis. In later stages history was assessed through 'restoration' and 'adaptation' studies: in 1905–06, for example, the coursework consisted of restorations (perhaps based on given plans) of 'A Byzantine Church' and 'A Gothic Venetian Palace', and an adaptation (perhaps an extension) of 'A Roman Renaissance Palace' [FIG. 5.13].[16] Lecture courses therefore gave students a physical knowledge of architecture as construction and composition which, though

viewed in chronological order, was seen essentially outside history in its applications to current design.

The other important element of the course was measuring. The junior class was expected to meet on Saturdays for a measuring class in Glasgow Cathedral, sometimes using ladders and any available scaffolding to survey its higher reaches; and trips were organised by railway to measure other medieval and Renaissance buildings. The senior students, meanwhile, could choose their own subjects, but were also taken on excursions, sometimes far afield: the earliest prospectus boasted of previous visits including York, Oxford, Cambridge, Chester, Gloucester, Bristol and Bath, with a predominance of destinations suggesting an interest in medieval architecture.[17] Yet one of Bourdon's changes was to alter this culture of measuring. When Edinburgh College of Art proposed that Glasgow students be employed to conduct a 'National Art Survey', in which all important Scottish buildings were to be measured and drawn, Bourdon objected, noting that 'it has already been decided that measuring should only be a secondary subject in the curriculum', and that there would be a danger of 'going back in the old system, from which Glasgow School of Architecture has departed with it is believed some good reasons and with some success.'[18] Furthermore, limiting the survey to a list of buildings in Scotland would give undue emphasis to examples of little pedagogical use. Bourdon wished instead to widen his students' horizons, helped by an expanded system of travel scholarships, noting that:

> a student of Architecture will learn far more from a journey – being even a short one – through England or the Continent – especially Italy – than from many weeks spent in measuring in his native country. At home he will be taught some details of Architectural and Archaeological interest, abroad his mind will open to his Art at large – more, his ideas will be broader in a general way.[19]

The 'old system' was that of the 19th-century historical scholar-eclecticist, while Bourdon was more interested in teaching students the means for original and modern composition. Measuring was therefore tolerated chiefly as an excuse for inspirational travel, and under Bourdon design was of primary importance.

Bourdon's achievements were to structure a clear syllabus across two institutions, unifying the staff with a sense of purpose, and to introduce a distinct educational policy in architecture. Surprisingly, the idea of conducting a course in architecture through design projects was a controversial one. Arts and Crafts architects such as W. R. Lethaby were insisting to the RIBA that design itself was unimportant in an architect's training, advocating instead an education in construction and materials, including exercises in craftsmanship.[20] Bourdon's approach concurred with those of C. H. Reilly at the Liverpool University School of Architecture and the architect Reginald Blomfield, prominent on the RIBA's Board of Architectural Education (and appointed as an examiner in Glasgow).[21] In their opinion, the mundane practicalities of architectural practice could be left to the periods of apprenticeship and office work. Education at the School of Architecture was to be an immersion into higher ideals: artistic composition in the grand manner and on a grand scale provided not so much a functional training as the formation of the 'perfect gentleman' that the 'true architect' was required to be.[22]

It might be objected that the Beaux Arts education is too high in its aims, and that it keeps a young man too much out of practice; that the problems dealt with are too lofty, that there is no need to design 'palaces' in order, afterwards, to make alterations in cottages. And there is certainly something in this. But let us consider that this education is merely a training, and an academical one – something to form the mind, and not be applied directly. So in architecture let the student live a little in his youth a life of noble dreams; he will soon enough come down to earth, and spend his manhood there. He will always retain some mark of his noble fostering.[23]

Bourdon's was the liberal view of education, like that proposed by John Henry Newman in his *Idea of a University* and Matthew Arnold's *Culture and Anarchy*.[24] The mere mechanics of employability would look after itself.

It is not immediately obvious how this structure of architectural education relates to the newly instituted 'tradition' that Bourdon and his colleagues later felt to be assailed from without and in pressing need of defence. For that, one must look to the contemporary debate on architectural style. Bourdon is, and was, more urgently seen as the proponent of the Beaux-Arts Classical style of architecture, though this was inherently connected to his teaching methods. His appointment in Glasgow was most likely to have been a deliberate attempt by the Beaux-Arts-trained architect J. J. Burnet to stifle the influence of the Art Nouveau and Arts and Crafts architecture of Charles Rennie Mackintosh and the Glasgow Style architects (despite the fact that Burnet's own office had previously dabbled with Art Nouveau motifs). This debate between Classicism and Art Nouveau

5.14 'Domelets, broken pediments, pinnacles': Frank R. Burnet & Boston, St George's Mansions, Glasgow, 1900.

reveals more of the underlying thinking behind Bourdon's confident educational stance – a philosophy which was not just aesthetic, but equally political and scientific.

The Governors of Glasgow School of Art, like Bourdon himself, preserved a tactful caginess on Art Nouveau and the reaction against it; only hints of division emerge as a subtext in official documents. In less formal venues, Bourdon's students and associates had no such reserve, however, and in the short-lived student magazine, *Vista*, the work of contemporaries is attacked in terms whose naïvety helpfully exaggerates their teacher's position.

5.15 Scottish Baronial and Flemish Baroque: James Thomson, Liverpool and London and Globe Assurance Buildings, Glasgow, 1899.

A discussion of recent architecture by James A. Morris (a local architect invited to contribute by the editors) is worth quoting at length:

> What in honest truth are most of our important buildings in essence, if not conglomerates, erratic mixings of trivial thought and puerile form? Domelets, broken pediments, pinnacles, are present in redundancy; massive masonry jostles crotchet-like detail, and elbows refinement aside; till the result seems a veritable *pot pourri* and jumble, not only of the semblance of conflicting styles, but of horizontal and vertical masses and lines as well, sure evidence of an architectural decrepitude... Dignity, power, strength, reticence, seem unknown... In forsaking Tradition the architect has much emasculated his art... and so by playing with misunderstood forms, as a child plays with toy bricks, his productions are necessarily futile, for by birthright alone come dignity and nobility, and they are the innate and inalienable inheritance of the artist... A modern building, however complete and even excellent in arrangement for the due administration of business, is yet in its architectural or aesthetic aspect, sadly deficient in those abstract qualities which are the hall mark of aristocracy in Art.[25]

Morris cites the Imperial Institute and additions to the Victoria and Albert Museum in London as examples of the so-called 'free style' architecture he decries, and it is clear in this context that the Glasgow Style is also implicated: such buildings as Frank R. Burnet & Boston's St George's Mansions, with its clutter of pediments and turrets, or James Thomson's Liverpool and London and Globe Assurance Buildings match perfectly this complaint of jostling and random ornament [FIGS 5.14 & 5.15].

Within this colourful passage is hidden a biological analogy. Firstly, modern architecture is represented as feminised, as it lacks 'Dignity, power, strength, reticence'; it is an art that has been 'emasculated' – its balls have gone. Since it lacks its procreative organs, it is 'futile', 'decrepit', and unable to pass on the 'dignity and nobility' that alone are heritable characteristics for the next generation. All this follows from the architecture's 'conglomerate', or mongrel, character, and its

dilution or rejection of 'aristocracy'. That aristocracy and its genetic inheritance are represented by the great tradition that architects have abandoned. Similarly, the student Alex T. Scott wrote that modern buildings 'bearing the stamp of ignorance and bad design, distorted orders, and ornament at once inconventional [sic] and bizarre' showed the presence of a 'disease', and later that, by comparison with the grandeur and dignity of contemporary Beaux-Art- inspired American architecture, British work was 'weak, small in scale, complicated and finicky in detail' and 'straining after effect', and therefore, as Morris implied, effeminate and feeble.[26] The tone of this writing is plainly homophobic: like gay men, the architects of such camp buildings will be unable to pass on their genes, and represent a dead branch in the family tree of history.[27] Tradition, identified in its current manifestation with Beaux-Arts Classicism, is virile, fertile, and will survive natural selection to pass on its qualities to the architecture of the future.

Mackintosh in particular was attacked in terms which are dismissive and humorous, perhaps as his more eccentric departure from precedent was seen as a personal aberration rather than a threat. To another writer in the *Vista*, 'the silly "New Art" stuff' seemed to be derived from drug-induced hallucinations.[28] In a spoof visit by 'Amenhotep the Scribe' to a lecture in the Art School's 'Hall of Symbolists', the students are seen to marvel at the architecture, declaring, 'What meaneth it – we know not – therefore it must be too great for us. Lo! what a genius is this man!'[29] It is clearly a jest directed to the person of Mackintosh, but this is because his architecture is seen as excessively private. One of the supposed advantages of Beaux-Arts architecture, saturated with conventional allegorical figures, was its communication using a shared, inherited language of forms, and therefore its suitability to the needs of the nation state for an official representation of itself and its citizens.

In contrast, the symbolism of Art Nouveau was private and anarchic.[30] The spectacle of so many young students, in their late teens and early 20s, deriding the experimental originality of young architects in practice and enthusiastically adopting the reactionary conservatism of their teachers at Glasgow School of Art is perhaps bemusing. But it is also likely to be a testament to Bourdon's charismatic advocacy of his noble tradition.

This tradition consisted for Bourdon of a selective view of western architectural history, a canon defined by adherence to Classical principles, and unfolding in a progressive evolutionary development towards the present. The canon is set out in shorthand in Bourdon's statement to Francis Newbery in response to the latter's tentative invitation to direct the design teaching in the Art School: 'I have brought here,' he stated, 'in Architecture, not French Architecture as a few fancy, but the architectural tradition, the old Greek tradition, transplanted to Rome, modified in the Gothic, renewed at the Renaissance.'[31] As Alex Scott wrote, that lineage of Classical tradition had been continued by the École des Beaux-Arts and flourished in America, and though temporarily lost in Britain had now been restored in Glasgow by Bourdon.[32] That this historical tradition was seen as evolutionary is evident in other contemporary writing. Banister Fletcher's *History of Architecture on the Comparative Method*, acquired by the Art School library in 1901, gave a detailed morphology of styles of architecture in chronological sequence in much the same way as natural history used the meticulous formal analysis of species to deduce their transformations; the author hoped to describe 'the gradual evolution of the various styles', and opened with a family tree of architecture.[33] In this view of history, culture progressed from the primitive to the civilised, and those, like Mackintosh, who rejected the idea of a slow progression were in danger of an atavistic regression to barbarism.

Thus it was thought essential in an artistic education for students to experience this tradition for themselves – not just to acquire a knowledge of the past, but to recapitulate it in a process of individual development that mirrored the progress of history. The knowledge that embryos repeated in their own formation the evolution of their species ('ontogeny recapitulates phylogeny') was wide-spread at this time, popularised by one of its first proponents, the German evolutionary biologist Ernst Haeckel, in widely translated works such as *The Riddle of the Universe* of 1900.[34] Haeckel argued that there was a causal connection between individual human growth and the progressive evolution of man as a species, through a fundamental law of progress in the universe, which applied as much to civilisation as it did to biology. Haeckel's emphasis (and that of French evolutionists such as Lamarck) was not on Darwin's concept of random mutation followed by natural selection, but on an idea that nature contained within it a force that impelled organisms forward towards higher forms of complexity and organisation.[35] Such an idea had an obvious application to education, if the aim was the production of modern men and women at the highest point of development. It is a theory that was debated by Bourdon and his Art School colleagues. Here, for example, is Francis Newbery in an article for the *Vista* entitled 'Tradition':

> Beauty... is not a question of creation, but of evolution ... Sometime in the future, a movement that may parallel the Hellenism of Ancient Greece or the Renaissance of Mediaeval Europe may come, and with it a Literature and an Art. But we can rest assured that, if this be so, neither the Literature nor the Art will be either new or strikingly original... Both will be an assimilation of old material and an evolution of new treatments. To imagine otherwise is to deny the testimony of history, or to assume that Darwinian man, in his upward ascent, will have reached at last a place among the angels.[36]

This is an implicit rejection of Mackintosh and Art Nouveau in a theory that is both aesthetic and pedagogical. For Bourdon, the way to form architects capable of making modern architecture was to train them in the architecture of the past, not just (through measuring and lantern slides) to instruct them in historical forms but (through design projects and the exercise of Classical rules) to force them to undergo the historical process. Indeed, Bourdon insisted that originality of design should only be permitted when the student had reached the final aim of educational progress, the Diploma.[37] This method was confirmed by an analysis of its opposite. Following a visit to Germany in 1911, Bourdon reported on a very different form of teaching he had discovered at the Kunstgewerberschule in Berlin under Bruno Paul:

> [In] order to obtain originality from beginners, they are shown nothing and taught nothing: indications on the materials and construction, along with a blank sheet of paper and a pencil are the only bases upon which a young man or girl has to make a start... The resultant design is a few squares in all cases, whether it be for furniture, china or embroidery no matter what, and more generally speaking the student (a XXth century student) is artificially placed in the conditions of a stone age man or of a zulu. He or she produces the same barbaric Art, which is not a little surprising in our over-civilised epoch.[38]

This attempt at encouraging originality through the denial of precedent and tradition to the student had the effect of wiping out progress and civilisation altogether. For Bourdon and his colleagues, this was proof that only a liberal, Classical and historically-informed education could produce a modern architect.

The opinions of future generations on Bourdon and his students have not been kind. Mackintosh's 'genius' has gained international acclaim, while Bourdon's reputation is confined to local academic journals. It is a historical irony that, when Glasgow School of Architecture transferred to the newly formed University of Strathclyde in 1964, the 'Mackintosh' School of Architecture was created, and was later housed in the 'Bourdon Building'

designed by Mackintosh's firm.[39] More seriously, Andor Gomme and David Walker cut short their first edition of *Architecture of Glasgow* with an unnecessarily tendentious judgement on the School:

> It is an extraordinary and depressing fact that a generation of architects taught by such distinguished men as W. J. Anderson, Eugène Bourdon and Alexander McGibbon, and growing up when Mackintosh, Burnet, Salmon and Campbell were at the height of their powers, should have produced nothing at all. Glasgow's record between the wars is as dismal as anywhere in the country...

This was a position they subsequently only half-heartedly revised.[40] The problem may not be a lack of architecture produced by Glasgow students, but a lack of knowledge of it: very few of the students who graduated between 1904 and 1916 are known, most having vanished as anonymous assistants into larger practices. Due apparently to an increasing bureaucracy in architectural practice, and no doubt to bouts of economic crisis, this was a period when it was harder than before or since for a young architect to make an impact. Many left Glasgow, taking their ideals elsewhere in Britain and beyond: Brisbane, Adelaide and Edmonton are listed as destinations in the *Calendar* of 1921.[41]

The most productive student was probably Edward G. Wylie, who obtained his Diploma in 1911 but taught in the School of Architecture as an assistant from 1909, at the same time as being its 'Keeper of Casts and Lantern Slides' and working in London as a draughtsman.[42] Wylie went on to found an architectural practice, variously known as Wright & Wylie, Wylie Wright & Wylie in the 1920s and Wylie Shanks & Wylie in the 1930s, responsible for the biggest of the inter-war neo-classical commercial buildings of Glasgow, the Scottish Legal Assurance Society building on Bothwell Street of 1927–31 [FIG. 5.16].[43] Meanwhile Richard M. Gunn, one of Bourdon's most lauded students, joined several others in the Glasgow firm of James Miller and, as Miller's chief assistant, reputedly designed the firm's well-known Union Bank of

Scotland office on St Vincent Street in the late 1920s [FIG. 5.17].[44] It is quite likely, given the stylistic similarities, that he also designed Miller's other

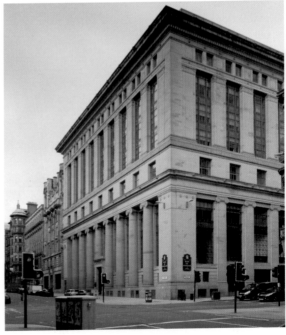

Top
5.16 Muscular commercial classicism: Edward G. Wylie, Scottish Legal Assurance Society Building, Bothwell Street, Glasgow, 1927–31. The building has relief carvings by Archibald Dawson, who was the Head of the Sculpture Department at the time.

5.17 American Beaux-Arts in Glasgow: Richard M. Gunn designing for James Miller, Union Bank of Scotland, St Vincent Street, Glasgow, 1924–27.

banks of this period, the branches of the Commercial Bank in Hope Street, Bothwell Street and West George Street, as well as Lomond House on George Square [FIGS 5.18 & 5.19].[45] All these buildings have a similar American-influenced treatment, designed as plain square boxes with broad corners framing glazed central bays divided by giant orders, attic storey windows in thick blank stonework making a counterpoint, and monumental cornices closing their skylines. Gunn's designs are severe abstracted pylons, compared to Wylie's fussier palazzo. The planning

was easy enough, as banks required tall central public halls with stacks of flexible offices around them. If the formula was hardly original, imported through American journals, the choices and handling of sources are nevertheless entirely consistent with these architects' student ideals under Bourdon: these are the virile buildings whose pulsing hormones will ensure the propagation and progress of architecture. Many of them are also, of course, vital contributions to Glasgow's cityscape and identity.

Wylie's other well-known buildings are the

5.18 Beaux-Arts becomes Art Deco: James Miller, Commercial Bank (West George Street branch), Glasgow, 1930.

5.19 Stripped Beaux-Arts: James Miller, Commercial Bank (Bothwell Street branch), Glasgow, 1934.

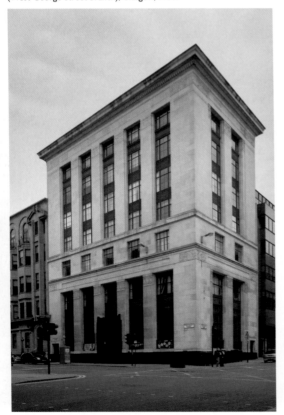

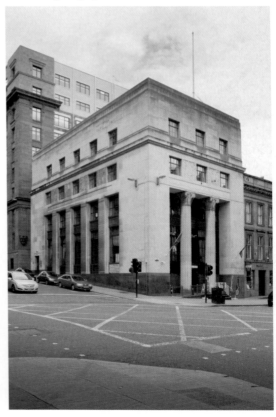

Dental Hospital on Renfrew Street [FIG. 5.20], and Albert Secondary School in Springburn, both sustaining the Classical tradition in modern guise with spiky decoration, and the more innovative Hillhead High School.[46] Some students, meanwhile, joined 19th-century practices and dabbled in uninspired but pleasant eclectic work – Thomas P. W. Young working with Dr Peter MacGregor Chalmers, perhaps on some of his church memorials, and Archibald G. Paton joining Keppie & Henderson. Yet others were in more modern practices: William James Anderson is credited with the Dudok-inspired Cosmo Cinema in Rose Street of 1938, and at least two students went to firms that later designed Art Deco cinemas – Joseph Wilson to Charles McNair, and Allan P. Buchanan to Watson, Salmond & Gray.[47] Bourdon's influence was not that of an architect but of an architectural educator; and it is an influence that extended beyond Glasgow, although we do not yet know enough about where or how.

Below

5.20 Modern Beaux-Arts in stone and steel: Wylie, Wright & Wylie, Dental Hospital, Renfrew Street, Glasgow, 1927.

Right

5.21 Bourdon remembered: Alexander Proudfoot, *Memorial to Eugène Bourdon*, bronze, 1925, in the foyer of the Mackintosh School of Architecture. [See also 7.22]

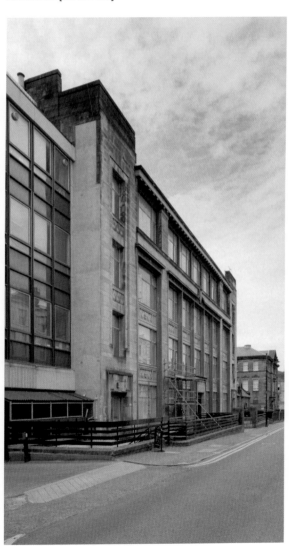

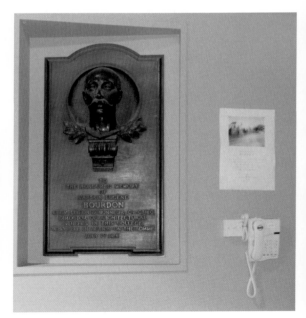

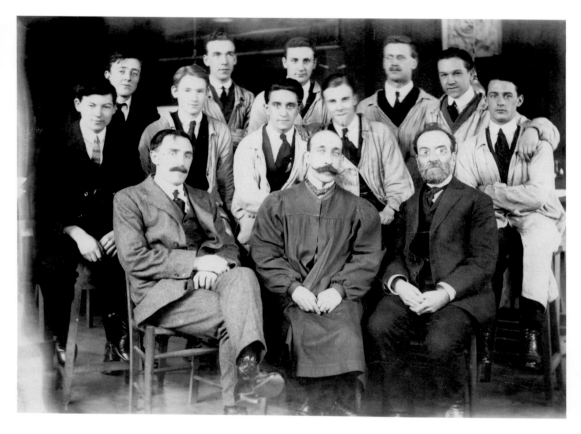

Bourdon died at the Battle of the Somme in 1916, keen to fulfill his duty to his nation, as he had been fervent in his sense of duty to an artistic belief, and having changed the course of architectural education in Glasgow for half a century [FIG. 5.21]. His innovations in education remained, at least in part. Yet the modern architect in the 20th century rejected any idea of continuity of tradition and history, refusing to advance in small steps; instead, his models were more often revolution and creative genius, or the pragmatic craftsmanship of Lethaby. Ultimately, then, it was Bourdon's misfortune to have been on the wrong side of the 20th century's story of architecture. [FIG. 5.22]

5.22 Bourdon with Charles Gourlay (seated left), Alexander McGibbon (right) and a group of their students, c.1910.

Chapter Six

The Glasgow Style and Beyond: the Department of Design and Decorative Art

GEORGE RAWSON

In 1921 Fra Newbery, in retirement in Dorset, reminisced to Jessie M. King, one of the most successful decorative artists to have studied at the School:

> In the dirt and in the gas fumes and the general squalor of those dear, dreary dirty rooms in Rose Street ... we worked because things had to be done and the outside world was a world well lost. Nothing like starving an artist to get the best out of him or her.
>
> We grew too luxurious up on the top of Garnethill; and the thin air piqued us and what we gained in altitude we lost by self consciousness and in this thing there is death. Better do badly but it be as good as you are able to do, than let the best Professor in the world show you how easily it is all accomplished![1]

The period after 1900 in the new building had been one of great expansion in which the School was able to attract staff of international standing. Yet while still producing work that was good enough to maintain its reputation both nationally and overseas, the Department of Design and Decorative Art was no longer the centre of innovation it had been in the previous decade, when the creation of the Glasgow Style had marked it out as one the most important schools in Europe. While it continued to produce Glasgow Style work, this had ceased to be cutting-edge, and the years leading up to the Great War were a time of educational consolidation in which the School concentrated on building on what it had already achieved, making continued efforts to rectify what were considered to be weaknesses. A major objective was the appointment of a prestigious head to give direction to the department, and to establish improved relations with Glasgow's trading and manufacturing community. This, it was hoped, would increase the School's influence on the quality of the city's design output. The School also strove to improve the teaching in specific areas of design, and some of the crafts in which students were establishing their own careers. Although it met with only partial success in influencing the city's manufacturers, by the outbreak of the war the department had been placed on a firm footing that promised good results from a pedagogical point of view. Yet while the School was still among the most important in Europe, its reputation rested more on the quality of the teachers it was able to attract than on its record as a producer of innovative work.

The Glasgow Style had been developed in the School by four students – Charles Rennie Mackintosh, Herbert MacNair, and the sisters Margaret and Frances Macdonald – and first came to public attention in 1894.[2] It subsequently gained international recognition as one of the 'New Art' styles alongside Franco–Belgian Art Nouveau, German Jugendstil and Austrian Sezessionstil, through a series of major exhibitions and coverage by leading art periodicals. The Glasgow Style was at its apogee at the beginning of the 20th century, at the time when the first stage of the School's new building was completed, and its showing at the International Exhibition of Modern Decorative Art at Turin in 1902 [FIG. 6.1] provided a summation of what had been achieved. The Scottish section [FIG. 6.2] was not only organised by Newbery and designed by Charles Rennie Mackintosh, but the vast majority of exhibits were the work of the School's past and present students. These comprised around 100 examples by some 44 artists, all trained in the School, 11 of whom would at some point also teach in the institution. Around two thirds of these works

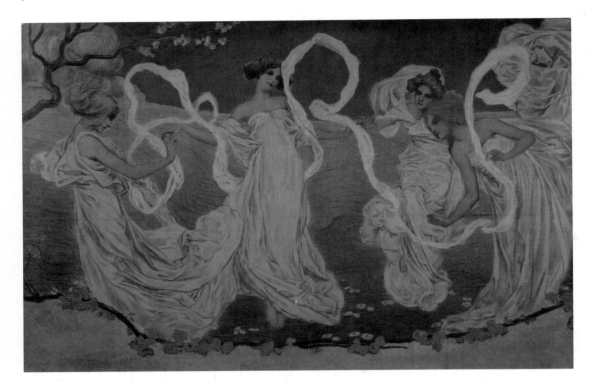

were craft productions, either made in the School's 'technical studios' or by students who had received their training there. Among them were examples of hammered metalwork, enamelling, bookbinding, stained glass, ceramic and glass decoration, gesso, needlework, etching, block printing and lithography, along with book illustrations and designs for posters and textiles [FIGS 6.3 & 6.4].[3]

The Glasgow Style owed its origin and character to several aspects of the School's established culture: high quality, individualised design teaching that exploited the best elements of the nationally enforced South Kensington curriculum, but sought

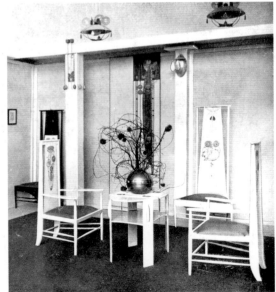

Top
6.1 Leonardo Bistolfi, poster for the First International Exhibition of Modern Decorative Art, Turin, lithograph with over-painting, 1902 (designed 1901).

6.2 Charles Rennie Mackintosh and Margaret Macdonald, part of *The Rose Boudoir* installed at the Turin exhibition, 1902.

Left
6.3 Dorothy Carleton Smyth, *Isolde*, stained glass and lead, 1901. The window was exhibited at the Turin exhibition, 1902, and is now in the entrance hall of the Mackintosh Building.

6.4 Jessie Marion King and John Macbeth, design for the cover of *Le Rêve*, 1907. This book, owned by Newbery, was exhibited at the Turin exhibition in 1902 and at the British Arts and Crafts exhibition in Paris in 1914.

to bring out the particular strengths of the student; the freedom allowed by the Glasgow School of Art Club to produce and exhibit work outside the demands of the official curriculum, where students could move beyond historical styles in response to contemporary developments in design; and the establishment of teaching in the crafts, enabling the School to realise finished products that could be shown in the newly fashionable decorative art exhibitions, thus establishing the Glasgow Style in an international arena. Despite the fact that the style became known through arts and crafts exhibitions, its major vehicles – posters, embroidery, *repoussé* metalwork and book bindings – were essentially two-dimensional, easily evolved from drawings and owing little to the craft ethos [FIGS 6.5a & 6.5b]. It is also worth noting that as many as 34 exhibits at Turin were designs on paper, while several of the artefacts on show, although designed in the School, had been made commercially.[4]

The reliance on drawing, in which a design was visualised on paper prior to its realisation in the relevant material, would be a characteristic of the School's approach during the first decade of the 20th century. This owed something to the nature of Glasgow itself as a trading and manufacturing city. During the 19th and early 20th centuries Glasgow had a widely diverse range of industries. Its largest employer was the textile industry, which specialised in the production of printed cottons, muslins, carpets and lace. The city also manufactured ornamental iron-work, glass, ceramics and silver-ware, and was active in the printing and book trades. It was a world leader in shipbuilding, and fostered

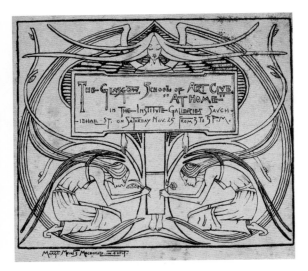

Top
6.5a Margaret Macdonald, programme for a School of Art Club 'At Home', 1894.

6.5b Margaret Macdonald (attrib.), *repoussé* panel in brass for a bookcase designed by Charles Rennie Mackintosh, *c*.1897. An example of a design on paper carried out in another medium.

the decorative trades associated with an immensely wealthy and expanding city, which required new public buildings and churches in addition to houses and tenements. Its art school thus needed to provide a broad-based approach to design that could also be adapted to the requirements of each industry. It had been reasonably successful in doing this from the inauguration of a design class in the early 1880s by its then headmaster, the designer

Thomas Simmonds, whose policy was continued under his successor Fra Newbery in the appointment of the School's first dedicated Design Master, Aston Nicholas, in 1885. He, along with Newbery as educational manager, would be primarily responsible for the design course until 1902.

Nicholas's remit had been to give a general course, design being seen more as the ornamentation of objects than the formal conception of the artefacts themselves. Training was a matter of inculcating a thorough knowledge of historical ornament across different cultures, and a study of natural form as a source of ornamental motifs. Thus students attended historical lectures in which ornament and its geometrical structure were analysed. They also made copies from what were deemed to be good examples and drew botanical specimens, examining their structure and different stages of growth in order to adapt their forms to ornament – a process known as 'conventionalisation'. Nicholas also gave lectures on different industrial processes, supported by visits to factories, warehouses and workshops. Designs on paper were then produced for specific manufactures and materials. Most of Nicholas's students were from the working and lower middle classes, who attended in the evening, being employed in the city's workshops during the day. It was these students who, during the 15 years up to 1900 when it was operating under the South Kensington regime, had helped to gain the institution a leading position amongst British schools of art, a position which had very little to do with the emergence of the Glasgow Style. Between 1886 and 1900 the School was consistently among the three most successful in the Kingdom, obtaining and retaining first place in the Department of Science and Art's league tables from 1897. During this period its students had won an impressive 242 medals in the National Competitions, 116 of which were for design, with 89 of the recipients being employed in Glasgow's commercial workshops.

Even in the 1904/05 session, when the Design Department had a roll of 89, the general design class, catering mainly for textile workers, was the largest with 65 students.[5]

The opening in 1893 of a suite of technical studios, which provided hands-on teaching in a number of crafts, appears to have had little impact on the majority of students, and was patronised far more by the middle-classes looking for an outlet for themselves as artists through craft production. The availability of the new facility coincided with a growing interest in design amongst middle-class women in the day classes, who had previously concentrated on fine art subjects but were now also taking courses with Nicholas. Art needlework, china-painting, bookbinding and illustration, silversmithing, gesso, enamelling and *repoussé* metalwork were all taken up by this group. These were crafts adapted to workshops in which individuals or small groups were the unit of production, and whose output could be sold via exhibitions or retail outlets, in much the same way as paintings. Middle-class women would also form the largest group of students and alumni to set up their own craft workshops in the city,[6] and would become a major part of the teaching staff in the technical studios.[7] Although most students attended Nicholas's classes, the technical studios were seen more as an optional adjunct to the design course rather than central to it. They were not under the control of the Design Master but were each run by a designer conversant with the particular craft, and a technician with the appropriate practical experience. This implicit distinction between designing and making was also present in the policy of the department: entry into the craft classes was optional and was only permitted to students after they had proved their ability in drawing.[8]

A view of the department when it had recently moved into the half-completed Mackintosh building was given by the SED's inspector, Robert Anning Bell (1863–1933), who visited the School in March 1903. At this time general design classes were being held in the large room at the eastern end of the first floor, which Mackintosh had intended as the Board Room [FIG. 6.6], and the technical studios were located in a leaking temporary shed on the undeveloped western half of the site [FIG. 6.7]. Bell was a particularly well-qualified inspector. He was an artist-craftsman, had been trained as an architect, and was a prominent member of both the Arts and Crafts Exhibition Society and the Art Workers' Guild. He was also a water-colourist and modeller, and a master of several crafts, such as stained glass, gesso and decorative plasterwork, mosaic, metalwork and enamels. In addition he was an illustrator and designer for embroidery and textiles, with a particular interest in the application of decorative art to buildings. He praised the School's insistence on good draughtsmanship as the basis of design as well as the work of several of the technical studios for the commercial potential of their teaching, noting that 17 designers were 'working in their own studios as independent artists'.[9] As far as the School's training of tradesmen was concerned, Bell, with his interest in decorative art, singled out the stencilling (interior design) classes for their useful work in training the heads of decorative firms and their foremen, whose example would exert more influence on the output of such firms and whose business had increased as a result of their attendance. His comments on the large textile classes were, however, more reserved: he had praise for their ability in adapting designs to the conditions of production, but found the work uninteresting and too subservient to trade demands.

His concerns were matched by those of Newbery and the School Governors, who were coming to the view that the department as a whole required a dedicated professor of high standing to raise the quality of the teaching, particularly in the textile area, and to improve the School's relationship with

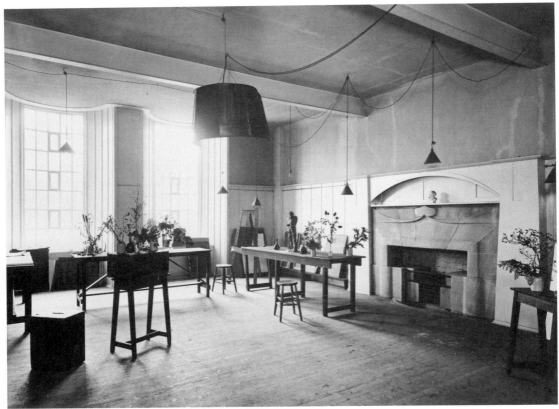

6.6 The Design Room, Glasgow School of Art, set up for flower drawing, 1910.

6.7 Alexander McGibbon (attrib.), *Glasgow School of Art*, pen and ink drawing, c.1907. The shed to the right of the main block contained the technical studios.

industry.[10] The belief that a major artist-designer as head of the department would provide the necessary impetus for the School to influence all areas of design and manufacture, achieving what the Glasgow Style had already done on a smaller scale through the establishment of craft workshops, would be a major driving force behind its design policy for the remainder of the period.

As it was believed that the best textile designs, along with much else in the field of decorative art, were still being produced in France, and as Glasgow's manufacturers tended to purchase many of their designs from Paris, a deputation was sent in January

6.8 Adolphe Giraldon, design for a book cover, c.1907.

6.9a Unknown designer, GSA letterhead in the Glasgow Style. The design was used on Annual Reports and other School documents from 1901 to 1935.

6.9b The Glasgow Style repudiated: Adolphe Giraldon's alternative design for GSA letterhead, c.1907.

1904 to the schools in Lyons, Paris, Roubaix and Lille to examine their methods and to seek a professor.[11] As a result of the visit the designer Adolphe Giraldon (1855–1933) was appointed. His work, the governors observed, had 'a distinct character and [was] carried out with that perfection of technique that is so noteworthy a feature of all French craftsmanship'.[12] Anning Bell, commenting on Giraldon's work over 20 years later, was less complimentary, describing it as being in a 'very accomplished but entirely bookish style.'[13] [FIG. 6.8] Margaret Macdonald, on the other hand, saw the appointment as an effort to stamp out the Mackintosh, or Glasgow Style, influence in the city [FIGS 6.9a & 6.9b].[14]

Despite the governors' expectations, the new professor's strengths lay more in general design than the crafts, or in relating teaching to industry. He required each student to go through a 'Preparatory Course' before passing into the Design Room. This was largely run by Nicholas and, like his own earlier course, embraced working from nature and historic ornament, as well as the study of geometry. It was, however, a more inclusive programme, incorporating fine art elements such as drawing from life and the Antique, elementary modelling and classes in perspective and architecture. The students would then be ready for the 'Advanced Course', a curriculum based on French Beaux-Arts practice, in which they were provided with the plan and elevations of a room for which they were asked to devise a programme of decoration. As part of this process, lectures on the various crafts and 'general studies' were followed by the production of sketch designs, which were then 'corrected' by Giraldon before being returned to the students for completion. One example, set in the 1907/08 session, was a project for the decoration of a room, which required the students to provide a general elevation along with designs for light fittings and vases, a mosaic pavement and a central rug, silk hangings and a frieze for the walls, lace curtains for the windows and stained glass in the roof-light, all drawn to a specified scale [FIG. 6.10].[15]

Giraldon's contract only required him to visit Glasgow for three months in the year and, although he certainly had an influence on the students' work,[16] this did not allow him enough time properly to direct the course. This was a weakness that was noted in 1906 by the SED's inspector Robert Rowand Anderson, who felt that Giraldon was 'not sufficiently in contact with the students to produce the desired results'.[17] Moreover, the improved links with manufacturers that the Governors had expected had not been realised.[18]

After two further years of unsatisfactory results the Governors and Newbery began to consider alternative arrangements. As early as 1903 the School had held a conference with the Glasgow and West of Scotland Technical College, at the latter's request, to examine ways of correlating the School's design course with its own classes, which had also been set up in 1893 but were focused more on the needs of the tradesman than the emergent artist.[19] The conference had produced no direct results, but the establishment of a Joint Committee on Architecture to run the Glasgow School of Architecture a year later (see Chapter Five) provided

6.10 Isabel Spence, design for a frieze incorporating stained glass and stencilled decoration for a hall dedicated to Shakespeare. The School *Prospectus* for 1905/06 tells us that this design was produced as part of Giraldon's programme for that session.

a permanent forum in which such projects could be discussed. The Joint Committee had been responsible for the appointment of the decorative artist John Ednie as Director of the College's Industrial Art Classes in 1906,[20] and by 1908 was beginning to look afresh at further possibilities for co-operation. The time for this was ripe, especially since the School would have enlarged facilities for design teaching on the completion of its building, and since the Glasgow Weaving College, where the School already provided design teaching, had itself recently been absorbed into the Technical College. It was suggested, therefore, that a 'Glasgow School of Design' might be established on the pattern of the Glasgow School of Architecture, under a joint, full-time professor, who would co-ordinate the artistic and practical training provided in the two institutions.[21]

The upshot of this was that Giraldon was asked to resign and a search was initiated for 'an artist of eminence' to replace him. The School's interest in French designers appears to have cooled, as the Governors were now considering some of the major British Arts and Crafts architects who also happened to be accomplished designers. This seemed an obvious strategy for a school still committed to the historic understanding of architecture as the 'mother of the arts', and the context in which all the other art and design practices found their natural home. By May 1908, M. H. Baillie Scott,[22] C. F. A. Voysey and Henry Wilson, together with the designers Herbert MacNair and Edward Spencer, were being discussed. Voysey and Wilson were the favoured candidates and were to be interviewed in London by a deputation of governors and a representative from the Joint Committee of the Technical College, after which the successful interviewee would be asked to submit a report on the section.[23]

Matters, however, turned out rather differently. Voysey, who had shown an interest in the post,

wanted £100 more than the £450 on offer. This was for travelling expenses, as he was not ready to relinquish his London practice for nine months each year in Glasgow. Wilson, on the other hand was not interested, but was able to recommend his own candidate, William Edward Frank Britten (1848–1916), who, he assured Newbery, was a 'genius'. Britten had an impressive record. He was a decorative figure artist of some note, having executed in situ work in two spandrels of the dome of St Paul's Cathedral alongside one of Britain's most highly regarded painters, George Frederick Watts. He had also been a protégé of the country's most eminent artist, Lord Leighton, late president of the Royal Academy, and visitors to the Victoria and Albert Museum could admire his work in the high classical style, located close to Leighton's own mural *The Arts as Applied to Peace* in the Prince Consort's Gallery [FIGS 6.11a & 6.11b].[24]

The deputation, however, recorded that:

> Mr Britten has done little or nothing in the way of design for the art manufactures, is not versed in the knowledge of mechanical requirements and technical processes. He frankly confessed this but stated that he should experience no difficulty in obtaining the required information and knowledge.

Wilson supported Britten in this, stating that 'his [Wilson's] experience led him to the conclusion that granted the great knowledge of design possessed by Mr Britten its application to the industrial arts was a small matter'.[25] The result was that Britten was appointed without even being required to submit a report. And like Giraldon,

he left his mark on the students' work. His style, described by Anning Bell as rather like the work of Alfred Stevens,[26] a well-regarded sculptor heavily influenced by Michelangelo, would have been in evidence in the allegorical murals featuring figures symbolising *Architecture, Painting, Science* and *The Arts of War and Peace*, together with modelled panels representing *Day* and *Night* that the School made for the Decorative Art building in Glasgow's 1911 Scottish Exhibition of History, Art and Science.[27]

Despite successful projects like this, however, the hopes of Newbery and the Governors that a distinctive Glasgow School of Design would result from the new incumbent's appointment were not to be realised. Britten's contract required him to take charge of design classes in both the School and the Technical College,[28] and Newbery also began to draw Britten into work with the Weaving College by organising a programme of shared lectures.[29] If Britten had strengths as an artist, Newbery soon came to the conclusion that he had no abilities as an administrator or a teacher. As early as November 1908, two months into Britten's first term, Newbery wrote to Henry Wilson: 'I rather fear he [Britten] finds it rather difficult to harness his Pegasus to the hum-drum pulling of the every day cart',[30] and two

Top
6.11a William Edward Frank Britten, *Irene and Plutus, c.*1907.

6.11b William Edward Frank Britten, *Blind Fury, c.*1907. This, like 6.11a, was designed for the soffits of a lunette containing Frederic Leighton's *Industrial Arts Applied to Peace*, in the Prince Consort's Gallery (now the Leighton Corridor) in the Victoria & Albert Museum, London.

months later it came to Newbery's notice that the Professor's classes were poorly attended, largely because Britten was unwilling to cater for the uneven level of ability among his students. He also had difficulty in drawing up and keeping to timetables.[31] Indeed, he appears to have been so ineffective that after a year in his post Newbery felt obliged to draw up a document explaining his responsibilities and proposing a reorganisation of the design section to give better provision for the teaching of textile design.[32] It was subsequently decided that Newbery should once more direct the department but should seek out a specialist textile professor, retaining Britten for some of the latter's other classes.[33] The new professor would be responsible both for the basic design course given to all students in the section, and for the specialist training of textile designers. He would thus have to be both an artist and a designer, and a man with expert knowledge of manufacturing and trade requirements.[34]

After an intensive search yielded no suitable candidates, Newbery opened discussions with Robert Anning Bell, asking if he might consider acting as Visitor.[35] Bell, however, replied that he would be interested in a closer association, putting himself forward for the design professorship.[36] Bell was thus invited to report on the design classes,[37] and was subsequently appointed to visit the School for six months each year at £500 per annum,[38] Britten being retained as Professor of Composition until July 1912.[39]

The 1909/10 session, during Britten's period as Professor, had witnessed the completion of the School building and a rewriting of the Diploma course by Newbery. The department retained its Design Room at the eastern end of the first floor but had acquired a suite of fully equipped technical studios, now referred to as 'Decorative Art Studios', along the north eastern frontage of the basement [FIG. 6.12]. The large art needlework section, under

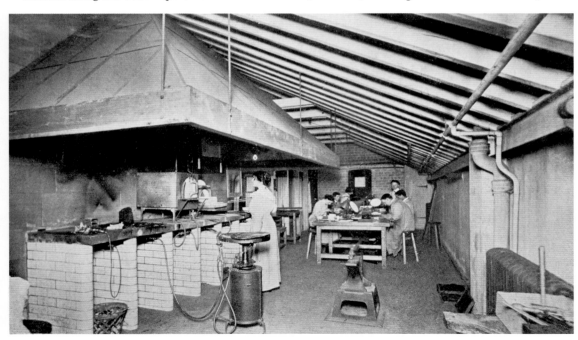

6.12 Enamelling and Jewellery Technical Studio, Glasgow School of Art, c.1913.

Ann Macbeth and Frances Macdonald, moved into a spacious classroom at the eastern end of the attic storey [FIG. 6.13] with other 'lighter' crafts being taught in the attic corridors.[40] The Diploma course, which was now only open to day students, included practical work in at least one craft, from Group 1, as a compulsory element.[41] Evening students first took an elementary course on the principles of ornament, the study of plant form (historic ornament now being regarded as less important), and the construction of pattern and its application to specific manufactures. This was followed by a course tailored to their individual needs including, if required, access to the Weaving College.[42]

From the start of his appointment Bell took a more active interest in the technical studios, integrating them still further into the curriculum, and had his own vital ideas on how to develop the department. In his report he had noted that too few students were going in for design and the crafts

compared to painting. He also pointed out that students were inclined to make designs for too many crafts that they would never have the opportunity of mastering. Moreover, indicating that the Glasgow Style still held a prominent position, he felt that the School's design work was 'too feminine in character', qualifying this by saying that a style of design that was suitable for embroidery had 'crept in everywhere'. Demanding 'less in the way of bric-à-brac', and echoing his 1903 inspector's report, he suggested that more prominence be given to 'the sort of design which is manifestly intended to play up to architecture'.[43]

In 1916, after five years at the School, Bell reported on the changes he had made. These embodied a reorientation in philosophy towards basing design on a direct and early knowledge of tools and materials, rather than beginning with designs on paper. Thus, for example, stained glass students were made to handle glass and lead, to choose glass for

6.13 Embroidery Studio, Glasgow School of Art, 1910.

6.14 Robert Anning Bell, *Florence Nightingale*, stained glass and lead, Glasgow Royal Infirmary, 1912. Bell worked on several windows for the chapels of three Glasgow hospitals, the Royal Infirmary, Gartnavel Hospital and the Western Infirmary, while he was on the staff at GSA.

manufacture, and all his suggestions related to developing these two areas. He was concerned that students were not given enough opportunity to discover the potential of design, *vis-à-vis* painting, as a profession, and believed that this accounted for the smaller numbers in his department. He thus proposed, with Newbery's agreement, that there should be a larger design element in the earlier years of the course, extending it into Group II.[45]

Bell, while fostering existing craft teaching, brought in specialists from elsewhere to improve weak areas such as enamelling,[46] which was not a craft indigenous to Glasgow, and inaugurated the School's first full-scale ceramics course.[47] Other skills closer to his own specialism – design in relation to buildings – were introduced, which he justified by pointing to Glasgow's strong architectural tradition. These were the staining and gilding of wood, and mural decoration, both in paint and plaster. He also set aside spaces in the School where decorative schemes could be constructed with the purpose of giving the students experience of working in collaboration, each applying their particular craft skills in conditions that they would be likely to meet in the real world. From a surviving photograph of one of these schemes it would appear that Bell's approach was derived from the model of a Renaissance workshop in which he, as the master, was responsible for the overall design, while the students carried out parts of the project under his direction [FIGS 6.16 & 6.18].[48] Painting was also taught in the School as a craft under a specialist master, Georges Baltus, who covered tempera [FIGS 4.13 & 4.15], fresco and casein in addition to the more traditional oil painting. Bell also encouraged closer collaboration with the Drawing and Painting Department in the production of murals for public buildings, the one completed scheme being the decoration in 1914 of Possilpark Library, discussed in Chapter Four.[49] Lastly he established a permanent exhibition space where work could be

its colour and texture, and attempt some simple painting before being allowed to make paper designs or cartoons.[44]

Bell's strengths were in craftwork and general design [FIGS 6.14 & 6.15], as opposed to designs for

shown to manufacturers, as potential employers, and to the general public.[50]

Bell had begun to attract increasing numbers of pupils by the outbreak of the Great War and far more of these were now specialising in the crafts. Between 1911 and 1913 the number of design students had increased from 67 to 88. At the same time, however, 157 students were taking general design subjects. Of these 22 men and 97 women were working in the craft studios.[51]

The School records are silent about the numbers of students specialising in textiles, an area that was still giving concern. In fact Newbery and several of the Governors were critical of Bell's failure to consider this in his 1916 report.[52] As early as 1905 the School and the Weaving College had introduced a course for commercial men in the textile trades.[53] Aimed at manufacturers, salesmen and buyers, it was intended, through them, to influence the future of design.[54] In the event it only attracted moderate numbers.[55] Additionally, an ongoing course of complementary lectures was given by the staff of both institutions.[56] These courses were continued when the Technical College took over the Weaving College in 1908, the School giving the art instruction in the Technical College's courses for diplomas and certificates in textile manufacture.[57] If Newbery and the Governors were concerned that Bell had not really addressed this aspect of the School's work in his plans, Bell himself found it difficult to discover ways of influencing design in the textile industry. Although the courses in general were well attended and resulted in ready employment for their students, he still found their designs uninspiring, describing them as 'the sort of thing which suits the rather uneducated taste of the majority of the

Top
6.15 Robert Anning Bell, illustration for *Poems by Percy Bysshe Shelley*, London, 1910.
6.16 Press photograph of the lunette painting *Titania and the Indian Child*, 1917. The lunette was designed by Robert Anning Bell and executed by his students.

public'.[58] This was hardly an instance of the artist pushing forward the boundaries of design.

The Glasgow Style had demonstrated the School's ability to do precisely this. Its fostering of individuality through the Glasgow School of Art Club was noted by contemporaries,[59] and there is ample evidence of this quality in the work of Mackintosh, MacNair, the Macdonald sisters, Jessie Newbery, Ann Macbeth and Jessie M. King. Much of the remainder of the Glasgow Style work was, however, highly derivative, and this suggests that Newbery's remarks to King quoted at the start of this essay refer to the failure to produce

6.17 Walter Crane, poster design for the British Arts and Crafts exhibition at the Pavillon de Marsan, Paris, 1914.

further innovative work in the new century. Additional confirmation of this can be found in Bell's observation that there were three conflicting styles in evidence in the School on his arrival in 1911: they were the Glasgow Style, and the work influenced by Giraldon and Britten respectively.[60] In turn Bell's own influence was to become apparent,[61] as can be seen from the collaborative projects he set his students, such as the Possilpark murals. It was almost certainly apparent also in the unlisted decorative art work shown at the School's last foreign exhibition before the war, in the Pavillon de Marsan in Paris in 1914 [FIG. 6.17]. This exhibition differed from the 1902 show at Turin in several respects. Rather than being international in its scope it focused on British and Irish decorative art, and whilst incorporating the work of living artists it had a retrospective flavour, prominently featuring the work of William Morris, who had died in 1896. This was also largely true of the work selected by Newbery and Bell, which Newbery described as being 'expressive of a certain phase of Scottish decorative art'.[62] In contrast to the work at Turin, all of the listed exhibits were by members of staff or alumni and were far fewer in number, representing only eight artists. Ten of the works were by seven designers associated with the Glasgow Style – Mackintosh, Margaret Macdonald, Jessie M. King, Ann Macbeth, the bookbinder John Macbeth and the sisters Dorothy and Olive Carleton Smyth – while the remaining 13 works were by Bell himself.[63] We only know that student work was included from a letter sent by Newbery to the exhibition organiser, Isidore Spielmann. Newbery's initial suggestion was that their contribution would take the form of allegorical figures painted by some of the artists who had worked on the Possilpark commission, with the intention that they could later be installed in Glasgow's new public library at Langside.[64] However, probably because of the shortage of time, and because of the uncertainty

about the requirements for the library, the scheme comprised no more than a series of heraldic shields representing Paris, London and the countries of the United Kingdom, together with a tympanum that was probably similar to the lunette already referred to designed by Bell [FIG. 6.18].[65] It is also likely that these works were all done to Bell's design and under his supervision.

So perhaps in his letter to King, quoted at the start of this chapter, Newbery was conceding that the reputation of the School's design section, once so noteworthy because of its students, now depended wholly on its staff. Despite the fact that all the educational elements that had produced the Glasgow Style were still present in the institution – the School of Art Club, a thorough, improved design course, an insistence on good drawing and better provision for training in the crafts – the department had proved itself incapable of repeating its earlier triumphs. Bell had probably been correct

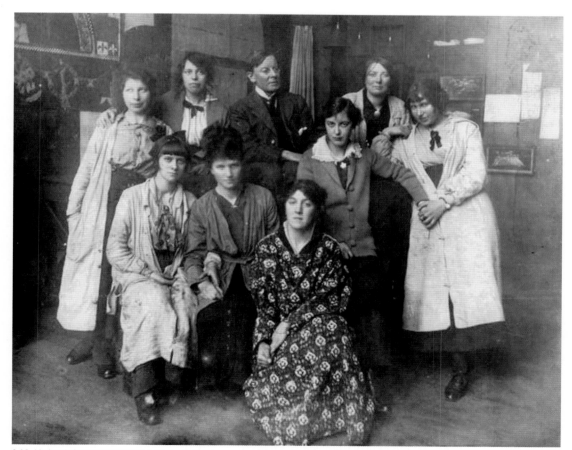

6.18 Undated photograph of Robert Anning Bell and a group of students. On the left is an example of a lunette that contains heraldry. A similar piece was produced for the British Arts and Crafts Exhibition at the Pavillon de Marsan, Paris, in 1914.

in seeing the Glasgow Style as a dead end on the grounds that it employed a limited vocabulary, but he was less perspicacious in claiming that its disregard for tradition would be a factor in its early demise.[66] Tradition would no longer guarantee a style's longevity. His own tradition-based style, a blend of Classicism and the Italian *quattrocento* in a unified architectural setting, still envisaged the future of design in terms of ornamentation, led by the individualist craft worker who produced one-off commissions for the luxury market. Design's future, however, would lie in a complete break with tradition and a jettisoning of ornament in favour of an orientation towards product design for mass consumption, a discipline that would flourish in Germany where educationists, innovative designers and entrepreneurial manufacturers willingly co-operated with one another.

Newbery had in fact seen this future with his own eyes. After accompanying some of his staff to the Paris exhibition[67] he had gone on alone to examine another very different show with which he declared himself to be 'nothing short of overwhelmed'.[68] This was the *Deutscher Werkbund* exhibition in Cologne, where he experienced Modernist architecture in concrete, steel and glass by Walter Gropius, Bruno Taut and Henry van de Velde. The *Werkbund* had been instigated in 1907 by Newbery's friend Hermann Muthesius as a state-sponsored effort to integrate design, craft and industrial production, embracing standardisation and functionalism, and repudiating ornament. Yet if Newbery was overwhelmed by the *Werkbund*, he was not inspired to follow its lead. Other British designers and manufacturers who had been to Cologne and wished to raise the standard of industrial design on the German model had set up the Design and Industries Association (DIA) in 1915 as a positive response. Newbery, however, decided not to join. He indicated his reasons in a letter to J. Hislop Pettigrew, a partner in a major Glasgow department store, who had sent him the prospectus of Leicester School of Art, one of the few schools in Britain to align itself with the DIA in promoting the design of everyday objects.[69] 'The Design and Industries Association', he explained:

> made us aware of its coming existence and we went carefully into the matter of its possibilities for good, but failed to find them. Professor Anning Bell is not, I think, a Member nor did I give adhesion because we both feel that the Arts & Crafts Society made the new association somewhat unnecessary. We keep ourselves in touch with any new movement, if only to find out its potentialities, and both in Art and in economics we feel the latter society to be the one that should be encouraged.[70]

Newbery was not opposed to the artist designing for mass manufacture; in fact he welcomed it as another area of influence and expression for the practitioner. He was less enthusiastic, however, about the artist being forced to design down to the 'level of the machine',[71] what after the war would be trumpeted as the 'machine aesthetic'. His sentiments remained firmly on the side of the romantic individualism that had produced the Glasgow Style, an attitude that would go rapidly out of fashion in the post-war world of functionalist Modernism. It was not until the late 1940s, some 30 years after Newbery retired, that Glasgow School of Art introduced a course in Product Design.

Chapter Seven

'Hope in Honest Error': the Department of Modelling and Sculpture

RAY MCKENZIE

To anybody visiting the Mackintosh Building today, one of the most striking reminders of the School's history as a place of higher learning is the abundance of plaster facsimiles of works of art that are encountered at almost every turn. Perhaps even more than the building itself, these ghostly simulacra of the glories of earlier civilisations offer a clue to the activities that occurred within it, and the pedagogic values that dominated the teaching of art until a

comparatively recent time. They come, almost literally, in all shapes and sizes. In the corridors and main access spaces they mostly take the form of full-length figures standing on bespoke pedestals, posing and gesturing with all the eloquence associated with the art of Classical Antiquity and the Italian Renaissance [FIG. 7.1]. Elsewhere we find relief panels of various kinds – including narrative friezes and portrait roundels – attached to

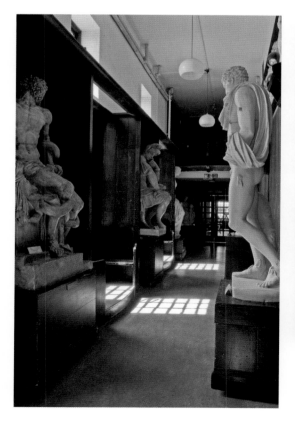

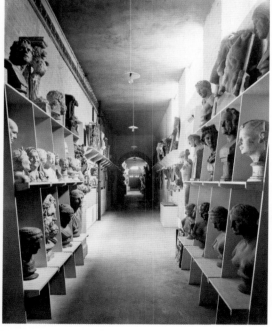

Left
7.1 West corridor, first floor, Glasgow School of Art, 2009.
7.2 West corridor, basement, Glasgow School of Art, 1910.

whatever wall space will accommodate them, and fragments of architectural ornamentation in every conceivable style jostling side by side on shelves [FIG. 7.2]. An inventory compiled in 2008 for conservation purposes lists nearly 200 individual items, but it is evident from early photographs, along with the purchase records dating from the time they were acquired, that this is only a small remnant of the original collection, which probably ran to well over 1,000 pieces.[1] A significant part of the School's annual budget was swallowed up by this continually expanding museum of historic specimens, so we may assume that they were more than just a decorative appendage to Mackintosh's building. In fact they were central to the education process itself. The mere visibility of such an abundance of artistic excellence was sufficient to ensure that the 'taste' of the students developed in the approved way. More importantly they were, along with the life model, the main focus of their attention during the act of learning itself, confronting the students with a succession of graded visual challenges that they were required to wrestle with and resolve for themselves in their own slow progress towards the mastery of form [FIGS 1.3 & 4.2]. Glasgow School of Art effectively came into being in 1845 with a government grant to facilitate 'the formation of [a collection] of casts of works of Art, for the purposes of instruction'.[2] Many important developments had occurred during the half century that had elapsed by the time the first cohort of students moved into the completed west section of Mackintosh's building, but in one major respect the approach to teaching had remained unchanged: it was the study of sculpture that turned students into artists and designers.

The ubiquity of sculpture in both the building and the curriculum meant that the Department of Modelling and Sculpture operated on a slightly different basis from the three other main teaching areas of the School. Odd as it may seem under the

circumstances, it was in fact the smallest of the four departments, with student enrolments rarely rising above 40 in any one year. In the academic session 1910/11, for example, there were no more than 35 modellers out of a student population of 1377.[3] The minority status of the sculpture students is also reflected in various other aspects of the School's performance that can be quantified statistically, such as the award of prizes, bursaries and scholarships. It is not unknown for the names of students from the Sculpture Department to appear in the lists of awards published in the Annual Reports of the period, and in 1914 a modeller named Walter Davidson won the coveted Haldane Travelling Scholarship, worth a princely £50.[4] But these are the exceptions rather than the rule, and on the whole it tended to be the painters who had the lion's share when it came to the disbursement of honours.

A closer examination of what actually went on in the department, however, suggests that the situation was a little more complicated than this, and that the raw statistics are misleading in a number of important respects. To begin with, the figures quoted in the Annual Reports refer only to those students enrolled in the department itself, taking no account of the much larger body of students for whom either modelling or carving was a regular, timetabled adjunct to their main study. Architecture students, for example, were required to attend modelling classes as a vital link between the purely imaginary conceptions they produced on their drawing boards and the structures that they would eventually build in the real world: structures, that is to say, that are made of solid materials, that occupy space, obey the laws of gravity and respond to the impact of light. Under the Beaux-Arts regime that has been described in Chapter Five, architecture was conceived as something that not only required carved ornamentation in order to be complete, but was itself defined primarily as 'an art of Sculpture in geometric forms' [FIGS 3.9 & 3.10].[5] Decorative designers, too,

stood to benefit from the acquisition of skills taught in the modelling room, and we have seen already that modelling was insisted on by Maurice Greiffenhagen as a mandatory requirement for painting students at an early stage (see Chapter Four). There was even a school of thought that regarded modelling from life, with its more direct engagement with material form, as a far more reliable route to the mastery of human anatomy than working with a pencil on a sheet of paper.[6]

Nor was the traffic all in one direction. If large numbers of students migrated on a regular basis into the modelling studios, the staff of the Sculpture Department made significant contributions to a range of disciplines across the rest of the School. For many years George Gregory, the Master of Ornament in the Modelling section, was also expected to teach stone carving and pointing to the students of decorative art, while his colleague James Gray, the Instructor in Antique Modelling [FIG. 4.2], was given responsibility for running the entire programme of Thursday and Saturday classes for art teachers. Some years earlier, when Gray was no more than an Assistant Master, his head of department William Kellock Brown [FIG. 7.3] was also in charge of the design students opting for the handicrafts involving metal, such as wrought iron and *repoussé*.

What all this shows is that in spite of the relatively modest numbers of students who opted for sculpture as their main study, the skills associated with it were seen as a central part of almost every other discipline in the School. Not only was modelling acknowledged as the most effective vehicle for developing a student's powers of observation, but it also encompassed anything in which the representational process that comes from those observations involves the fashioning of a three-dimensional object, in whatever material and whatever the scale. When Mackintosh placed the modelling studios in the basement of the new building he was no doubt thinking primarily of the practical advantages of locating all the processes that involve the use of large quantities of heavy materials – stone, clay and plaster – in spaces immediately adjacent to the entrance on Scott Street [FIG. 3.14]. But there was a metaphorical aptness to this arrangement as well, as if modelling and carving – but most of all modelling – provided the foundation for everything that went on in the studios on the three floors above.

If the involvement of modelling staff in so many other areas of the School gave the section something of the status of a 'service department', it nevertheless had clearly defined educational objectives of its own, and developed its curriculum and teaching strategies accordingly. From 1905 onwards, in keeping with the practice adopted by the rest of the School, the modelling students had to pass through four separate stages – the 'Groups'

7.3 William Kellock Brown in 1898.

already referred to in Chapter One – with the first two belonging to the Lower and the second to the Upper Division of the School.[7] There was a heavy emphasis on drawing throughout, but once the actual process of modelling was embarked on in Group 11 – in every sense the start of the 'hands-on' part of the course – the students were taken through a series of increasingly demanding tasks that would lead eventually to the production of full-size figures from the life model and the Antique, together with ambitious architectural schemes incorporating the human figure. Only when they had mastered all this would they have been ready to present 'proof works' for the Diploma examination.

The teaching methods adopted by the staff on the studio floor varied according to the requirements imposed by different aspects of the curriculum. Guided by Newbery's conviction that 'an ounce of practice is worth a pound of precept',[8] much of the real learning no doubt occurred through the daily grind of trial and error, with the staff criticising and correcting the students' practical efforts as they progressed. This is surely what lies behind W. R. Lethaby's maxim, quoted so memorably by Mackintosh, that 'there is hope in honest error, none in the icy perfection of the mere stylist'.[9] But of course there was room for 'precept' as well, and a regular programme of lectures on anatomy and proportion and other theoretical concerns formed an important supplement to the ongoing routine of working directly with clay and stone. More than any other discipline in the School, however, modelling relied very heavily on practical demonstration, in which the tutor would almost literally 'perform' a

particular technique to the class, who would learn by seeing a work created in front of their eyes. These would progress in the natural sequence involved in the making of a figure or a portrait bust, starting with the construction of the armature, then moving through the more specialist procedures that came into play in building up the bone and muscle structure from within. They would be shown how to use 'butterflies' to support the interior mass of the clay, callipers and plumb lines and other measuring devices to manage the increasingly complex pattern of three-dimensional relationship that evolved as the main volumes took shape, and finally the technique of applying the outer 'skin' to bring the completed work to life.

As a pedagogic strategy, the practical demonstration is very much associated with Edouard Lanteri, the Head of Modelling at the Royal College of Art [FIG. 7.4], who was acknowledged as not only the most influential modelling teacher of his generation, but was even credited with creating the so-called New Sculpture movement, the extraordinary flowering of innovative sculpture in Britain in the decades straddling the turn of the century.

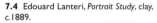
7.4 Edouard Lanteri, *Portrait Study*, clay, c.1889.

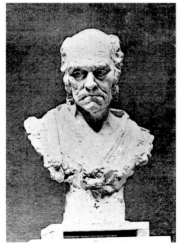

Newbery was a firm believer in this approach to teaching, and in fact invited Lanteri to give a series of four public demonstrations in Glasgow in March 1889. His appointment of William Kellock Brown, a former pupil of Lanteri, to teach at the department at about the same time confirms his claim that the event provided the 'impulse to the study of the art of modelling in Glasgow'.[10] Other sculptural celebrities were invited to conduct master classes of this kind at various later intervals, including Alfred Drury

(1866–1944) in March 1914 and Albert Hodge (1875–1917) in April of the following year.[11] Drury seems to have had a particularly good rapport with the students, prompting a round of cheering from the class after an audacious display in which he corrected the faulty angle in the chin of a portrait bust by removing a wedge of clay with a cheese wire.[12] We must presume that such performances were a regular part of the studio teaching of the School's permanent staff.

An impression of the character of the work the students themselves produced as a result of this guidance, along with an insight into working conditions of the sculpture studios at that time,

can be gained from a group of contemporary photographs preserved in the School Archive. In one print that clearly dates from the end of the School's time at Rose Street [FIG. 7.5], we see the recently appointed Head of Sculpture Johan Keller with his assistant James Gray in the company of a mixed group of male and female students, each of whom is at work on a full-size clay model of a boy holding a shell to his ear. The pose of the figure, together with its unidealised – one might say even rather scrawny – anatomy, is very reminiscent of the contemporary work of Francis Derwent Wood, who was in fact busy with more than one important commission in Glasgow at this time. [FIG. 7.14]

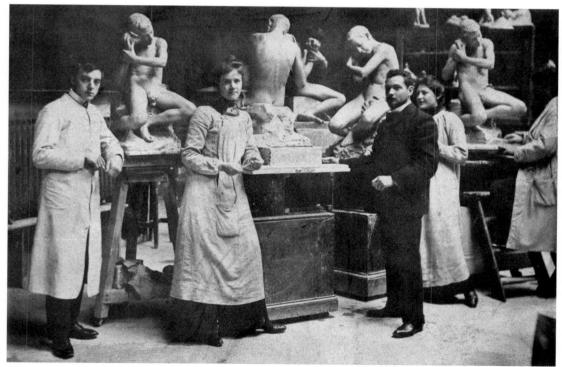

7.5 Johan Keller with students in the modelling studio, Rose Street, 1900. Keller is in the centre, with the students George Alexander and Winifred Hamilton to his left, and Mary Buchanan behind him. His colleague James Gray is on the extreme right. George Alexander (1881–1942) went on to become a successful and highly regarded sculptor [see 7.13 & 7.14], and was particularly admired for his decorative wood carving. Mary Buchanan was admitted to the School in 1900, which suggests that this photograph was taken just before the Department moved to its new studios in Renfrew Street.

In a slightly more ample interior view, this time in one of the basement studios of the Mackintosh Building [FIG. 7.6], Keller appears again with a larger group of students whose assignment in this case is an allegorical female nude seated on a roughly hewn bluff of rock. Perhaps the most striking aspect of both photographs is the discipline-based uniformity of what the students are being taught. Unlike sculpture students today, who are encouraged to produce work that is entirely personal and creatively unique, the students here are much more like apprentices striving to master a clearly circumscribed set of manual skills. At this stage of their development they are all producing what is effectively the same statue,

with very little opportunity to express their 'individuality' as artists. It is evident, however, from the very high standard of the work on display here that this narrowness of pedagogic focus had a very clear pay-off in terms of the students' mastery of technique.

In another group of photographs, which were probably taken slightly later [FIGS 7.7, 7.8 & 7.9], the work on display is more mixed, with portraits and small figures from both life and the Antique combined with a number of examples of architectural ornamentation, such as a scroll bracket, a window pediment and a relief of a winged griffin reminiscent of the sepia drawing made by Mackintosh when he was a student in 1886.[13]

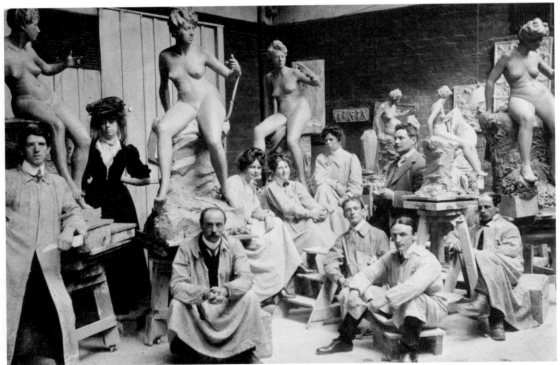

7.6 Johan Keller with students in a modelling studio, Mackintosh Building, c.1904. This is one a group of photographs that were probably donated to the School by the family of Sir William Reid Dick, who is seated here front left. Dick was enrolled at the School between 1899 and 1901, and again between 1904 and 1907. This photograph probably dates from one of the later sessions. The woman on the left wearing a hat and outdoor clothes is probably the model.

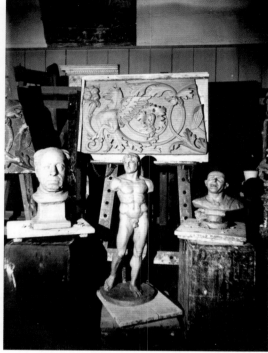

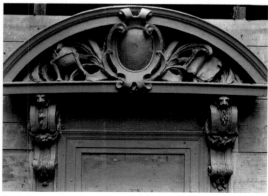

Here too the modelling is carried out with a confident command of technique and a clear understanding of the language of decorative form.

The fact that the same department encompassed these two very different forms of practice reveals the essentially dual role that sculpture tuition was expected to perform at the School at this time, balancing its commitment to the liberal education of creative practitioners with a recognition of a more economically driven demand for skilled craft workers with no pretensions to be thought of as 'artists'. Although we do not have the statistical data to provide an accurate demographic profile of the students who enrolled in the Sculpture Department, there is enough evidence to show that the majority of them were what we would today call 'vocational' students for whom the courses they took at the School were supplementary to their employment as

Top Left
7.7 Architectural bracket in clay by an unknown modelling student, c.1910.
7.8 Door or window pediment in clay by an unknown modelling student, c.1910.
Top Right
7.9 View of a modelling studio with student work, c.1910.

wage-earning artisans. Typically, a student in this category would have been a full-time worker in any one of a variety of trades for which enhanced skills in either carving or modelling were regarded as desirable: stone masonry, metal fabrication, cabinet making, gilding, plastering and so on. His or her studies would almost invariably have been confined to the evening school, on a timetable of two-hour sessions attended three times a week, and the aim of their study would have been to simply develop their hand-skills – and therefore their earning capacity – in the context of an already established career. This was an aspect of the School's function that Newbery took very seriously. As a major manufacturing centre, and with a building boom still underway, Glasgow was a city with an almost insatiable appetite for specialist manual workers, and it was the responsibility of a School of Art to meet that demand with a regular supply of appropriately trained practitioners. How successful the School was in doing this is impossible to quantify except in the broadest terms: indeed part of the purpose of the training programme was that the sculpture students, once qualified, would join the large and almost entirely anonymous workforce that were responsible for the visual adornment of so many of the buildings that were erected in Glasgow at this time: the cartouches and floral friezes, the miles of honeysuckle and egg-and-dart motif that enrich their exteriors, the stair rails, door fittings and plaster reliefs that we find within. Looking over the records of student successes from this period, one wonders what career trajectory was followed by a student named Alexander Weir, who was awarded a silver medal in 1897 for making a copy of an ornamental bracket, or David Brown, who won a national book prize two years later for modelling a 'design for a door knocker'.[14] Perhaps the knocker was eventually produced in cast iron to grace the door of an Edwardian villa in Hyndland. Perhaps it is still there to this day. We will never know.

And yet not every student who passed through the Sculpture Department would remain so obscure, or disappear so readily into the mists of historical anonymity. In the same year that David Brown produced his prize-winning door fixture, another sculpture student named Albert Hodge was similarly rewarded for a 'Modelled Design for the top of a Newel Post'.[15] Within less than two years he had established himself as a full-time independent artist, and by 1901 was being described by the *Glasgow Daily Mail* as 'a Glasgow sculptor now domiciled in London, whose years are yet in the early 20s, but whose work is already known and appreciated among British connoisseurs of his art' [FIG. 7.19].[16] Prizes and bursaries of various kinds were also won in the vintage year of 1897 by Phyllis Archibald, Colin Kenmure and William Vickers, all of whom were soon to achieve wide recognition as professional sculptors. (In fact Phyllis Archibald was already receiving public commissions before she had completed her studies.)[17] In the decades that followed we find a regular stream of students passing through the department on their way to establishing solid reputations in the world of professional practice, including Aniza McGeehan (who completed her studies in 1896), Thomas Clapperton (1901), George Alexander (1902) [FIGS 7.10 & 7.11], Alec Miller (1902), Alexander Proudfoot (1910), Benno Schotz (1917), Archibald Dawson (1920) and Loris Rey (1925). Perhaps the most distinguished of them all was Sir William Reid Dick, who received his Diploma in 1908 and went on to be appointed the King's Sculptor in Ordinary in 1952. Dick is in fact a good example of a student who was able to move freely between the jobbing work of a decorative stone-carver and the more exacting demands of the grand tradition of the figure. He appears in one of the photographs of Keller's class already referred to, seated in front of one of the female nudes, and in a separate photograph that shows him at work on his own with the

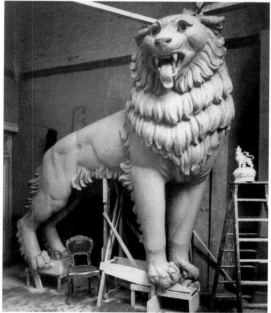

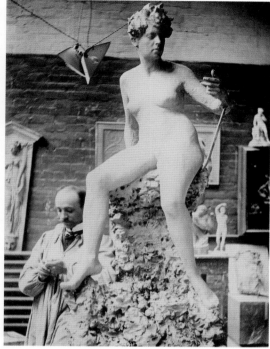

Top Left
7.10 George Alexander, model for *Sheffield War Memorial*, n.d.
7.11 George Alexander, *Lion* for Coronation display, Selfridges, London, 1953.
Top Right
7.12 William Reid Dick, c.1904.

model at a slightly earlier stage of completion [FIGS 7.6 & 7.12]. But we also have photographs of him carrying out repair work on one of the decorative friezes of the City Chambers in 1901, and as one of a team of masons executing the designs of Francis Derwent Wood on the British Linen Bank in Govan a year or so before [FIGS 7.13 & 7.14]. All this was part of the grounding that would guarantee his later emergence as one of the greatest sculptors of his generation.

Nor was it just the high-flying students who achieved outside recognition in this way; many members of staff also had thriving practices as

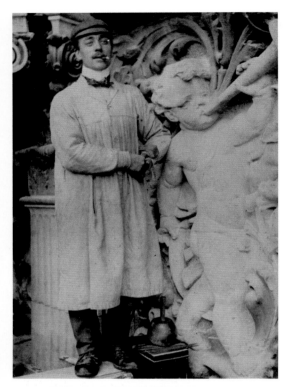

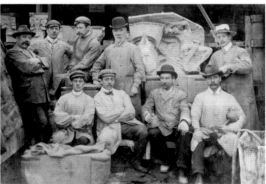

7.13 William Reid Dick carrying out restoration work on the north façade of the City Chambers, Glasgow, 1901.

7.14 Sculpture workshop with William Reid Dick, who is seated in the front row wearing a chequered cap. Among the works being carved are Francis Derwent Wood's *Zephyrs* for the British Linen Company Bank, Govan Road. This would suggest a date of *c.*1898, when Dick was in his late teens and on the point of enrolling at the School.

independent sculptors. One of the most important of Newbery's innovations was his insistence that a good art teacher must be first and foremost a good artist, whose experience of the world of professional practice was as valuable to the student as anything that could be passed on in terms of technical competence. The key to success in Newbery's day, as it perhaps remains in our own, is striking the right balance in the allocation of time between teaching and fulfilling external commitments. For William Kellock Brown, the head of the department for much of the 1890s [FIG. 7.3], it was a balance that became increasingly difficult to maintain as private commissions began to flow in. 'I can see', he wrote in response to Newbery's proposal that he spend more time with his students, 'that this arrangement would prevent me doing important work in my studio'.[18] He resigned in March 1897. Johan Keller, his eventual successor [FIG. 7.15], found it easier to combine the two areas of responsibility, and in the early years of his appointment executed a stream of important commissions that kept him sufficiently in the public eye to warrant an appearance in the 'Men You Know' column of the *Bailie* in 1907 and a full entry in the 1909 edition of *Who's Who in Glasgow*.[19] Among the public works he carried out at this time were the symbolic statue of *Religion* on the parapet of the newly completed Kelvingrove Art Gallery and Museum in 1901 [FIGS 2.6 & 7.16], the *Monument to Dr James Gorman* (1906), in Rutherglen [FIG. 7.17], and the symbolic statue of *Wisdom* on the Mitchell Library (1909). The latter must have been a particularly satisfying experience for him because the building also features a bronze figure of *Minerva* on the dome by one of his most brilliant former pupils, Thomas Clapperton.[20]

Of all the projects with which Keller was associated, however, it is the sculpture scheme for Kelvingrove Museum that tells us most about how the department he ran sat within the wider world of

7.15 Johan Keller in 1907.

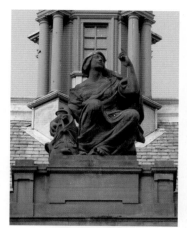

7.16 Johan Keller, *Religion*, Locharbriggs sandstone, 1899, Kelvingrove Art Gallery and Museum, Glasgow.

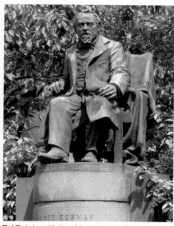

7.17 Johan Keller, *Monument to Dr James Gorman*, bronze, 1901, Main Street, Rutherglen. Keller secured the commission for this monument partly through the intercession of the Chair of the School's Board of Governors, Sir James Fleming [FIG. 1.4].

professional practice. This was not only the most ambitious programme of architectural sculpture in Glasgow since the completion of the City Chambers in 1888, but because it coincided with the inauguration of the Glasgow International Exhibition in May 1901, had an unusually high public profile. As it happens, Keller's statue was, with the exception of the three bronze figures by Archibald Macfarlane Shannan that were added a little later to the towers, the only piece of major figurative work executed by a Glasgow sculptor, with the majority of the others being entrusted to artists from London, including Francis Derwent Wood, who produced the four most prominent parapet figures on the main frontage, and George Frampton, who supervised the whole scheme [FIGS 2.7 & 2.8]. The fact that so much of the work on the building was given to sculptors from outside Glasgow was the cause of some local disquiet, and was even interpreted by some as a snub to the School of Art itself.[21] It is important to note,

however, that this only applies to the figurative work. The scheme also encompassed an extensive programme of decorative carving, the bulk of which was carried out by local artists, almost all of whom had been trained at the School. Although it is now impossible to make precise matches between individual passages of decorative relief work and the carvers who actually chiselled the stone, the documentary records are detailed enough for us to know that at least six of them had received their training in the sculpture department of Glasgow School of Art, including James Harrison Mackinnon, James Sherriff, William Vickers and a then still very youthful William Reid Dick.[22] On balance it seems appropriate, given the dual function of the department, that its head should have been invited to contribute a fully-fledged work of figurative art to the programme, while a small army of former students worked in semi-anonymity on the minor ornamental details.

And there were other ways in which the School

7.18 The Sculpture Hall, Glasgow International Exhibition, Kelvingrove Art Gallery and Museum, 1901. The exhibition was organised by Fra Newbery and the installation was designed by George Frampton and Edward Onslow Ford.

was implicated in the creation of the city's new museum. Visitors to the International Exhibition that accompanied its inauguration in May 1901 would have had ample opportunity to see what the staff and students of the School were capable of achieving at that time by calling in at the ground-floor gallery in the north-east pavilion, which contained a substantial display of their work. In order to reach that corner of the building, however, it would have been necessary for them to pass through the great vaulted Central Hall, and it is here they would have encountered the centrepiece of the Fine Art section: the 'loan exhibition' of

contemporary sculpture, which was described by one reviewer as 'the first representative exhibition of British sculpture ever held' [FIG. 7.18].[23] More than 200 pieces, many of them on a monumental scale, were gathered together for this conspicuous affirmation of Glasgow's status as a centre of visual culture, with work spreading out into the east and west courts, up the two main stair-cases and flowing into the arcaded galleries on the floor above. The selection of work was carried out in the main by the two most prominent British sculptors of their generation, Edward Onslow Ford and George Frampton, who, as we have seen was

7.19 Interior of the Grand Dome, Glasgow International Exhibition, Kelvingrove Park, 1901. Albert Hodge made the colossal plaster statue of King Edward VII and the decorative figures in the pendentives.

also in charge of the sculpture programme on the building itself. Their appointment, however, was made on the recommendation of Fra Newbery, who chaired the relevant sub-committee and was largely responsible for the layout of the show.[24] How much control Newbery had in the actual selection of the work is difficult to say, but it must have been a source of some pride to him to see the work of so many sculptors who had either taught or been taught at the School – Keller himself, his predecessor Kellock Brown and his current assistant James Gray, together with Albert Hodge and William Shireffs – displayed in the company

of the finest sculptors in Britain at that time, along with a range of continental luminaries such as Constatin Meunier, Charles Van der Stappen and Auguste Rodin. It must have been equally gratifying to him to know that one of the undoubted 'stars' of the International Exhibition was Albert Hodge, whose winged figures on the exterior and interior of James Miller's temporary Industrial Hall drew gasps of admiration from everyone who saw them, and whose colossal statue of Edward VII was the most talked-about sculpture in the entire event [FIG. 7.19].[25] In short, 1901 was a good year for Glasgow School of Art in general and for the

Department of Modelling and Sculpture in particular. With its staff occupied with a variety of outside projects, and so many of its recent students beginning to make their mark on the world, it would be difficult to imagine a better set of 'performance indicators' in the year that Glasgow School of Art finally achieved autonomy as a Central Institution in Scotland.

And yet not everything was as it seemed. Throughout the period with which we are concerned, the management of the modelling class was a recurring headache for Newbery, who was forced on a number of occasions to intervene personally to prevent the department's activities grinding to a standstill. His anxieties date back as far as March 1897, when, following a minor dispute with Kellock Brown over his salary, he appointed a sub-committee to 'consider the question of the present working of the modelling department'.[26] Brown's resignation in November – not the most convenient time for a senior member of staff to be departing – was followed by an urgent consultation with George Frampton in London, who for his part suggested that Newbery should invite Francis Derwent Wood to make a flying visit to the School to try to impose order on the modelling classes.[27] The shake-up seems to have been successful, and the outcome was the appointment of Wood as a temporary Visiting Director, with Keller brought in on his recommendation to act as his executive assistant on the ground. In the Annual Report for 1898, Keller is described as the Master of Modelling, with James Harrison Mackinnon acting as his assistant.[28] By 1904 we find him being elevated (along with Maurice Greiffenhagen, Eugène Bourdon, Jean Delville and Adolphe Giraldon) to the status of Professor, with overall responsibility for the programme of 'Antique, Life and Composition' in the now fully-fledged Department of Modelling.[29]

Ironically, it was at this point that the real bomb-shell was dropped on the department. In December

7.20 James Pittendrigh Macgillivray, c.1908.

1904, the distinguished sculptor James Pittendrigh Macgillivray (1856–1938) made the first of a series of four visits to the School as part of an official survey for the SED on the state of art education in Scotland [FIG. 7.20].[30] His findings were damning. With one or two minor reservations, his assessment of the School as a whole was favourable enough, describing its accommodation and equipment as 'much the most advanced in Scotland'.[31] In Drawing and Painting, for example, he judged the teaching to be 'of a high order comparatively', though it is significant that his most serious criticism was that there was too much drawing from plaster statues, which he described as 'a kind of incubus inherited from the past'.[32] But the generally good practice he found here only served to highlight what seemed to him to be the almost completely dysfunctional condition of the modelling classes. The studios that

he no doubt expected to find throbbing with productive energy were virtually deserted, with Keller's own class populated by no more than 'three or four young ladies, who, incidentally, happened to be without a model.' What little activity was going on at the time of his visit he found to be characterised by a lack of 'valuable, practical instruction' on the part of the staff and an 'absence of workmanlike method' among the students. The dire state of the teaching, which left the students unable to perform operations even as basic as rigging up an armature or making a waste-mould in plaster, was matched by equally glaring deficiencies in the provision of tools and equipment, such as pointing machines for the modellers and bankers in the carving studios. When grilled on these matters, Keller apparently conceded that things were a long way from ideal, and that he was in fact 'ashamed of the amateurish methods' that prevailed under his regime.[33] Newbery himself also freely admitted that he was aware of the 'unsatisfactory state' into which the department had been allowed to fall, although if this was intended as a pre-emptive defence it backfired badly, prompting what was probably the most stinging of all the rebukes contained in Macgillivray's evaluation:

> Had the state of matters in this section been fully realised by those responsible for the direction of the school, it would appear to me to be a matter of culpable neglect. Judged by the place it ought to take, comparatively, in the work of such a school at such a centre of population as Glasgow, the section can scarcely be said to exist.[34]

Nor was that all. Pittendrigh Macgillivray was a fine sculptor and a writer of real distinction, but he was also a notorious controversialist, capable of quite spectacular displays of bloody-mindedness and often unable to resist the temptation to launch into a polemical tirade in situations that required no more than sober, dispassionate judgement. In particular, he clearly allowed his view of the School to be coloured by his political commitments, which inclined very firmly towards Scottish nationalism, and the eccentric belief that the function of all art is to express, in some quasi-mystical fashion, the 'spirit' of the country in which it was produced. It is not an exaggeration to say that he wanted art in Scotland to have a Scottish 'accent', and that it was the job of the art schools to provide the appropriate elocution lessons. And so we find him devoting the final section of his report to an extraordinary chauvinistic harangue in which he denounces the 'importation of foreigners to teach in our Art Schools'. He did not 'object to the foreigner as such', only to those 'foreign "Professors"', who could not by definition 'enter into intimate contact with the manner and expression of our emotions', and whose motive for enduring the condition of cultural exile that working in Scotland entailed could never be anything other than 'mercenary'. Keller is not mentioned by name – and there were plenty of other 'foreign "Professors"' he might have had in mind – but it seems likely that he was the main target of Macgillivray's diatribe.[35]

What Newbery's private thoughts were about the findings of this School Inspector from Hell are not recorded, but the official response by the governors was both measured and diplomatic.[36] From their point of view the most positive aspect of the report was that it contained recommendations for practical improvement that could be implemented without delay, such as the purchase of stone bankers for the carving students, a set of 'French Pointing Machines' for the modellers and various other items of studio hardware.[37] They also undertook to allocate more studio space to the department when the second half of the building was completed in 1909, which eventually incorporated facilities for casting, both in plaster and in bronze. These were all boxes that were relatively easy to tick. On the matter of staff competence, however, they were less prepared to be lectured to by a bigoted, ranting xenophobe,

tactfully refusing to rise to the implied slur on the School's use of staff from overseas by simply noting that the 'general Statements' made by Macgillivray were of 'too sweeping a character' for them to be realistically acted upon.[38] Their defence of Keller, moreover, was not just supportive: it was positively fulsome. In what was effectively a thumbnail *curriculum vitae* they set out all the reasons why Keller, far from being the incompetent who had been caught 'asleep' on the day of the visit, was in fact more than qualified to do the job. He had been trained in Brussels under the celebrated Charles Van der Stappen – an artist who had been a good and trusted friend of the School since the late 1890s – and had completed his studies in Paris, Venice and Rome. He had won a gold medal at the International Exhibition in Amsterdam in 1891 and, after coming to the School on the joint recommendation of Derwent Wood and George Frampton, had gone on to win a string of major public commissions in Glasgow. 'We are', the Governors concluded, 'of the opinion that for our purposes he is in every way competent.'[39]

And indeed their confidence in Keller was fully vindicated two years later, when a further inspection of the School was carried out, this time by the veteran architect Sir Robert Rowan Anderson. His endorsement of the work of the department was unequivocal:

> The modelling carried on by Mr Keller both from the antique and the life, is in my opinion of a very high order. I specially noticed some life size models from the nude, which showed great skill on the part of the students. The modelling of ornaments for architectural purposes is well attended to. The practice of making sketches in clay of architectural features, such as doorways and portions of vaulting is worthy of imitation in all schools.[40]

This presents us with a puzzle. His description of the life-size models of the nude calls to mind nothing if not the photographs of the studios already referred to [FIGS 7.5 & 7.6], which date from the period immediately prior to Macgillivray's hostile evaluation. How do we explain the sudden decline in standards between c.1902 and 1904, and their equally dramatic recovery two years later? Perhaps the harshness of the Edinburgh sculptor's assessment was a result of personal prejudice. It is impossible to say. What is clear, however, is that despite Keller's emergence from this episode with a clean bill of health, it was not long before more genuine doubts were to be raised about his effectiveness as a department leader, with the criticisms coming this time from an internal rather than an external source. For the whole of the decade following Macgillivray's report, the department's failure to recruit more than just a handful of students remained a matter of concern for Newbery, who on one occasion in February 1909 was forced to summon Keller's assistant James Gray to explain why he had found the modelling studio completely empty when he chanced to pass through it on the evening of a timetabled class.[41] By 1912, the situation had deteriorated so far that Newbery felt it necessary to initiate a formal investigation, subjecting Keller and his staff to a ferocious interrogation on why the department was failing to thrive.[42] While Gray made the perfectly legitimate observation that the building trade in Glasgow was going through a recession, with a corresponding reduction in the demand for stone carvers, Keller evaded the issue with the rather lame – and mildly tautological – observation that 'sculpture was not yet as popular in Glasgow as elsewhere'. The judgement of the sub-committee appointed to assess the situation (and which incidentally included Mackintosh himself) was swift and brutal. The department was so lacking in vitality and drive that the results it achieved were 'not commensurate with the cost of the Section.' While recognising that the slump in the building trade had adversely affected recruitment, there was still no explanation as to why the department failed to attract students from within the School itself.

Their gloomy conclusion was that 'from the method adopted, no real educational results of any value were possible'. They made three proposals, all of which were accepted by the School Committee with the recommendation that they should be carried out without delay: firstly, that the services of the Professor were to be 'dispensed with'; secondly, that more responsibility should be given to his assistants; and thirdly that a 'professional Sculptor of eminence be asked to take full control of the work of the Section as Visitor on an arranged timetable'.[43] A letter from Keller in February 1913 indicating that he would be unable to continue working at the School beyond September satisfied the first of these requirements without the need for the School to initiate dismissal procedures.[44] In the event, however, his departure appears to have been less than dignified, with the School offering to pay his salary until the end of August if he would agree to leave at Easter. 'It might meet your convenience', the governors volunteered with the casual dissimulation familiar to connoisseurs of management-speak the world over, 'if you were set free at this time from any further responsibility for the work of this section'.[45]

For Newbery himself this must have brought back alarming memories of the crisis into which he had been plunged after the departure of Kellock Brown in 1897. Once again we find him consulting his old friend, the recently knighted Sir George Frampton, for advice on whom he might approach as a replacement for Keller, using his detailed knowledge of the London art scene to rule out sculptors whom he knew 'could not be had' and identify those who might be lured to Glasgow.[46] Ernest Gillick, described as 'one of the most successful of those that have studied with Mr Lanteri', was a strong candidate, but Newbery appears to have been unable to track him down. Another major contender was the rising star of British sculpture, Jacob Epstein, whose appointment would surely have injected a dose of much-needed Modernist energy into the ailing department. However, the recent controversy that had led to the removal of his *Monument to Oscar Wilde* in Pére la Chaise cemetery in Paris evidently made Newbery nervous and he decided against approaching him. 'Mr Epstein is a stylist', he reported to the governors, 'whose work is so personal that it could not be a reliable vehicle for education'.[47]

What Newbery needed at this difficult juncture was, of course, a safe pair of hands, and these he eventually found in the American sculptor Paul Wayland Bartlett, who had recently scored a major success with the completion of his *Monument to Lafayette* in the Cours La Reine in Paris, and was in the early stages of a commission to carve the three northern pediments on the Capitol building in Washington DC.[48] By all accounts Bartlett was a popular and effective Visiting Professor, but the logistical problems involved in trying to organise regular trips to Glasgow while carrying out the Washington commission (acknowledged by Newbery as a 'work of practically life-long duration')[49] proved insurmountable and the arrangement lasted not much more than a year. Even so, despite the brevity of his involvement with the School, Bartlett had managed to introduce some real improvements, and with the assistance of James Gray, who had been working in the department since the days of Kellock Brown, and the more recently appointed Alexander Proudfoot [FIG. 7.21], the department seemed to be on the road to recovery. This was certainly the impression it made on Albert Hodge when, on Newbery's invitation to step temporarily into the breach after Bartlett's departure, he discovered the department to be not only 'the best equipped modelling school I know', but also one 'founded on a distinctly good method of teaching'.[50] His only complaint was that there were still deplorably few students taking advantage of it.

By this time, however, the period we are concerned with in this publication was coming to

its own natural conclusion. If the department had always found it difficult to recruit and maintain its students, the outbreak of the First World War saw the numbers dwindle even further, reaching a point in 1915 when it became necessary to suspend classes 'in consequence of an absence of Male Students'.[51] The main problem for the management was finding ways of keeping the staff busy when there were so few students to teach, the salary cuts

7.21 Alexander Proudfoot, c.1920.

that some members of staff had to accept as a result of this only adding to the general gloom.[52] Nor was it just student numbers that fell as a result of the war. The requirement that all able-bodied teachers sign up for active service resulted in a significant depletion of staff from across the School, including the Modelling Department, which released Alexander Proudfoot from teaching duties in February 1916 to enable him to train with the Artists' Rifles in London.[53] Some idea of the impact the war made on the School generally can be gauged by the figures set out in the Roll of Honour that appeared in the *Annual Report* for 1916/17, which lists the names of 400 students, both past and present, who had gone to the front, along with eight of the teaching staff and one member of the Board of Governors. To these must be added the 33 students and one member of staff – the Head of Architecture Eugène Bourdon – who never returned from the Western Front. In comparison to the war contribution made by other, larger educational

establishments in Glasgow these are perhaps not huge statistics, but their consequences for the School generally, and for the Department of Modelling and Sculpture in particular, were severe. Benno Schotz, who was a part-time student in the department throughout the war years, provides a vivid recollection of the mood of demoralisation that prevailed at this time in the studios, which became increasingly deserted as the war progressed. At one point he was the only modelling student in the entire School, but even so hardly ever spoke to the acting head of the department, possibly because he was, according to Schotz, also doubling as the School Registrar. In the three years he spent in the drawing class he never once received either criticism or advice from the master in charge.[54]

Fortunately for Schotz, no long-term damage was done by this apparent pedagogic neglect. He went on shortly afterwards to establish himself as one of Scotland's leading professional sculptors, eventually returning to the School in 1938 to take over as the head of the department, where he was to remain for the next 23 years. But all this lay in the future. In 1914, when the 23-year-old Schotz enrolled as a part-time evening student, the School was entering a historical twilight zone in which the first phase of its tenure of the Mackintosh Building was drawing to a close, and any sense of what the years ahead had in store was far from clear. The School had many reasons to lament the effects of the war, one of which,

as we have seen, was the loss of Eugène Bourdon, the founding Head of the School of Architecture, who had been killed at the Battle of the Somme on 1 July 1916. Less dramatic, but in the long run much more profound in its impact on the future direction of the School, was the retirement of its Director, Francis H. Newbery, in January 1918, after a prolonged period of ill health, brought on, it would appear, by overwork, and almost certainly exacerbated by the impact of the war on the School.[55] Newbery was to live, and practise as an artist, for another 28 years, but his departure marks the end of an era.

It seems appropriate, under the circumstances, that despite the apparent lassitude into which the Department of Modelling and Sculpture had fallen during the war years, it is to the work of one of its staff that we must turn to find a symbolic closure to these two historically charged events, one of them conceived as an act of mourning, the other as a tribute to an enduring achievement. In November 1916 the School opened a correspondence with Mme Bourdon, the architect's mother, to discuss the funding of a suitable memorial to her son.[56] There were three outcomes: a prize fund, a stained glass window designed by Anning Bell, and a bronze portrait tablet by the recently demobilised Alexander Proudfoot [FIG. 7.22].[57] Newbery led the

7.22 Alexander Proudfoot, *Memorial to Eugène Bourdon,* bronze, 1925. [See also 5.21]

way in commissioning the portrait, and his original idea was that there would be two identical casts, one for GSA and one for Glasgow Technical College, its partner institution in the teaching of architecture. In the event, only one was made and this went to the College. By the time the Bourdon Building was erected in 1978, however, the Technical College had already been absorbed into the University of Strathclyde, and the now, as it were, orphaned tablet was given a new home in the foyer of the building that bears his name.[58] It is a fine representation of the man, and a fitting tribute to an era of architectural teaching that saw such close parallels between buildings and works of sculpture.

Although Newbery had been the prime mover behind this tribute to a distinguished colleague, he had long since left Glasgow for Dorset when the project came to fruition in 1925. In the meantime, however, a no less generous proposal by the governors to mark the contribution that Newbery himself had made to the School was also to be realised in sculptural form. Once again it was Alexander Proudfoot to whom the governors turned, and in April 1920 he was invited to produce a design for a bronze medal to be awarded annually, in Newbery's name, to the 'student who passes the Diploma Examination with the most distinction' [FIGS 7.23a & 7.23b].[59] On the front he shows in

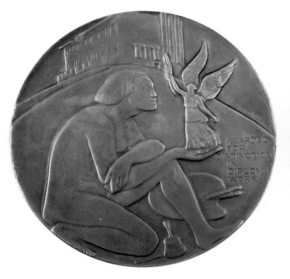

profile the stern features of the man who had dominated Glasgow School of Art for more than 30 years, along with a palm frond and the arms of the city of Glasgow. On the reverse, a naked figure holds a statuette of a winged Victory, while on the hill behind her rises the distinctive form of the Mackintosh Building. With a diameter of less than seven centimetres, the Newbery Medal is modest enough as a work of sculpture. It is also very rarely seen, making only a brief appearance at the annual graduation ceremony, when it is publicly handed by the Chairman of the Board of Governors to that year's most outstanding student. But what it lacks in scale and visibility it makes up for in symbolic importance, providing, along with the plaster statues that still haunt the corridors, a tangible connection between the institution that exists today and the School that Newbery so successfully transformed at the close of the 19th century.

Left
7.23a Alexander Proudfoot, *Newbery Medal* (verso), bronze, 1920.
7.23b *Newbery Medal* (recto).

Chapter Eight

'A much needed stimulus': Glasgow School of Art's contribution to elementary and secondary education in Scotland, 1900–18

ALISON BROWN

In 1916–17 the School Board of Glasgow (GSB) undertook a photographic survey of its schools. The images preserve an invaluable snapshot of the classrooms of the day. The single image of the higher grade art rooms at North Kelvinside Public School shown in FIG. 8.1 encapsulates the positive journey art education had made in Glasgow following the establishment of compulsory education for all children in 1872. Boys and girls, some in their early teens, occupy two purpose-built art rooms with good natural light.[1] They are making tonal drawings of three-dimensional still-life compositions of everyday objects, which are set out in a way that allows all the pupils room to have a good view of the subject. The younger children, at the rear of the photograph, have a simpler set of objects placed at eye level; the older children at the front have more complicated arrangements with objects positioned to test their ability in foreshortening and perspective. On the walls can be seen completed examples of pupils' artwork displayed for discussion and encouragement.

Glasgow School of Art is omnipresent in the image. Some of the Antique casts and other objects in the room are probably borrowed from the School as part of its museum lending scheme.[2] The Art Master and Assistant Art Mistress were both trained at GSA and qualified to SED standards. The Art Master received his teaching qualifications by the old method – by passing the assessments of the Science and Art Department, South Kensington; the young female teacher has just received her Art Diploma from GSA and will gain her full Art Teacher's Certificate in a year's time after gaining

experience in the classroom and through attending teacher-training courses.[3] The teachers have probably taken the pupils this year to Glasgow's Art Gallery and Museum to participate in the Annual Schools Art Competition, judged by, amongst others, Francis Newbery, the Director of GSA. Newbery has also visited this art room to observe the standard of teaching and the work produced, making recommendations for improvement and progress in his role as Higher Inspector for Art to the SED.[4] Some of the children pictured may have gone on to study full-time at the Art School after being hand-picked to sit the entrance examination.

When the Education (Scotland) Act was passed in 1872, drawing was not introduced immediately as a core classroom subject. The role of drawing in schools, and as a means of learning, would come to be hotly debated at a national level. Drawing was seen as a subject primarily for the benefit of industry, and therefore based predominantly on technical and mathematical instruction. It would not be until about 1900 that art evolved in instruction from copying from models, diagrams, the Antique and the flat to encouraging pupils to develop drawing as an alternative tool to the written or spoken word, which could improve their observation, exploration and analysis of the world around them. By the time the photograph of North Kelvinside was taken the role and influence of GSA had become essential to the development and delivery of elementary and secondary art education in Glasgow and the west of Scotland. The School had had to reposition itself over the years since the Act was passed.[5]

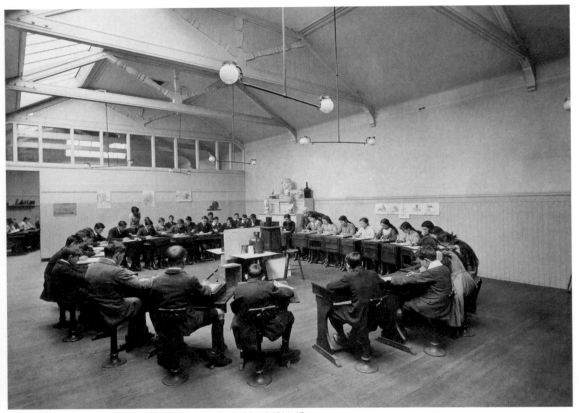

8.1 The Higher Grade Art Rooms at North Kelvinside Public School, 1916–17.

Originally a victim of this new development – competing against, and losing pupils to the new sources of elementary and evening-class education in the city and somewhat uncertain of its role – GSA emerged as a vibrant hub, a Central Institution for Higher Art Education in Glasgow and the west of Scotland. GSA also provided the silent foundations for many schools. Between 1872 and 1919 at least 90 schools in Glasgow, and 135 in Scotland,[6] were designed by architects trained at, or serving on the Governing Board of, GSA.

New Directives: 1900–05

On Saturday mornings during the past winter no more interesting a sight could have been found in Glasgow, than that seen within the classrooms of the School of Art, where about 400 teachers gathered together under competent instructors, seeking to improve their skill in drawing and their acquaintance with Art.[7]

On 8 March 1900 the Governors of GSA sent a letter to Sir Henry Craik of the SED, enclosing a list all of the teachers working in schools across the country who had been trained at the School. The letter seems to have been sent in response to a report they

had noticed in a newspaper for the Evening Classes run by the School Board of Glasgow.[8] The GSB were announcing their fees for the next academic year, which were significantly lower than those for the corresponding courses at GSA. There was obviously much non-minuted discussion and the Governors eventually decided to reduce all their class fees with the exception of the course for Architectural and Building Construction. The fees for students under 16 years had the greatest reduction.[9] The tactic worked, and GSA saw a rise in the number of applicants.[10] The reason for this seemingly petty competition was legislation: the Continuation Class Code obliged GSA, as well as the school boards, to provide continuing education for the city – bridging the years between compulsory education (soon to rise to 14 years) and higher instruction. For decades the school boards and GSA had been competing for the same students. In July 1901 the SED effectively agreed that the legislation was folly in this instance, and told GSA to continue only with such courses as related to architecture and industrial art. The focus at GSA was now to be on the highest levels of instruction.[11] From this point on the art continuation classes taught by the GSB followed a scheme drawn up in collaboration with the School of Art. Annually, both parties adjusted and agreed the courses with the SED in order to facilitate a smooth passage up to the higher institution.[12] Such a partnership delivered results that both parties were exceptionally proud of: 'The cordial co-operation of the School Board with the School of Art has made it possible to organize for the City of Glasgow a complete and progressive system of Art Instruction, beginning with the lowest classes of the Primary Schools and leading on to the School of Art. The influence of this arrangement is already being felt, and the future is still more hopeful.'[13]

The list of teachers enclosed in the letter does not survive, but we know that the number of students graduating from GSA with their South Kensington-assessed teaching qualifications was impressive. Between 1893 and 1901 as many as 16 Art Master's and 74 Art Class Teacher's Certificates were awarded to pupils.[14] The Art Master's Certificate qualified the recipient to teach advanced, higher and continuation classes, while the Art Class Teacher's Certificate, a new qualification instituted in 1880, met the growing requirement for elementary level art teaching in schools.[15] By 1885, 'almost all the teachers of the Elementary Art Classes through-out the City' had been appointed following their qualification from GSA.[16] Those who were awarded this lower certificate could work towards the higher Master's Certificate by continuing classes at GSA, submitting work to London for assessment. As art teaching became a viable profession, and as more women were taking this opportunity for independence, so GSA saw the number of teachers on its roll rise: from 19 in 1878/79 to 62 in 1900/01. Within two years the figures would go stratospheric through the introduction of a new scheme of Saturday and Summer School courses for teachers. For many years after 1902/03, the number of teachers out-stripped the number of students studying in the four main School departments.

Special Saturday classes for teachers were not new. The School had been offering them for some time as part of the Certificate courses. But these new teacher-training classes of 1901, entitled Article 91d, were implemented in response to the new code for instruction, of the same title, issued by the SED the previous year. This new department, still based in London, had taken over full responsibility for art instruction from South Kensington, and delegated the training of teachers in drawing to technical colleges and approved institutions. Teachers voluntarily attended classes on Saturday mornings from 10.00 am to 12.30 pm in their own time. The new courses of instruction coincided with a growing alternative (but at this stage still voluntary)

scheme in elementary art education. This 'Alternative Syllabus in Drawing' would eventually be consolidated and made compulsory as a memorandum on the teaching of drawing by the SED in 1907. The scheme had its roots in late 19th-century thought – when psychologists began to recognise that children had a different way of seeing and comprehending the world around them, and that drawing was a creative tool for exploring that understanding.[17] Art instruction was now 'the study and interpretation of reality'[18] and would be particularly closely allied with another new course introduced to the school syllabus in 1902: Nature Study.

This alternative scheme brought with it new methods of instruction. Children from the age of five were encouraged to start with free-arm drawing [FIG. 8.2], which involved making simple but large shapes, in single strokes on a large vertical surface, preferably a blackboard, to gain 'freedom of action'.[19] The idea was psychologically and physiologically to get away from the previous method of elementary drawing instruction using slates, which were found to encourage a 'cramped and heavy style of drawing'.[20] Such simple abstract shapes gave way to the representation of simple natural forms such as leaves and flowers. Drawing from memory was actively encouraged. Once loosened in thought and movement, the child progressed to tinted paper and coloured crayons, and then quickly to pencil and the mixing of watercolours to develop an understanding of colour and tone. Throughout this process they would draw nature – especially plant forms in all their seasonal variety and stages of life [FIG. 8.3]. This involved another new instruction technique – brush-work – which concentrated on painting shapes and representational pictures using only a brush and watercolours. As the child grew in age and ability, natural subjects were replaced by 'fashioned' objects, in which familiar, everyday artefacts were classified according to their complexity, and ranged from the two-dimensional (such as a letter or a kite) to the three-dimensional form (a box, vessel or household object) [FIG. 8.4]. The increase in complexity was achieved by introducing pattern into the background, by arranging objects into groups [FIG. 8.5], and by placing them in interior or landscape settings. This new scheme, though a far cry from the old dry syllabus of art instruction under South Kensington, required teachers well trained and versed in these new schemes to teach it. The educational presses may have been publishing books and teachers' cards to assist instruction in these new methods, but they did not assess ability and give qualifications.

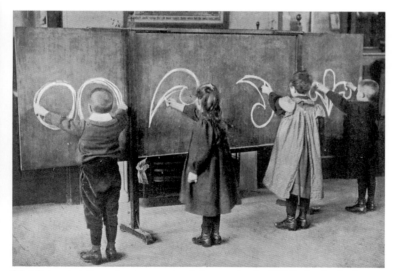

8.2 Infants undertaking rudimentary exercises in free-arm drawing, 1900. Designed to let the arm move from the shoulder as a pivot, the exercise encouraged pupils to draw shapes ambidextrously in order to exercise both sides of their body and brain equally. Because of its physicality, a free-arm drawing session would last between 5 and 15 minutes.

GSA ran their first year of Article 91d classes at the request of Lanark County Council, who specifically wanted their teachers trained in free-arm, blackboard and brush-drawing.[21] It is clear that Newbery had already taken part in informal discussions with Lanark to formulate a certificate scheme approved by the SED. A total of 84 teachers attended, 61 of them travelling to take classes at GSA, and the remaining 23 studying in Lanark. That summer, further courses were initiated for Argyll County Council, with 83 teachers studying at Glasgow, and a class of 20 held at Lochgilphead.[22] The inspector's report was exceptionally positive:

> much interest has been aroused in the newer methods of study and a great deal of latent skill with chalk, pencil and brush has been discovered among the teacher students... [The] work which has been accomplished will react most beneficially upon the drawing lessons given in future in the Schools throughout the County.[23]

In the following year the Article 91d courses were opened up to teachers from all County Council and Roman Catholic Schools.[24] There were 734 participants in total, about half of them attending classes in Glasgow, the rest attending local classes in Lanark, Lesmahagow and Stranraer. Teachers travelled from the counties of Renfrew, Dumbarton, Stirling and Ayr to attend. The summer school was reinstated for Argyll and attended by teachers coming from the Highlands of Argyllshire, and from islands

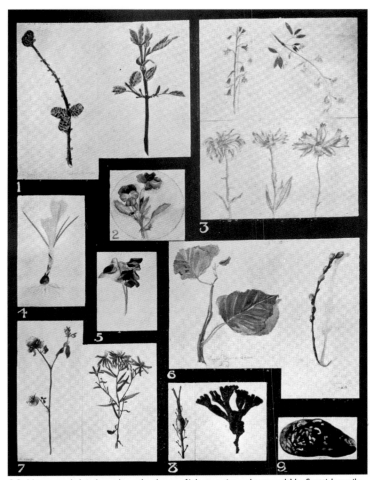

8.3 Nature study brush-work on the theme of 'plants, twigs and seaweeds' by Scottish pupils aged 11 to 12 years, c.1908. These watercolours represented Scotland at the Third International Art Congress for the Development of Art Teaching and Drawing in London, August 1908, and were further exhibited in Amsterdam, Paris, Dublin and Leeds. Drawing 4, a flowering crocus bulb, is by a pupil of an unspecified GSB school.

such as Islay, Coll, Jura, Tiree, Iona, Gigha, Colonsay and Mull. A further 82 teachers continued voluntarily to develop their skills by attending other, non-Article 91d classes at the School.[25] The inspector of the classes was very impressed, especially as 'a large proportion of those in attendance had no

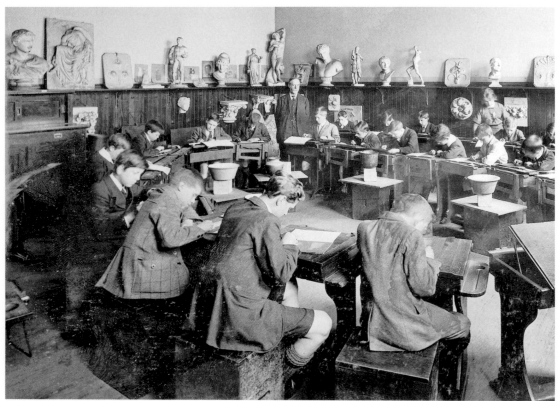

8.4 Detail of a photograph of Senior boys at Woodside Public School making tonal studies of glazed and unglazed ceramic vessels on tinted paper, 1916–17. Boys will always be boys: note the hand-drawn moustache and goatee applied to the Antique bust on the far left of the photograph!

previous instruction whatsoever in drawing.'[26] With art now a core class subject in the primary schools, even non-art-trained teachers needed to be able to understand the principles of instruction. The SED observed that the classes 'cannot fail to give a much needed stimulus to the teaching of Drawing in Public and Secondary Schools.'[27] The School of Art turned the classes into a professional qualification: a Public School Teacher's Drawing Diploma was launched, and awarded after completion of three courses of study.[28]

Many teachers wholeheartedly supported the new scheme of drawing instruction: 'when one thoroughly understands the new system, and gets it into working order, a feeling of thankfulness that the old system has passed away will go up in most teachers' hearts'.[29] But not every teacher in Scotland greeted it with open arms. Some of the detractors protested on practical as well as theoretical grounds; the new instruction methods required investment not just of time but money and space. Free-arm drawing was difficult to implement because of the amount of wall space it required per pupil and the

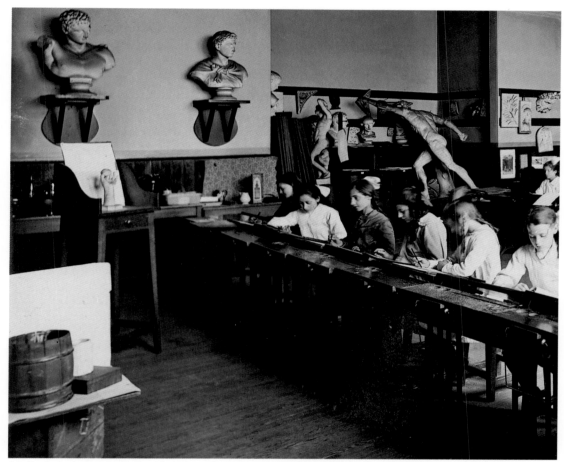

8.5 Detail of a photograph of Senior girls drawing elaborate compositions of objects in the cast room at John Street Public School, 1916–17. Note in the centre the still-life composition incorporating patterned paper and angled printed packaging. John Street also participated in GSA's museum lending scheme to schools: some of these casts, such as the *Borghese Warrior*, are from the School's collection.

cost of the equipment to set it up. Not every school authority had the flexibility for this new scheme, and even a large, progressive authority like the Govan Parish School Board struggled with it, commenting:

> What is known as free-arm drawing has been introduced only to a very limited extent, for while there may be much to be said in its favour, there are serious practical difficulties in the way of its general introduction.[30]

Brush-work, requiring little more than a small watercolour box, brush and paper, was easier to implement, and its close educational relationship to the study of nature happily encouraged schools to take outdoor classes or request flowers and plants from the city's parks and gardens for classroom study.[31] However, it still attracted derogatory terms such as 'Blob-work' by those less inclined to teach it.[32]

The Diploma classes continued to grow, with 858 teachers attending GSA's classes in 1903/04. However, the demand put a severe strain on the School's resources.[33] That year 28 diplomas were awarded to the first graduates of the course, and 18 stayed on to undertake post-diploma instruction.[34] The School of Art tailored the post-diploma work to the school curriculum, especially the teaching of higher grade and continuation classes and instruction in nature study. The course covered drawing and painting from the cast and Antique, the making of pattern and modelling.[35]

All this instruction, initiative, investment and enthusiasm led to exceptionally positive results in the classroom, and this in turn drew more and more boards and councils into financial partnership with the Art School for the delivery of this instruction to their staff. The results are clearly shown in the reviews of exhibitions and displays of school art work around Scotland over the years, and the judges' comments from the newly established Glasgow Schools Art Competition.[36] The competition was a means to get the city's children out of the confines of the classroom for nature study – not the easiest subject to teach in a busy industrial city – by drawing natural history specimens in the Art Gallery and Museum. Extra incentive was offered via a prize fund of £20. Over 700 entries were received for the first competition, which was judged by the three most qualified men in the field: James Grigor, Inspector of Drawing for the SED, Joseph Vaughan, Inspector of Drawing for the GSB, and Fra Newbery. The competition was also a means for those driving this new art education to spot the weaknesses of the city's art instruction, and to offer advice on how to improve classwork. This was something the judges were clearly noticing after only the second year of the competition:

> Viewing the work as a whole we are convinced that this competition forms an excellent adjunct to the art instruction given in the elementary schools and continuation classes of the city.[37]

It was also a good way to feed upwards, as these three men picked the most promising pupils from the continuation classes to sit the entrance examination for GSA. They were truly the arbiters of the future direction of art education in Glasgow.

Expanding Horizons: teacher training from 1905

Recorded appointments between 1896 and 1906 show the spread of art teachers graduating from GSA to be significant. They filled positions in 28 academies and high schools, not just in Glasgow but in Alloa, Greenock, Nairn, Kirkcudbright, Peterhead, Kilsyth, Hamilton, Oban, Perth, Beith, Hawick, Bonnybridge, Kilmacolm and Wigtown.[38] They filled 22 teaching positions in Glasgow Board Schools, especially higher (secondary) schools. Over these 10 years, Glasgow graduates took 32 art master and art mistress positions, as well as eight assistant instructor positions across Scotland. A further 51 took teaching positions with the School's own Article 91d Saturday and summer classes and five graduates pursued a career in private tuition. Over a third of these newly appointed teachers were women. These are the ones that we know of: the lists do not record the many other schools with teachers already in their employ who had graduated from GSA.

One school making some of these appointments was Glasgow's Strathbungo Public School. It was one of many new school buildings, extensions and annexes appearing across the city from the mid-1880s to accommodate the rapidly expanding higher grade curriculum, including purpose-built rooms for art instruction. Opened in 1895 by the Govan Parish School Board, Strathbungo contained a suite of art rooms set up for elementary, cast, life and modelling classes. Once they saw the art rooms in operation, the Science and Art Department – which had contributed financially to their establishment – judged them to be of such a high standard that they bestowed the title 'School of Art' upon Strathbungo's art department. The Strathbungo School of Art (SSA)

taught art at all levels: elementary, higher grade, day and continuation classes. When the Article 91d code was established, Strathbungo undertook the art training of Govan Parish's own teachers.[39] Like the other Board School art classes, including two others run by Govan, the SSA competed against GSA for extra-curricular pupils. By 1900 it had 120 pupils on the evening roll. However, the SSA achieved very good results in examinations under a versatile and growing staff of GSA graduates. Under its headmaster, Frederick C. Nairn (who studied at GSA between 1880 and 1889) and his deputy John P. Main (GSA from 1890 to 1896), the SSA made a significant contribution to art and applied art education in the city.[40]

With the new school-leaving age coming into effect in January 1902, and new intermediate and leaving certificates being introduced, many boards found that if they had not yet done so, they now had to build and expand. Such changes, however, did not just affect stone and mortar – the training of teachers once again came under review. In 1905 the system was reorganized once more. The SED brought training under its centralized control, delegating local management to four new provincial committees centred on the provinces of the four ancient Scottish universities. GSA had one member, elected from its Governors, on the Glasgow Provincial Committee, a 33-strong committee whose members met for the first time on 15 November 1905.[41]

New regulations mean new codes and the course previously taught at GSA as Article 91d became Article 55 at the beginning of the 1906 academic year. It continued to provide the same further instruction of teachers active in service through Saturday, evening and vacation classes. To reflect the change, the old Public School Teacher's Drawing Diploma gained under the 91d classes was renamed the Public School Teacher's Drawing Certificate. The new certificate was designed by the former GSA student Annie French [FIG. 8.6] and awarded upon completion of three years of instruction and a final

exam. As with the Drawing Diploma, the teachers did not study exclusively at GSA; years one and two were held at their own schools or at another institution designated by the Provincial Committee. The third and final year had to be taken at GSA, where the students would also receive demonstrations on teaching, lectures on the history and sociology of art and on art education.[42]

In 1907, a new course of training was introduced responding to Article 47 of the Scotch Code, which outlined the regulations for the preliminary training of teachers. For GSA this course of instruction – known as Article 47b – focused on the training of those holding an Art Diploma to become specialised teachers of higher-grade art. The purpose of this course was to 'assure that the Art workman [comes] first', and that they could 'then make him a teacher afterwards'.[43] Once again GSA collaborated with Joseph Vaughan of the GSB to ensure a complete course of instruction. After their four-year GSA Diploma the students would undertake a year of teacher training, with practical work experience in a GSB school for at least two afternoons a week. Lectures were given on educational history and teaching methods. Instruction in non-art subjects – hygiene, physical training and psychology – were given via the Provincial Committee. After a year of probationary service in a school, the students would gain the SED's Special Certificate for Teachers of Art.[44] The course was slowly fine-tuned in order to bring what was effectively the old Art Mastership qualification into conformity with the more expansive educational needs of the day. Students would not even be able to begin the course without first demonstrating that they possessed acceptable levels of general knowledge.

Both Article 47 and 55 teachers could choose to stay on at GSA after qualification for as many years as they wanted to take vacation and term-time post-certificate courses in a growing number of fine and applied art subjects. Teachers were encouraged to

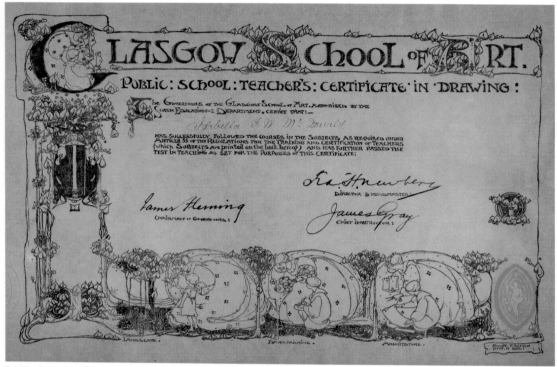

8.6 The Public School Teacher's Certificate in Drawing, designed by Annie French. French's rhythmical design cleverly incorporates the main themes of the instruction teachers received: modelling is incorporated into the G at top left, whilst the lower border represents drawing from the Landscape, Flower Painting (nature study) and Architecture (interiors and exteriors).

keep up their own work – thereby keeping alive their enthusiasm for the subject – and to stay abreast of new methods of instruction. The School launched a new programme of Christmas vacation classes to which any teacher, except a private tutor, could pay a five-shilling fee and take a two-week art course selecting from a range of options that included life, Antique painting and composition, anatomy, modelling, embroidery, enamels and *repoussé* metalwork.[45]

A two-year post-certificate programme for teachers in art needlework, under the instruction of Ann Macbeth [FIG. 8.7] was launched in 1905, the first such applied art course. Within six years

this specially graded syllabus in needlework instruction for children between the ages of six and 14 established itself as GSA's most progressive and influential teacher-training course. Macbeth gradually developed the course over the first few years with the primary school teacher Margaret Swanson, who became assistant instructress of the scheme in 1910. Teachers attending the Saturday and vacation classes applied the methodology learned to create their own pieces of needlework. At the end of two years the teachers were assessed on their designs, a satchel of work and an examination piece.

The introduction of sewing and needlework instruction in elementary schools in Glasgow had

been slow. Some of the smaller school boards had continued needlework instruction as given at the old parish schools, whilst the larger boards seem to have been only galvanised into serious discussion and feasibility assessments following the establishment of the Royal Commission on Technical Instruction, which had been appointed to enquire into the teaching of industrial subjects (including vocational courses such as sewing and cookery for girls) across Britain in 1882. The Commission's report was published in 1884 and the Scotch Code was adjusted to implement its recommendations. By 1885 both the Govan and Glasgow School Boards had placed courses in sewing and needlework firmly on the curriculum, employing specially trained instructresses. It was a compulsory subject for girls to study for four hours a week, but the work was plain, 'no fancy work allowed'.[46] Establishing the courses required much investment: in Edinburgh, for instance, it had cost £1,500 to set up the subject for 6,000 girls, and employ 15 sewing mistresses across 14 schools.[47] But the investment was more than worthwhile, and very quickly examples of sewing and knitting produced in Glasgow's schools were being exhibited at international and industrial exhibitions in both Edinburgh and Glasgow, winning 'favourable notice'.

In 1910 Macbeth published a two-part manifesto announcing her Art Needlework scheme for schools. Macbeth was strident and unswerving in her mission to reposition needlework in the classroom and make the needle an artistic tool. Current sewing instruction was not in keeping with the progress that had been made in elementary drawing:

> we have presented the work to the child in the wrong way – we have forgotten that young eyes love colour, and we have given it none – we have asked for microscopic stitching whilst eyesight is not fully come to its normal strength, and we have taxed it to the uttermost... [The] utilitarian is much more easily attained and learned by first being applied as the beautiful.[48]

8.7 Ann Macbeth, c.1900. Macbeth's talents were not confined to needlework at GSA: she also taught metalwork, bookbinding, ceramic decoration and the pottery course for teachers.

She also believed that the teaching of handiwork at an early age helped to develop 'the intellectual and logical side of the child mind', creating small projects that gave 'practical and tangible' outcomes to lessons learned in subjects such as calculation.[49]

Her words followed on the heels of a very successful exhibition of work by teachers taking the Art Needlework course at the School of Art in April 1910. The exhibition presented examples of elementary and advanced needlework and Macbeth described it as marking 'an epoch in its ingenuity and invention and in its consideration for the development of the child, which should go far to make needlework in our schools, not merely a craft,

but a National Art'.[50] The exhibition attracted great interest. A visit to one of her GSA Saturday classes was featured in the Studio:

> In one of the fine classrooms in the new section at the top of the great building, where the thoughtful architect has introduced an abundance of light, there sit about a hundred young women, drawn from the teaching staffs of the Board Schools in the West of Scotland, sacrificing well-earned leisure weekly in the interests of the advancement of a scientific system of art education.[51]

Publication of the scheme as the book *Educational Needlecraft* [FIGS 8.8a & 8.8b] gave it a wider audience and drew yet more interest. Macbeth was tireless in her championing of the subject. 'Working with a magnetic enthusiasm quite irresistible',[52] she and Swanson gave talks around the country, while Macbeth advised on the schemes of instruction produced in the day and continuation classes in schools and colleges in the west of Scotland.[53]

Inspectors' reports give a good idea of the widespread take-up of the course, and its impact across schools in the city. The silk embroidered folding screen shown in FIG. 8.9 was designed and made by the post-diploma pupil Eliza Kerr, a teacher in charge of the classes for physically disabled children at Shields Road Public School in Glasgow. Her simultaneous application of the course to her classwork resulted in her pupils' handiwork being judged 'specially commendable' by the SED's inspector.[54] Some schools had practiced the scheme for some time and the work was described as 'becoming a keen joy' to the pupils as they demonstrated 'astonishing constructive ability' in the lessons.[55] But uptake was dependent on the inclination of the boards, or the headmasters,[56] leading Newbery to remark: 'We do not expect a sudden conversion of School Boards to the doctrines laid down in Educational Needlecraft.

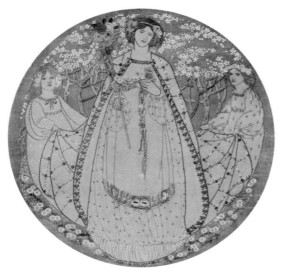

EDUCATIONAL NEEDLECRAFT

BY MARGARET SWANSON
AND ANN MACBETH
INSTRUCTRESS AT THE GLASGOW
SCHOOL OF ART

WITH A PREFACE BY
MARGARET McMILLAN

*WITH 8 COLOURED PLATES
AND NUMEROUS OTHER ILLUSTRATIONS*

NEW IMPRESSION

LONGMANS, GREEN AND CO.
39 PATERNOSTER ROW, LONDON, E.C.4
55 FIFTH AVENUE, NEW YORK
BOMBAY, CALCUTTA, AND MADRAS, 1922
All rights reserved

8.8a & 8.8b Frontispiece and title page from *Educational Needlecraft* by Margaret Swanson and Ann Macbeth, first published 1911. These are from the 1922 edition.

We are surprised and gratified at the progress the movement is making'.[57]

The Provincial Committee provided excellent opportunities for cross-fertilisation and development between educational institutions – not just for teacher training. One example of this is the instruction in applied botany. For two years Miss Margaret A. Kennedy, a botany demonstrator in Glasgow University's Master of Arts Department, gave classes at GSA 'on the possibilities of plant form for the purpose of designing'.[58] The course seems to have been initiated for the instruction of teachers on the Art Needlework course, but was rolled out by Newbery to design students in the rest of the School.[59] Kennedy gave systematic lectures examining plant structures and symmetry, with analysis aided by demonstrations, blackboard drawings and teaching materials from the University. Such a course harked back to the analytical plant studies taught at GSA as early as 1852,[60] but as a modern course it assisted teachers by both dealing with nature study and showing possible applications of the subject in a practical class, perfectly fitting in with both schemes of instruction for children. For the teachers attending, their notes on the lectures became part of the art needlework assessment.

As the years passed, GSA gradually introduced more applied art and craft post-certificate courses for teachers – *repoussé* metalwork, silversmithing and enamels in 1909, woodcarving in 1912 and pottery in 1915 – all under the instruction of permanent staff with assistance by appointed instructors. The establishment of these teachers' courses was galvanised by the introduction of more and more craft and educational handiwork classes coming onto the primary and secondary school curriculum.[61] By 1912, four of the GSB's secondary

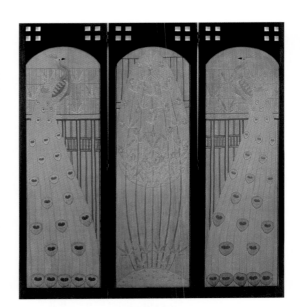

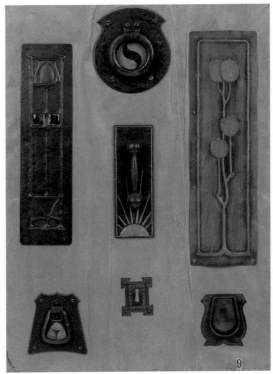

Top right
8.9 Embroidered three-panelled folding screen, designed and made by the teacher Eliza C. Kerr, c.1910, as part of the Saturday Art Needlework course at GSA.

8.10 Display board of art metalwork door furniture by the teacher James McNeill, c.1913.

schools were equipped to teach construction and decoration in metal and leather; at the High School of Glasgow it was decorative pottery.[62] GSA was not the only institution in the city providing these types of classes for teachers, but it seems to have kept the syllabus balanced and artistic rather than purely technical. The display board of door furniture in FIG. 8.10 illustrates this. It was made by James McNeill, a teacher of Manual Instruction at Newtonhead Public School in Ayr, who attended many Article 55 classes across the city. In 1913 he completed GSA's 60-hour *repoussé* metalwork post-certificate course, gaining an 'Excellent' for his work. The previous year he had attended another metalwork course provided under the aegis of the Provincial Committee, this time held at the Manual Instruction room at Kent Road Public School. The GSA course covered design, tools, materials and execution, including the colouring of metals and enamelling. The latter was less artistic in content, and was more geared towards trade skills in industrial metalwork, such as bending, riveting and soldering. The sample board shows a body of imaginative work blending the skills learnt from both courses. Testimonials for McNeill's teaching were glowing, not only for his skill but for his enthusiasm for the subject and his ability to transfer that to his pupils to create 'a splendid tone in his classes' and an atmosphere of 'cheerful and willing industry'.[63] McNeill is the perfect example of Newbery's ideal teacher: one that continues to learn new skills, keeps his own artistic interests alive and delivers with enthusiasm.

In his capacity as Higher Inspector for Art, Newbery visited many schools and probably saw every possible interpretation of the art syllabus, with differing standards of work. He was often harsh in his assessments of teachers: 'though earnest and desirous is somewhat weak and aimless' was his assessment of one.[64] But he would also champion those who he believed had a genuine talent that could make a difference: 'Personal opinion: Mr Kipling is not a strong student, nor a very good artist. He is earnest and determined, and has turned out to be an extremely good teacher'.[65] The ability to communicate and inject life into a subject is the true quality of a good teacher. Under Newbery, the Art School fostered a suitably do-as-you-would-be-done-by attitude for their teacher training: 'they came as teachers perhaps, but they were received as artists, and the results have justified the treatment'.[66]

'The interest created in things outside of the four walls of a school is of vital importance educationally',[67] declared the judges Newbery, Grigor and Vaughan. The continuation of the Schools Art Competition and the increasing number of opportunities to exhibit pupils' work in and out of the classroom helped maintain interest and enthusiasm. Such projects provided a goal to work towards: the excitement of a day out and – if you were really good – a prize. The art competition provided unusual objects to draw, something which even Newbery was no doubt relieved by: 'teachers', he admitted, 'and students alike must become nauseated with pots and pans, and kettles and cans, with boxes and stools and tables and chairs, most of these objects of study being, black, dirty, uninviting and monotonous'.[68] Some schools, particularly private fee-paying schools, created their own special awards for work, often sponsored by or commemorating private donors. Sometimes the full original intention of the award, or the identity of the donor it commemorates [FIG. 8.11] may be lost to us, but the associations they hold with the Glasgow School of Art, in this case the maker of the trophy, are not. Newbery donated his own medals – a Dux in Art awarded to higher-grade pupils at Glasgow High School [FIG. 8.12] and another for the Glasgow High School for Girls. He was probably behind the cheeky concept of the design which he deconstructed for the High School's rector as

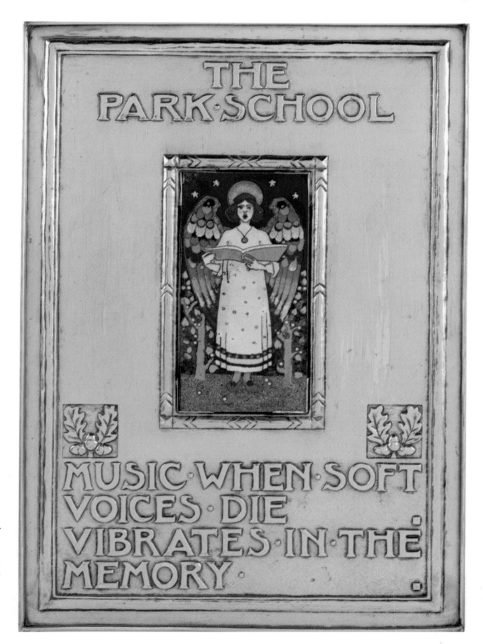

8.11 Trophy shield awarded at Laurel Park School, possibly for music, designed and made by De Courcy Lewthwaite Dewar, undated (probably after 1920). Dewar was instructor in enamels at GSA from 1902 to 1908 and from 1912 to the 1920s, and undertook many commissions in the medium. This is one of two trophies made for Laurel Park School.

follows: 'The ring symbolic of Art encloses the two schools each represented by its badge and a hand symbolic of education beckons from the High School to the School of Art'.[69] It is somehow appropriate for Newbery that the central feature of his award is the come-hither gesture of his own higher institution.

Epilogue

By the 1916/17 academic year, 48 secondary schools and art schools were affiliated to the Glasgow School of Art as their Central Institution for Art Instruction. From all of Glasgow's school boards and those in the west of Scotland to those further afield in Callander, Perthshire, Elgin and Dundee,

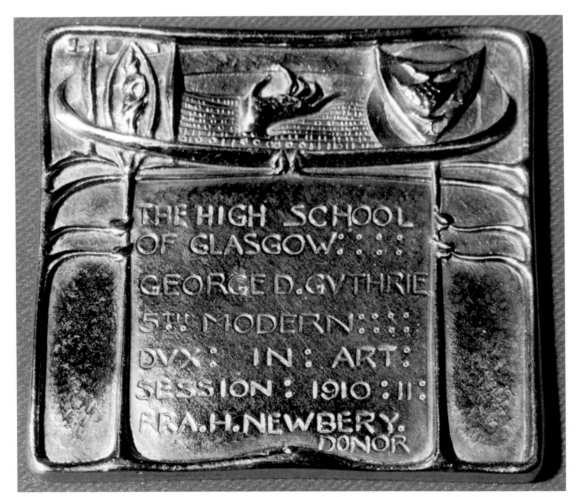

8.12 The Dux in Art medal for the High School of Glasgow, designed by Frances Macdonald and made by Peter Wylie Davidson, 1911. At the time of production, Macdonald was a full-time design instructor and Davidson a technical instructor in metalwork and enamelling at GSA.

each tied their continuation classes into the scheme of instruction offered at GSA. The subjects drawn in their art classrooms became less monotonous through participation in GSA's museum lending scheme, instituted in 1915, which attracted a growing number of subscribers every year.

In 1918 everything changed. The First World War was drawing to a close, the School of Art's new director was settling in after a year in the post, and a new education act had been passed – the most radical since 1872. The school boards were to be replaced by education authorities and the school-leaving age was raised to 15, with attendance at daytime continuation classes compulsory until the age of 18.[70] The key institutions and individuals who had laid the solid foundations for art and applied art instruction in 20th-century Glasgow were either retired or retiring. However, some of their initiatives continued unscathed for many decades. *Educational Needlecraft* became a course of instruction used in schools around the world and remained on the Scottish syllabus until the 1950s.

The Schools Art Competition still occurs annually at the city's municipal museums. It is now known as the Young Person's Art Competition, but the principle is the same: hundreds of school children still come to the museums to draw the collections and compete for the top prizes. Artists who have passed through Glasgow School of Art have continued to have an involvement over the years, whether as judges or prize givers – or even the winners themselves [FIG. 8.13].

PRESENTATION TO YOUNG GLASGOW ARTISTS.—Mrs. E. A. Taylor (Miss Jessie M. King) presenting gold medals to the five leading prize-winners in the School Children's Drawing Competition under the auspices of the Glasgow Art Galleries and Museums. The successful entrants were:—A. Gowans (Hyndland Second Grade School), May Turnbull (Dumbarton Academy), Lilian Chivers (Glasgow High School), Nan Marr (Glasgow High School), and Masie Hamilton (Laurelbank School).

8.13 The top five prize-winners of the annual School Children's Drawing Competition receive their gold medals from Jessie Marion King at Kelvingrove Art Gallery and Museum in March 1926.

Appendix

The Glasgow School of Art Song

This affectionate satire on the School, in which so many members of staff from the Mackintosh period make an appearance, began life as just the first two verses, which were written 'lines about' by Allan D. Mainds and Alexander Proudfoot shortly before the outbreak of the Great War. Twenty years later, a certain Mr Eadie suggested to Proudfoot that he finish it, which he did, with the results that we have here. It is meant to be sung to the tune of the Somerset folk song, *Richard of Taunton Dean*. Fra Newbery, who was well known for giving recitals of west-country folk song in a rich baritone voice, was born in Membury, not far from Taunton, and probably had *Richard of Taunton Dean* in his repertoire.

Dumble-Dum-Dearie: or how Fra Newbery got his Cloak and Hat

Oh! Mackintosh – he built a School
And Newbery – he filled it full
With Painters and Sculptors and Arkerytects
Of various ages and every sex
Singing Dumble-dum-dearie-cum-dumble-dum-day.

And how did he do it we'd like for to know
Why – he promised to everyone who would go
A Fifty-Pound Travelling Scholarship
A Maintenance Bursary and the Dip;
And some Dumble-dum-dearie-cum-dumble-dum-day.

He got some Professors to show 'em the way
To lay on the paint and to rough-up the clay,
A Frenchman from France with a straightedge and rule
To build up the arkerytectural school
Singing Dumble-dum-dearie-cum-dumble-dum-day.

The honours they had made a splendid array
From A. R. C. A. to full-blown R. A.
With Fra; at the top with his S. P. G.
And his Cav-a-li-er-e Uf-fic-i-al-ee
Singing Dumble-dum-dearie-cum-dumble-dum-day.

The first on the list was old Maurice Greiff,
There was no one like him who knew more about life
He never spoilt no one by sparing the rod
And when he looked at our drawings he said – 'O my God!'
Singing Dumble-dum-dearie-cum-dumble-dum-day.

There was Baltus the Belgian – the tempera toff
He could fresco the paint so it wouldn't rub off
With yolk of egg, bees wax and lots of casein
Then wash it all down with a drop of dry gin
And some Dumble-dum-dearie-cum-dumble-dum-day.

There was Jimmy Dunlop – the anatomy bloke
He rattled his mastoids whenever he spoke
Sitting on his 'gluteus' he'd speak for a week
Of his favourite form – the external oblique
Singing Dumble-dum-dearie-cum-dumble-dum-day.

There were lots of small fry adorning the Staff
With some we would cry with some we would laugh
Gray – Nicholas – Huck –J-J-F-X-King
All excellent teachers of any old thing
And of Dumble-dum-dearie-cum-dumble-dum-day.

But who they all were we don't need to tell
And the last we'll mention is old Anning Bell
He not only showed us to do a design
But got it accepted and hung on the line
With some Dumble-dum-dearie-cum-dumble-dum-day.

Fra went to the Continong every year
For plaster casts for his Students dear
France – Austria – Germany – Italy – Greece
Like Jason of old for his Golden Fleece
And some Dumble-dum-dearie-cum-dumble-dum-day.

He got up a lecture scheme – lofty and grand
Artists to talk – the best in the land
He also invited James Whistler McNeill
To tell 'em of Art – what was false – what was real
What was Dumble-dum-dearie-cum-dumble-dum-day.

Mr Whistler inquired as to who he had had
To tell 'em of Art – what was good – what was bad
Fra answered – he'd had Walter Crane – Lewis Day
When Whistler heard these names he said – Go away –
With your Dumble-dum-dearie-cum-dumble-dum-day.

He said 'Mr Fra; what a blizzard you've had
To what they have told you I've nothing to add'
So Fra took his leave said Good-bye and all that
But he borrowed his cloak and he purloined his hat
Singing Dumble-dum-dearie-cum-dumble-dum-day.

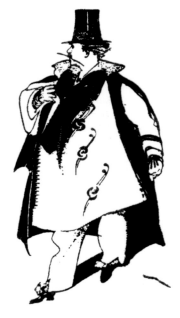

Hugh Munro, 'Suggested Costume Guide No. 1:
Le Comte Fra Nooberie', illustration from *St Mungo* (1897).

Notes to the Text

Chapter One

1 GSAA, NEW I/I, vol. 3, p.110: James Salmon, 'Fine Art in Glasgow', cutting from an unidentified newspaper of 1911 in which Salmon appears to be referring to the holistic approach to art – which included music, dance and drama – adopted by Glasgow School of Art.
2 GSAA, SEC 35: Thomas Armstrong, 'Glasgow, Renfrew Street School of Art' (Report to SED, 1900), p.2.
3 Newbery signed his name as 'Fra.' rather than 'F.' so that it would not be mistaken for 'Fred'.
4 GSAA, NEW I/I, vol. 3, p.129: Francis H. Newbery, 'Art instincts', a lecture delivered on 23 December 1911 at GSA. Chalk was the common medium for graffiti in the early 20th century.
5 GSAA, DIR 5/6: Newbery to Miss Wicksteed, 11 January 1911.
6 Herbert Courthope Bowen, Froebel and Education by Self-Activity, London, 1893, p.v.
7 Newbery, op.cit. (note 4).
8 Mitchell Library, Glasgow, CDf700 NEW, Newbery (News cuttings relating to GSA and general art matters), p.64: cutting relating to a lecture by Newbery entitled 'Art and Personality'.
9 Edward J. Poynter, Ten Lectures on Art, London, 1879, p.viii.
10 Anon., 'Glasgow School of Art and Haldane Academy', Glasgow Herald, 16 October 1885, p.4.
11 F. H. Newbery, 'Tradition', Vista, vol. 1, no.1, May 1908, p.4.
12 The other two in this period were Gray's School of Art, Aberdeen, in 1903, and Edinburgh College of Art, in 1908.
13 Calendar, 1909/10, p.19, gives the various entry requirements at that date.
14 Ibid., p.22.
15 GSAA, REG 3/6–7, General Register of Students, 1901–1919, passim.
16 NAS, ED 26 275, SED Records GSA General Administration, 1910–15, 21 December 1910.
17 Calendar, 1909/10, p.64. From 1908 external assessors were selected by a conference of the three Central Institutions before being approved by the SED.
18 Annual Report 1906/7, p.13.
19 Calendar, 1914/15, pp.91–92.
20 Calendar, 1909/10, pp.33–34, 47–48 and 53–54. In the Painting and Sculpture departments these were designated as 'Stages' but did not include a 'Stage IV'. In Design the course was divided into elementary and advanced sections.
21 Calendar, 1909/10, pp.67–68.
22 Ibid., p.79.
23 F. H. Newbery, 'On the training of architectural students' [1887], Proceedings of the Philosophical Society of Glasgow, vol. 19 (1889), pp.181–82.
24 Anon., 'Glasgow School of Art: a flourishing Institution', Glasgow Evening News, 22 May 1895, p.2.
25 The other two Beaux-Arts courses were at the Architectural Association in London and Liverpool University.
26 See, for example, Studio, vol. 24, no. 106 (January 1902), pp.281–89; vol. 30, no. 128 (November 1903), pp.107–15; vol. 56, no. 234 (September 1912), pp.318–21.
27 GSAA, GOV 2/4, p.163: minutes of School Committee, 3 November 1897.
28 Jude Burkhauser, '"Sala M" Arte Decorativa Scozzese: Charles Rennie Mackintosh and the Glasgow Group at the Venice Biennale Exhibition in 1899', Charles Rennie Mackintosh Society Newsletter, no. 50 (Spring 1992), pp.9–13.
29 Peter Wylie Davidson, unpublished autobiography (1963), pp.44–45. Private collection.
30 GSAA, NEW I/I, vol. 1, p.74: undated cutting 'Glasgow School of Art Club: Presentation of Diplomas'.
31 GSAA, 2/2, Alphabetical Register of Students, 1892–1903. Thirty-five of the 52 female 'designers' enrolled in the 1893/94 session had attended in previous years. Only four of these had previously recorded their profession as 'designer' or 'draughtswoman'.
32 John Swift, 'The Arts and Crafts Movement in Birmingham Art School, 1880–1900', in David Thistlewood (ed.), Histories of Art and Design Education: Cole to Coldstream, Harlow, 1992, pp.28–29.
33 Anon., 'Glasgow School of Art: a flourishing Institution', Glasgow Evening News, 22 May 1895, p.2.
34 GSAA, SEC 3, pp.887–94: GSA Correspondence to Department of Science and Art, 1882–87.

35 GSAA, REG 3/6, General Register of Students, 1904, passim.

36 GSAA, SEC 2: Newbery to Fred Miller, 29 September 1915.

37 Calendar, 1909/10, pp.16–17.

38 Annual Report, 1911/12, p.22.

39 GSAA, GOV 2/7: minutes of Sub-committee on Relations with University, 11 May 1909 (pp.7–8) and minutes of Extraordinary General Meeting, 13 December, 1910 (pp.164–66). See also NAS, ED 26.275, SED Records, GSA General Administration, 17–18 November 1910.

40 GSAA, GOV 2/5, pp.233–34: minutes of School Committee, 19 May 1905; GOV 2/6: minutes of School Committee 14 January (pp.105–07); 26 January (pp.111–13); and 30 March 1909 (pp.139–40).

41 GSAA, EPH I, 1913/18: University of Glasgow printed flyer, 'Lectures on the Arts of Representation', November 1913.

42 GSAA, GOV 2/11, p.23A (1): undated letter from student delegation to Newbery.

43 GSAA, NEW I/1, vol. 3: 'Mrs Langtry on Rosalind', unidentified cutting dated 20 February 1915 (p.223), and 'Shakespeare's verse: Mr F. R. Benson as lecturer', Glasgow Evening Times, 10 March 1915 (p.224). See also DIR 5/6: letter to George Bernard Shaw, 4 May 1911; and DIR 5/21 (B): letter to W. B. Yeats, 19 March 1914.

44 F. H. Newbery, A Masque of the City Arms: or, the Saint; the Ring; the Fish; the Tree; the Bird; the Bell, Glasgow, 1905.

45 F. H. Newbery, The Birth and Growth of Art: a Symbolistic Masque in Five Ages and an Allegory, Glasgow, 1909.

46 GSAA, EPH I, 1913-26: passim.

47 GSAA, EPH I, 1907-12: The Glasgow School of Art Official Opening: Programme of Proceedings, Glasgow, 1909.

48 Annual Report, 1911/12, p.23.

49 Annual Report, 1911/12 to 1915/16, passim.

50 Annual Report, 1904/05, p.15.

51 GSAA, DIR 5/15: Newbery to Alfred Longden, 3 February 1913; and DIR 5/24: Newbery to Alfred Longden, 12 March 1914. See also DIR 5/26: Newbery to Isidore Spielmann, 7 April 1914.

52 Annual Report, 1913/14, p.43; 1914/15, pp.38–40; 1915/16, pp.21–24; 1916/17, pp.20–24.

53 GSAA, DIR 5/28: Newbery to D. Y. Cameron, 26 October 1916.

54 NLS, MS 10581, pp.224–26: Jessie Newbery to Anna Geddes. 'I am sorry to tell you that my husband is in bed suffering from a serious nervous breakdown – the result of years of overstrain – but the shock of the war "knocked him out"'; also MS 10582: Margaret Mackintosh, to Anna Geddes, referring to 'a sort of nervous breakdown to begin with, which became very serious'.

55 GSAA, GOV 2/11, pp.88–89: minutes of Extraordinary Meeting, 8 May 1918.

Chapter Two

1 Francis H. Newbery, 'Introduction' (September 1897), in David Martin, The Glasgow School of Painting, London, 1902, p.xiii.

2 Annual Report, 1900, p.6.

3 C. A. Oakley, The Second City, Glasgow, 1946, p.238.

4 Ibid., p.200.

5 Juliet Kinchin, 'Second City of the Empire', in Jude Burkhauser (ed.), Glasgow Girls: Women in Art and Design 1880–1920, Edinburgh, 1990, p.28.

6 Oakley, op.cit. (note 3), pp.212–13.

7 David Harvie, Lines Around the City, Glasgow, 1997, p.96.

8 Oakley, op.cit. (note 3), p.310.

9 Ibid., p.238.

10 Roger Billcliffe, The Royal Glasgow Institute of the Fine Arts 1861–1989: a Dictionary of Exhibitors at the Annual Exhibitions etc., Glasgow, 1992, vol. I, pp.9–12.

11 Liz Bird, 'Collectors, Patrons and Dealers', in Burkhauser, op.cit. (note 5), p.31.

12 G. Baldwin Brown, The Glasgow School of Painters, With Fifty-four Reproductions in Photogravure by J. Craig Annan, Glasgow, 1908. Annan was co-publisher with James MacLehose & Son.

13 It is worth noting also that none of the Glasgow Boys is mentioned in Stanley Cursiter's Scottish Art to the Close of the Nineteenth Century, London, 1949.

14 Perilla Kinchin and Juliet Kinchin, Glasgow's Great Exhibitions: 1888, 1901, 1911, 1938, 1988, Wendelbury, n.d. (1988), p.55ff.

15 For a fuller discussion see Ray McKenzie, Public Sculpture of Glasgow, Liverpool, 2002, pp.247–59.

16 Harvie, op.cit. (note 7), pp.9–12

17 Oakley, op.cit. (note 3), pp.257–58.

18 Ibid., p.261. The School installed its own 'cinematograph' in December 1923.

19 Ibid., pp.159; John Lindsay (ed.), Municipal Glasgow, Glasgow, 1914, p.72.

20 Frederick Niven, The Staff at Simsons, London, 1937, p.297; Frederick Niven, Justice of Peace, New York, n.d. (1914?), p.378.

21 A little disappointing, perhaps, given the attempts by the Italian Futurists at precisely this time to find ways of evoking sounds and smells in their pictorial representations of the modern city.

22 John Buchan, *Memory Hold-The-Door*, London, 1940, p.33.

23 Frederick Niven, *Coloured Spectacles*, London, 1938, p.45.

24 See, for example, Harry Hems, 'Glasgow and its Exhibition', *Building News*, 4 October 1901, p.446a.

25 Niven, *op.cit.* (1938) (note 23), pp.31 & 42.

26 James Hamilton Muir, *Glasgow in 1901*, Oxford, 2001 [1901], p.19.

27 J. A. Hammerton, 'Snap Shots in "Our Strand"', in *Sketches from Glasgow*, Glasgow, Edinburgh & London, 1893, p.119.

28 *Ibid.*, p.124.

29 *Ibid.*, pp.217 *et seq.*

30 GSAA, NEW I/1, vol. 3, p.110: James Salmon, 'Fine Art in Glasgow', cutting from an unidentified newspaper of 1911.

31 Niven, *op.cit.* (n.d.) (note 20), p.260.

32 See Guy McCrone, *The Philistines*, Book Two of *Wax Fruit*, London, 1947, p.279.

33 Harvie, *op.cit.* (note 7), p.113.

34 John Carswell, 'Introduction', in Catherine Carswell, *Open the Door!*, Edinburgh, 1996 [1920], p.viii.

35 *Ibid.*, p.217.

36 Niven, *op.cit.* (n.d.) (note 20), p.x.

37 Niven, *op.cit.* (1938) (note 23), p.25.

38 *Ibid.*, p.29.

39 *Ibid.*

40 Niven, *op.cit.* (n.d.) (note 20), pp.240 & 212. The School's demographic profile was very mixed (see Niven's description of the students, below) and their home addresses ranged across the city, from the leafy suburbs of the south side and the West End to areas such as Hillhead, which remain densely populated with students to this day. The School registers, however, show that a significant number of the students had lodgings in Garnethill itself, as well as in streets that have now disappeared, such as Grove Street and Shamrock Street in neighbouring Cowcaddens. By far the most popular place for lodgings was New City Road, which appears repeatedly in the registers, with numbers ranging from 118 to 640. Some appear to have been multi-occupancy lets. For the record it is worth noting that the student who lived closest to the School was Mary Frew, a designer, who moved into a flat in a now-demolished building at 183 Renfrew Street, a few yards west of the Mackintosh Building, the year after it was first occupied.

41 *Ibid.*, pp.212–13.

42 The central novel in Guy McCrone's later *Wax Fruit* trilogy is set in Glasgow in the 1880s and is entitled *The Philistines* (see note 32).

43 Niven, *op.cit.* (n.d.) (note 20), p.25.

44 *Ibid.*, p.190.

45 *Ibid.*, p.292.

46 *Ibid.*, p.433.

47 *Ibid.*, p.144.

48 *Ibid.*, pp.152 & 143.

49 *Ibid.*, p.143.

50 *Ibid.*, p.211.

51 *Ibid.*, p.150.

52 *Ibid.*, p.151.

53 *Ibid.*, pp.157–58.

54 *Ibid.*, p.144.

55 *Ibid.*, p.184.

56 *Ibid.*, p.252.

57 Perilla Kinchin, 'Introduction to the 2001 Edition', in Muir, *op.cit.* (note 26), p.ix.

58 Niven, *op.cit.* (1938) (note 23), p.47.

59 Niven, *op.cit.* (n.d.) (note 20), p.337.

60 *Ibid.*, p.399.

61 *Ibid.*, p.385.

62 *Ibid.*, p.340.

63 *Ibid.*, p.361. Niven is being a little free with the chronology here, as Greiffenhagen began working at the School in 1906 and Anning Bell in 1911. And yet references, a few pages later, to 'the new galleries in Kelvingrove Park' as well as to 'our late Queen' (see pp.340–41), suggest that in Niven's mind the episode is taking place closer to the beginning of the century.

Chapter Three

1 Mackintosh's lecture, 'Scotch Baronial Architecture', which he delivered to the Glasgow Architectural Association on 10 February 1891, is published in Pamela Robertson (ed.), *Charles Rennie Mackintosh: the Architectural Papers*, Wendlebury, 1990.

2 In Murray Grigor, *The Architects' Architect*, Bellew, 1993.

3 GSAA, GOV 2/4, p.43: minutes of Governors' Annual General Meeting, 18 September 1895. Reference to a 'plain building' is made in an excerpt from Glasgow

Corporation minutes inserted here. The reference is a quotation from a letter of 4 March 1895 from GSA governors (Burnett, Salmon *et al.*) to the Corporation.

4 GSAA, GOV 5/1/1, p. 2: extract from minutes of meeting of Governors, 16 March 1896.

5 *Ibid.*, p.6: minutes of Building Committee, 11 May 1896.

6 *Ibid.*, p.17: minutes of Building Committee, 17 December 1896.

7 GSAA, GOV 5/4/10: 'Design by ['wish-bones' symbol] for the Glasgow School of Art: Description and Schedule of Contents', n.p. (p.2).

8 GSAA, GOV 5/1/1, p.20: minutes of Building Committee, 17 December 1896.

9 Mackintosh studied at GSA on and off from 1883 to 1894.

10 *Evening Times*, 5 February, 1895.

11 GSAA, GOV 5/1/1, p. 22: minutes of Building Committee, 13 January 1897.

12 In a letter to Hermann Muthesius of 11 May 1899, Mackintosh says: 'You must understand that for the time being I am under a cloud – as it were – although the building in Mitchell Street here was designed by me the architects are or were Messrs Honeyman & Keppie – who employ me as an *assistant*. So if you reproduce any photographs of the building you must give the architects' name – not mine. You will see that it is very unfortunate for me, but I hope, when brighter days come, I shall be able to work for myself entirely and claim my work as mine.' Quoted in William Buchanan (ed.), *Mackintosh's Masterwork: the Glasgow School of Art*, Edinburgh, 1994, p.36.

13 GSAA, GOV 5/1/3, p.67: minutes of Building Committee, 15 January, 1907.

14 GSAA, GOV 5/1/5, p.156: Honeyman, Keppie & Mackintosh to Edward R. Catterns, 15 March 1907.

15 GSAA, GOV 5/1/3, p.70: minutes of Building Committee, 22 January 1907.

16 *Ibid.*: 'Glasgow School of Art. Extensions and Alterations. General Conditions', inserted in minutes of Building Committee, 9 September 1907, between pp.90 & 91.

17 Andor Gomme and David Walker, *Architecture of Glasgow*, London, 1962, p.198.

18 See GSA annual prospectuses: GSAA, REG 1/1-2.

19 GSAA, SEC 35: James Pittendrigh Macgillivray, 'Report on School by Mr. Pittendrigh Macgillivray, RSA, 7 Dec. 1904', 29 June 1905, pp.6–7.

20 Buchanan, *op.cit.* (note 12), p.37.

21 *Ibid.*, p.66.

22 Robertson, *op.cit.* (note 1), *passim*.

23 David MacGibbon and Thomas Ross, *The Castellated and Domestic Architecture of Scotland from the 12th to the 18th centuries*, Edinburgh, 1971 [first published in 5 volumes, 1887–1892].

24 Robertson, *op.cit.* (note 1), p.38.

25 Colin Rowe, *The Mathematics of the Ideal Villa*, London, 1976, pp.59–87.

26 GSAA, GOV 5/1/4, p.26: minutes of Building Committee, 31 August 1908.

27 *Ibid.*, p.30: minutes of Building Committee, 29 September 1908.

28 *Ibid.*, p.50: minutes of Building Committee, 30 November 1908.

29 *Ibid.*, p.54: minutes of Building Committee, 8 December 1908.

30 *Ibid.*, p.64: minutes of Building Committee, 26 January 1909, with reference to 8 December 1908 (p.54).

31 *Ibid.*, p.64: minutes of Building Committee, 26 January 1909.

32 *Ibid.*, p.73: minutes of Building Committee, 8 February 1909.

33 GSAA, GOV 5/1/3, p.118: minutes of Building Committee, 7 February 1908.

34 *Ibid.*, pp.127–28: letter from Governors to Honeyman, Keppie & Mackintosh, 27 February 1908, inserted in minutes of Building Committee, 26 February 1908.

35 In a lecture given around 1892 to an unknown literary society (the editor David Walker suggests the Scottish Society of Literature and Art, founded in 1886 in Glasgow, and refers to the lecture itself as 'Untitled Paper on Architecture') Mackintosh himself cites this definition of architecture but mistakenly assigns it to Madame De Stael: 'When Gothe [*sic*] calls it a "petrified religion" or Madame de Stael "frozen music"'. The paper, together with David Walker's editorial, is published in Robertson, *op.cit.* (note 1), pp.153–80.

Chapter Four

1 The authors would like to record their indebtedness to Vivien Hamilton, Research Manager for Art, Glasgow Museums, who was originally commissioned to contribute an essay on the Painting Department but was unable to complete it owing to ill health. Her extensive research and detailed notes have proved invaluable in the drafting of this chapter.

2 GSAA, EPH I, 1907–12: Francis Henry Newbery, The Birth and Growth of Art: a Symbolistic Masque in Five Ages and an Allegory, Glasgow, 1909, p.12. The statement 'Art is the flower – Life is the green leaf' is from Charles Rennie Mackintosh's lecture 'Seemliness' (1902), for which see Pamela Robertson (ed.), Charles Rennie Mackintosh: the Architectural Papers, Wendlebury, 1990, p.224.

3 Peter Wylie Davidson, unpublished autobiography, pp.44–51. Private collection.

4 Thomas Howarth, Charles Rennie Mackintosh and the Modern Movement, 2nd ed., London, 1977, p.11.

5 William Morris, 'Art a serious thing', in Eugene D. Lemire (ed.), The Unpublished Lectures of William Morris, Detroit, 1969, pp.46–47.

6 GSAA, SEC 2, 1910–11: School secretary to J. H. Reynolds, 19 February 1910.

7 GSAA, SEC 35: Thomas Armstrong, 'Glasgow, Renfrew Street School of Art', 2 June 1900, pp.7–8.

8 GSAA, GOV 2/4: minutes of School Sub-committee, 8 May 1900 (p.351); minutes of Extraordinary Meeting of Governors, 4 June 1900 (p.359).

9 GSAA, GOV 2/4, p.347: minutes of Annual Governors' Meeting, 27 September 1900.

10 Clovis Pierard, 'Jean Delville: peintre, poète esthéticien, 1867–1953', Memoire et publications de la Société des Sciences des Arts et des Lettres du Hainault, 1971–1973, pp.217–18.

11 GSAA, SEC 3: Correspondence with SED, vol. I, 1899–1910, p.287, 20 November 1900.

12 GSAA, GOV 2/4, p.383: translated transcript of letter from Delville to Newbery, 2 November 1900, in minutes of School Committee, 8 November 1900.

13 This turned out to be at 42 Kersland Street, in the West End. See Roger Billcliffe, The Royal Glasgow Institute of the Fine Arts 1861–1989: a Dictionary of Exhibitors at the Annual Exhibitions etc., Glasgow, 1992, vol. I, p.342.

14 GSAA, GOV 2/4, p. 380: transcript of letter, dated 6 November 1900, from School Secretary to Delville, in minutes of School Committee, 8 November 1900.

15 Billcliffe, op.cit. (note 13), vol. I, p.342.

16 Jean Delville, The New Mission of Art: a study of idealism in art, trans. Francis Colmer, London, 1910.

17 Ibid., p.58.

18 Ibid., pp.30–31.

19 Ibid., p.32.

20 Edouard Schuré, 'Introductory Note to The New Mission of Art', ibid., p.xxviii.

21 Francis H. Newbery, 'Introduction' (September 1897), in David Martin, The Glasgow School of Painting, London, 1902, p.xiv.

22 GSAA, GOV 2/4, p.392: minutes of School Committee, 29 November 1900; SEC 2, 1897–1904, p.289: letter to Fernando Agnoletti, n.d. (c.December 1900).

23 GSAA, SEC 35: James Pittendrigh Macgillivray, 'Report on School by Mr. Pittendrigh Macgillivray, RSA, 7 Dec. 1904', p.9.

24 Anon., 'The Recent Annual Glasgow School of Art Club Exhibition', Studio, vol. 30, no. 128 (November 1903), p.111.

25 GSAA, GOV 2/7: Director's report, inserted in School Committee, 10 March 1910 (between pp.73 & 74), p.2.

26 Anon., op.cit. (note 24), pp.112–13.

27 GSAA, SEC 35: 'Copy of a Report by Sir R. Rowand Anderson, LL.D., on the Glasgow School of Art', 17 March 1906, n.p. [p.2].

28 GSAA, NEW I/I, vol. 2: Anon., 'Education: School of Art Exhibition', cutting from Evening Citizen, 1 December 1904 (p.138); and 'Simon Pure', letter to Glasgow Herald (p.141).

29 Clifford Bax, 'Jean Delville', in Delville, op.cit. (note 16), p.xiii.

30 GSAA, GOV 2/5, p. 65: minutes of Staff Sub-committee, 10 April 1902.

31 Musée d'Ixelles, Paul Artôt (ex. cat.), Brussels, 1982, n.p.

32 GSAA, SEC 35: E. A. Walton, 'Report', n.d. (April 1904), p.4.

33 GSAA, SEC 35: GSA, 'Report by the Governors of the Glasgow School of Art', 12 February 1904, p.1.

34 Prospectus, 1903/04, pp.14–17.

35 GSAA, DIR 5/17, 1913–14: Newbery to George Pirie, 9 October and 17 November 1913; and DIR 5/4 1909, vol. I, p.89: Newbery to convener of Parks and Galleries Committee, 19 March 1909.

36 Prospectus, 1903/04, p.14.

37 H. Barbara Weinberg, The Lure of Paris: Nineteenth century American painters and their French teachers, New York, 1991, p.22. The École des Beaux-Arts in Paris had introduced a 'three arts' section from 1883 with simultaneous instruction in painting, sculpture and elementary architecture.

38 GSAA, GOV 2/5: minutes of School Committee, 27 January 1905 (p.221); minutes of Finance Committee, 3 October 1905 (p.252).

39 Adolf von Hildebrand, Das problem der Form in der Bildenden Kunst, Strasbourg, 1901; translated by Baltus

as *Le Problème De La Form Dans Les Arts Figuratifs*, Paris and Strasbourg, 1903.

40 GSAA, GOV 2/6, p.139: minutes of School Committee, 30 March 1909.

41 Georges-Marie Baltus, *The Technics of Painting: an elementary guide for students and for artists*, Glasgow, 1912.

42 'A. G. T.', 'Maurice Greiffenhagen', *Art Journal* (August 1894), pp.225–29.

43 GSAA, GOV 2/5, p.288: minutes of School Committee, 4 April 1906; and DIR 5/2, p.31: Newbery to G. W. Lambert, 23 May 1906.

44 GSAA, SEC 35: MS 'Report of a Deputation appointed to visit London and Brussels', June 1906, pp.3–4.

45 GSAA, SEC 35: James Pittendrigh Macgillivray, 'Report on School by Mr. Pittendrigh Macgillivray, RSA, 7 Dec. 1904', p.4.

46 *Calendar*, 1909/10, pp.28–32; Albert Boime, *The Academy and French Painting in the Nineteenth Century*, New Haven, 1986, p.44; and Weinberg, *op.cit.* (note 37), p.20.

47 William Buchanan (ed.), *Mackintosh's Masterwork: the Glasgow School of Art*, 2nd ed., London, 2004, p.60, which shows the plan of the second floor dated April 1907; Boime, *op.cit.* (note 46), pp.43–47.

48 David Brown, 'Introduction', *Frederick Cayley Robinson A.R.A., 1862–1927* (ex. cat.), London, 1977, n.p. See also Maurice Maeterlinck, trans Alexander Teixeira de Mattos, *The Blue Bird; a fairy play in six acts, with twenty-five illustrations in colour by F. Cayley Robinson*, London, 1911.

49 GSAA, GOV 2/9: report by Newbery to Staff Sub-committee, 9 October 1913, (inserted at p. 58A), p.6.

50 Ibid., pp.1–6.

51 GSAA, GOV 2/5: Chairman's Committee, 1 May 1903 (p.119); School Committee, 5 May 1904 (p.177).

52 GSAA, GOV 2/7, p.42: minutes of School Committee, 12 October 1909.

53 GSAA, GOV 2/7: report to School Committee, 10 March 1910 (inserted between pp.73 & 74), p.2.

54 GSAA, GOV 2/8, p.55: minutes of Finance Committee, 27 December 1911.

55 GSAA, GOV 2/9, pp.43–44: minutes of Finance Committee, 5 June 1913.

56 GSAA, GOV 2/9, p.54A: transcript of letter from Artôt dated 1 September 1913, School Committee, 1 October 1913.

57 Letter from the Private Secretary of Albert I, King of the Belgians, to Paul Artôt dated 26 February 1912. Private collection.

58 Anon., 'Honour to Glasgow Artist', unidentified newspaper cutting inscribed '*probablement Mars/Avril 1912*'. Private collection.

59 GSAA, GOV 2/5, p.110: transcript of undated letter from Artôt to Newbery, minutes of School Committee, 3 May 1903; GOV 2/9, p.36: transcript of letter dated 2 May 1913 from Artôt to Newbery, minutes of meeting of School Committee, 15 May 1913.

60 GSAA, DIR 5/8 (H): Newbery to A. G. Hannah, 26 October 1912: 'A man must keep up his personal practice or he speedily loses that vital power which in teaching is so important'.

61 GSAA, GOV 2/9: Newbery report to Sub-committee on Staff, 9 October 1913 (inserted at p.58), p.5.

62 GSAA, GOV, 2/5, p.90: report of Annual Public Meeting, 14 November 1902, including cutting from *Glasgow Herald* [?], 'Glasgow School of Art: Effect of the New Regulations'.

63 Anon., 'Art of the Exhibition: decoration of grand dome', *Glasgow Daily Mail*, 18 February 1902, p.2e-f; Anon., 'The Exhibition Sculpture: proposed statue of the King', *Glasgow Daily Mail*, 13 February 1901, p.4e.

64 *Annual Report*, 1910/11, p.23.

65 Elizabeth Williamson, Ann Riches and Malcolm Higgs, *Glasgow*, London, 1990, p.162.

66 Ibid., p.549.

67 GSAA, GOV 2/9, p.97: Anon., Panels for the New Public Library at Possilpark', unidentified cutting dated 27 January 1914.

68 GSAA, GOV 2/9: Newbery report to Sub-committee on Staff, 9 October 1913 (inserted at p.58), p.5.

69 See Ray McKenzie, *Public Sculpture of Glasgow*, Liverpool, 2002, pp.80–81 *et seq.*

70 GSAA, GOV 2/9, p.97: Anon., 'Panels for the New Public Library at Possilpark', unidentified cutting dated 27 January 1914.

71 *Annual Report*, 1913/14, p.26; *The Scotsman*: 30 May 1914, p.9; 10 June 1914, p.9; 15 June 1914, p.9.

72 Boime, *op.cit.* (note 46), pp.42–44. Boime also stresses that it was seen as a means of developing the students' imagination.

73 GSAA, DIR 5/5, p.695: letter from Newbery to Dr Struthers, 28 December 1909.

74 GSAA, DIR 5/16 (H), contains letters with advice to William Hunter who made copies from Rembrandt, Van Eyck, Moroni and Titian, and was advised to study Velázquez, Ribera and Goya in Madrid.

75 GSAA, DIR 5/6 (W): Newbery to Miss Wicksteed, 11

January 1911. In referring to 'the questionable activities of the French studios', he added: 'We here neither send students to Paris, nor in the case of Scholarships allow them to study there' maintaining that he was 'not a believer in undeveloped genius'.

76 GSAA, DIR 5/9 (M): Newbery to A. E. H. Miller, 24 October 1912.

77 GSAA, NEW I/I, vol. 3, p.183: unidentified cutting dated 22 December 1913.

78 GSAA, NEW I/I, vol. 3, p.188: Anon., 'Modern tendencies in art: the revolt against convention', cutting from Glasgow News dated March 1914.

79 GSAA, NEW I/I, vol. 3, p.155: unidentified press cutting dated 13 January 1913.

80 Annual Report, 1913/14, p.27.

81 GSAA, NEW I/I, vol. 3, p.158: unidentified review, dated 15 December 1913, of the Glasgow School of Art Club exhibition. It records that Miss Amour's Post-Impressionist figure subject won a prize.

82 Anon., 'Youth's Odyssey: Glasgow Society of Painters and Sculptors', Glasgow Herald, 9 May 1919, p.6.

83 Anon., 'Challenge of Youth: Glasgow Painters and Sculptors', Evening Times, 12 May 1919, p.3.

84 Anna Gruetzner Robins, Modern Art in Britain, 1910–1914 (ex. cat.), London, 1997, p.140.

85 Baltus, op.cit. (note 41), pp.10–11.

Chapter Five

1 USA, OE 16/1/2: extract of letter from Eugène Bourdon to Charles Gourlay, 11 November 1914, in minutes of Joint Committee on Glasgow School of Architecture.

2 USA, OE 16/1/2: extract of letter from Eugène Bourdon to Alexander McGibbon, 9 November 1914, in minutes of Joint Committee on Glasgow School of Architecture.

3 Gavin Stamp, 'An Architect of the Entente Cordiale: Eugène Bourdon (1870–1916) – Glasgow and Versailles', in Architectural Heritage, 15 (2004), pp.83–85.

4 GSAA, GOV 2/5, p.186ff.: minutes of the School Committee, 17 June 1904.

5 GSAA, GOV 2/5, p.194ff.: copy of letter dated 25 July 1904 from Eugène Bourdon to the Governors of Glasgow School of Art, in minutes of the School Committee, 20 September 1904; Glasgow School of Architecture: Calendar, 1905/06, p.7.

6 See issues of Glasgow School of Architecture: Calendar in GSAA, e.g. 1905/06, p.3; also Eugène Bourdon, 'The Glasgow School of Architecture', in the Builder, 106 (January–June 1914), 29 May 1914, p.646.

7 Eugène Bourdon, 'The Education of the Architect', in Architectural Review, 18 (May 1905), p.239.

8 GSAA, GOV 2/6, p.100: minutes of the School Committee, 8 December 1908; USA, OE/6/1/1: minutes of Joint Committee on Glasgow School of Architecture, 26 February 1907; on other student activities, see e.g. H. L. H. [Herbert L. Honeyman], 'The Tite Prizeman Interviewed', in Vista: the Quarterly Magazine of the Glasgow School of Architecture Club, 1 (April 1909), p.80.

9 GSAA, Glasgow School of Architecture: Calendar, 1905/06, p.14. For more detail on the École des Beaux-Arts, see Arthur Drexler (ed.) The Architecture of the École des Beaux-Arts, London, 1977, pp.61–109; and Donald Drew Egbert, The Beaux-Arts Tradition in French Architecture, Princeton, NJ, 1980.

10 GSAA, issues of Glasgow School of Architecture: Calendar, 1905/06 to 1915/16, (e.g. the latter two projects are in 1915/16, p.10, and 1914/15, p.10 respectively).

11 GSAA, student drawings: NMC322 (Alex T. Scott) and NMC321A (Richard M. Gunn); the same may be said for the drawings for a 'Theatre Façade' published in Bourdon, op.cit. (1914) (note 6), pp.648–49.

12 GSAA, NMC323.

13 Julien Guadet, Éléments et théorie de l'architecture. Cours professé à l'École nationale et spéciale des beaux-arts, 3 vols, Paris, 1901–03, vol. 1; see also David van Zanten, 'Architectural Composition at the École des Beaux-Arts', in Drexler, op.cit. (note 9), pp.111–18.

14 Richard Chafee, 'The Teaching of Architecture at the École des Beaux-Arts', in Drexler, op.cit. (note 9), p.97.

15 GSAA, Glasgow School of Architecture: Calendar, 1905/06, p.17.

16 GSAA, Glasgow School of Architecture: Calendar, 1906/07, pp.12–13.

17 GSAA, Glasgow School of Architecture: Calendar, 1905/06, p.6.

18 GSAA, GOV 2/7, pp.54–56: minutes of the School Committee, 17 November 1909.

19 GSAA, GOV 2/8, p.119: copy of letter from Eugène Bourdon to George MacDonald (National Art Survey), 23 April 1912.

20 Alan Powers, 'Arts and Crafts to Monumental Classic: the institutionalisation of architectural education, 1900 to 1914', in Neil Bingham (ed.), The Education of the Architect: Proceedings of the 22nd Annual Symposium of the Society of Architectural Historians of Great Britain 1993, Edinburgh, 1993, pp.35–36; see also Alan Powers,

'Edwardian Architectural Education: A Study of Three Schools of Architecture', in *AA Files*, 5 (January 1984), pp.49–59 (e.g. p.50) for further background.

21 On Reilly, see Joseph Sharples, *Charles Reilly and the Liverpool School of Architecture, 1904–1933*, Liverpool, 1996.

22 Eugène Bourdon, *op.cit.* (1905) (note 7), p.238.

23 Eugène Bourdon, cited in Stamp, *op.cit.* (note 3), pp.93–94; compare also the anonymous student essay, 'Editorial', in *Vista*, 1 (Summer 1910), pp.3–5.

24 John Henry Newman, *The Idea of a University, Defined and Illustrated*, 2 vol, London, 1889, especially vol. 1, discourse 5, 'Knowledge its Own End' and discourse 7, 'Knowledge Viewed in Relation to Professional Skill'; Matthew Arnold, *Culture and Anarchy: an essay in political and social criticism*, London, 1869.

25 James A. Morris, 'Truth and Tradition: the architect and the engineer', in *Vista*, 1 (December 1908), p.40.

26 A. T. S. [Alex T. Scott], 'To-Day', in *Vista*, 1 (May 1908), p.24; A. T. S. [Alex T. Scott], 'To-Day', in *Vista*, 1 (April 1909), pp.83–84.

27 Similar terms were used to criticise the openly gay architect Paul Rudolph's architecture in the 1950s. See Timothy M. Rohan, 'The Dangers of Eclecticism: Paul Rudolph's Jewett Art Center at Wellesley' in Sarah Williams Goldhagen and Réjean Legault (eds), *Anxious Modernisms: Experimentation in Postwar Architectural Culture*, Boston, MA, 2001, pp.191–214.

28 'Newcomer', 'The City – No. 2', in *Vista*, 1 (December 1908), p.44.

29 Anon., 'An Echo from the Past', in *Vista*, 1 (Summer 1910), pp.29.

30 Eric Hobsbawm, 'Mass-Producing Traditions: Europe, 1870–1914', in Eric Hobsbawm and Terence Ranger (eds), *The Invention of Tradition*, Cambridge, 1983, p.304; see also Bourdon, cited in Stamp, *op.cit.* (note 3), p.93.

31 GSAA, GOV 2/7, p.101: copy of letter from Eugène Bourdon to Francis Newbery, 6 May 1910, in minutes of the Sub-Committee on Design, 9 May 1910.

32 A. T. S., 'To-Day', in *Vista*, 1 (May 1908), p.25.

33 Banister Fletcher, *A History of Architecture on the Comparative Method*, 12th rev. edn, London, 1945 [1896], p.vii; acquisition noted in minutes of the School Committee, 28 November 1901, for which see GSAA, GOV 2/5, p.31. For more on this idea, see Robert Proctor, 'Architecture from the Cell-Soul: René Binet and Ernst Haeckel', in the *Journal of Architecture*,

11 (2006), pp.407–24 and Robert Proctor, 'René Binet and the *Esquisses Décoratives*', in Robert Proctor and Olaf Breidbach, *René Binet: From Nature to Form*, Munich, 2007, pp.5–34.

34 Ernst Haeckel, *The Riddle of the Universe*, trans. by Joseph McCabe, London, 1900, e.g. ch. 4; see also Ernst Haeckel, *The Evolution of Man: a popular exposition of the principal points of human ontogeny and phylogeny*, London, 1879.

35 See Proctor and Breidbach, *op.cit.* (note 33), for more detail; also Erike Krausse, 'Haeckel: Promorphologie und « evolutionistische » ästhetische Theorie: Konzept und Wirkung', in Eve-Marie Engels (ed.), *Die Rezeption von Evolutionstheorien im 19. Jahrhundert*, Frankfurt, 1995, pp. 358-59; Richard Somerset, 'Transformism, Evolution, and Romanticism', in *Nineteenth-Century French Studies*, 29 (2000–2001), pp.1–20.

36 Fra. H. Newbery, 'Tradition', in *Vista*, 1 (May 1908), pp.5–6.

37 Bourdon, *op.cit*, (1905) (note 7), p.240.

38 GSAA, GOV 2/8, p. 35: Eugène Bourdon, report on German Art Education, minutes of the School Committee, 14 November 1911.

39 For details of the split see Hugh Ferguson, *Glasgow School of Art: the history*, Glasgow, 1995, pp.144–47.

40 Andor Gomme and David Walker, *Architecture of Glasgow*, London, 1968, p.228; the 1987 edition of this book omits the passage here, but gives only reluctant descriptions of a small number of inter-war buildings.

41 GSAA, *Glasgow School of Architecture: Calendar*, 1921/22, p.15.

42 GSAA, *Glasgow School of Architecture: Calendar*, 1909/10, p.17; GOV 2/7, pp.135–36: minutes of the School Committee, 12 October 1910.

43 Elizabeth Williamson, Anne Riches and Malcolm Higgs, *Glasgow*, London, 1990, pp.83 & 218.

44 Stamp, *op.cit.* (note 3), p.102.

45 Charles McKean, *The Scottish Thirties: an Architectural Introduction*, Edinburgh, 1987, pp.101–04; Williamson, Riches and Higgs, *op.cit.* (note 43), pp.177, 216, 234 & 250.

46 Williamson, Riches and Higgs, *op.cit.* (note 43), pp.269–70, 346 & 428; see also the re-evaluation of the Dental Hospital in Gomme and Walker, *op.cit.* (note 40), 1987, p.271.

47 Student destinations in GSAA, *Glasgow School of Architecture: Calendar*, 1921/22, p.15; architect information from Williamson, Riches and Higgs,

op.cit. (note 43); see also David Walker *et al.* (eds), *Dictionary of Scottish Architects, 1840–1980,* www.scottisharchitects.org.uk (ongoing publication [2009]).

Chapter Six

1 NLS, Acc. 6740 no. 26: Fra Newbery to Jessie M. King, 29 December 1921.
2 Janice Helland, *The Studios of Frances and Margaret Macdonald,* Manchester, 1996, pp.36–47.
3 Anon., 'The International Exhibition of Modern Decorative Art at Turin – the Scottish Section', *Studio,* vol. 26, no. 112 (July 1902), pp.91–104; GSAA, EPH 8, Turin Exhibition file, *passim.*
4 GSAA, EPH 8, Turin Exhibition file, *passim.* Nine of the 16 bookbindings in the exhibition had been designed in the School but made by a commercial bookbinder.
5 GSAA, REG 3/6, General Register of Students, 1901–10.
6 GSAA, REG 3/2, General Register of Students, 1892–95. Thirty-five of the 52 female 'designers' enrolled in 1893/94 had attended in previous years, but only four of these had previously noted their occupation as 'designer'. Most of these were from the middle classes and must have been attracted to design as a profession as the technical studios had been opened during this session. The *Studio,* vol. 56, no. 234 (September 1912), p.318, observed, perhaps with a measure of hyperbole, that there were 'a hundred studios and craft-shops in Glasgow', and with more accuracy that the movement that gave rise to this was 'largely controlled by women'.
7 *Prospectus,* 1902/03, pp.33–34. Taking this session as an example, seven women and nine men served on the staff of the technical studios. The women taught art needlework, book decoration, metalwork, ceramic decoration, enamels, sgraffito, gesso and illumination.
8 *Ibid.,* p.30. 'Inability to draw or model well hinders students in the expression of their ideas, and no good design is possible unless the designer be first a good draughtsman'.
9 GSAA, SEC 35: Robert Anning Bell, 'Report on the Glasgow School of Art', 9 April 1903, pp.3–6.
10 *Prospectus,* 1902/03, p.31.
11 GSAA, GOV 2/5, p.141: minutes of the Annual Ordinary Meeting, 8 October 1903.
12 GSAA, NEW I/I, vol. 2, p.129: Anon., 'Glasgow School of Art: Interesting Appointment', *Glasgow News,* 23 February 1904.

13 GSAA, SEC 35: Robert Anning Bell, 'Twenty Years of the Glasgow School of Design', 1931, p.1.
14 Werkbund-Archiv, Berlin: Margaret Macdonald Mackintosh to Anna Muthesius, Christmas 1904. Mrs Mackintosh links the growth of the 'French Colony' at Glasgow School of Art with 'efforts to stamp out the Mackintosh influence'.
15 GSAA, SEC 35: Adolphe Giraldon, 'Report on Design Teaching', 25 April 1906; *Prospectus,* 1907/08, p.54.
16 Bell, *op.cit.* (1931) (note 13), p.1.
17 GSAA, SEC 35: R. Rowand Anderson, 'Copy of a Report by Sir R. Rowand Anderson, LL.D., on the Glasgow School of Art', 17 March 1906', p.1.
18 GSAA, GOV 2/5, p.287: minutes of School Committee, 4 April 1906; Giraldon, *op.cit.* (note 15). The report evaded the question of how to adapt the work more closely to manufacturing needs, leaving it to Giraldon's assistant, Aston Nicholas, to answer, but it allowed the latter no influence on the students' approach to designing. Rather it required that work should be sent periodically to France 'for correction', added to which Giraldon offered to make three separate visits of a month's duration instead of only one of three months.
19 GSAA, GOV 2/5, pp.117–18: minutes of Half-yearly Ordinary General Meeting of Governors, 28 April 1903.
20 GSAA, GOV 2/5, p.283: minutes of Half-yearly Ordinary General Meeting of Governors, 26 March 1906.
21 GSAA, GOV 2/6: minutes of School Committee, 24 January and 5 February (pp.24–27) and Extra-ordinary General Meeting of Governors, 4 March 1908 (pp.37–38).
22 GSAA, DIR 5/3, p.71: Newbery to Anne Macbeth, 6 April 1908.
23 GSAA, GOV 2/6, p.52: minutes of School Committee, 8 May 1908. The deputation included James Fleming [fig. 1.4], W. F. Salmon, John Henderson and Newbery representing the School, and the architect T. L. Watson from the College governors. In addition, J. J. Burnet was probably present at the interview with Voysey. For this see GSAA, SEC 2, 1907–09, p.79: letter to Fleming, Salmon, Henderson and Watson, 11 May 1908; and DIR 5/3, p.96: Newbery to Burnet, 11 May 1908.
24 W. E. F. Britten, 'Some thoughts on Decorative Art: the Cartoons at South Kensington', *Architectural Review,* vol. I (November 1896–May 1897), pp.114–23.

25 GSAA, GOV 2/6, pp.56–58: minutes of Sub-Committee on Design, 22 May 1908.

26 Bell, op.cit. (1931) (note 13), p.1.

27 GSAA, SEC 2 (H): letter to the Editor, Glasgow Herald, 1 May 1911. Unfortunately, images of these works have not been traced, but the allegorical nature of their titles, some not dissimilar to titles employed by Leighton, and Anning Bell's observation that Britten's work had influenced that of his students, suggests this.

28 GSAA, GOV 2/6, pp.61–62: minutes of Sub-Committee on Design, 5 June 1908.

29 GSAA, GOV 2/6: minutes of School Committee, 25 September 1908 (pp.70–71) and 13 October 1908 (p.78).

30 GSAA, DIR 5/3: Newbery to Harry Wilson, 24 November 1908 (p.316); Newbery to Britten, 14 January 1909 (p.413); DIR 5/34g: Newbery to Britten, 26 October 1910.

31 GSAA, DIR 5/5, vol. 2, p.432: Newbery to Britten, 12 October 1909.

32 GSAA, GOV 2/7: minutes of School Committee, 21 April 1910 (p.88); Newbery, 'Duties and Responsibilities of the Professor in the Design Section', in minutes of Sub-committee on Design School, 27 April 1910 (pp.95–98).

33 GSAA, GOV 2/7, pp.99–107: minutes of Sub-Committee on Design, 9 & 11 May 1910.

34 GSAA, GOV 2/7: Newbery report 'Design Department – Textiles', inserted in minutes of Sub-committee on Design, 12 October 1910 (between pp.132 & 134).

35 GSAA, GOV 2/7: Newbery report 'Staff Arrangements', second of two reports inserted in minutes of School Committee, 17 January 1911 (between pp.169 & 170), p.5.

36 GSAA, GOV 2/7, pp.175–76: minutes of School Committee, 31 January 1911.

37 GSAA, GOV 2/7, pp.198–200: minutes of School Committee, 9 March 1911.

38 GSAA, GOV 2/7, p.230: minutes of School Committee, 26 April 1911.

39 GSAA, GOV 2/8, p.10: minutes of School Committee, 29 September 1911.

40 Calendar, 1909/10, p.55.

41 Ibid., p.56.

42 Ibid., pp.53–54.

43 GSAA, GOV 2/7: Robert Anning Bell, 'Report to the Board of Directors of the Glasgow School of Art', inserted in minutes of Sub-committee on Design, 13 March 1911 (between pp.201 & 202).

44 GSAA, GOV 2/11: Robert Anning Bell, 'Report on the Design Section of Glasgow School of Art 1911–1916', inserted in minutes of School Committee, 23 January 1917 (between pp.28 & 28b), pp.1–2. This had not proved to be necessary in the embroidery or textiles sections where such changes had been made several years before.

45 Calendar, 1915/16, pp.39 & 40.

46 Harold Stabler visited the enamelling section in 1913. Because enamelling was such a specialised subject the School had periodically brought in experts to advise – Alexander Fisher in 1903 and Arthur Gaskin in 1905 – and had appointed a special deputation to visit several English Schools and Guilds of Handicraft in 1905 to report on enamelling, gold and silversmithing.

47 Bell, op.cit. (1931) (note 13), p.2.

48 Anon, 'Artistic Mural Decorations Exhibition', Bulletin, 20 March 1917, p.8. The main focus of the photograph is a lunette design by Bell based on Shakespeare's A Midsummer Night's Dream. The caption stated that this decorative work in coloured relief was being developed by Glasgow School of Art, and was 'particularly adapted to tea rooms, music rooms, cinemas, theatres, etc.'

49 'J. T.', 'Art School Notes', Studio, vol. 61, no. 252 (April 1914), pp.254–55.

50 Bell, op.cit. (1911–16) (note 44), pp.1–8.

51 Annual Reports, 1908/09, p.17; 1909/10, p.14; 1910/11, p.12; 1911/12, p.14; 1913/14, p.13. See also GSAA, REG 3/7, General Register of Students, 1910–19.

52 GSAA, GOV 2/11: minutes of School Committee, 23 January (p.27) & 6 February 1917 (p.30), and Sub-committee on Bell's Report, 9 February 1917 (pp.33–35).

53 GSAA, GOV 2/5, pp.244–48: minutes of Extraordinary Meeting of Governors, 9 September 1905.

54 GSAA, EPH 1, 1900–06, Glasgow School of Art, Glasgow Weaving College, Prospectus: Art Instruction: textile & allied trades,1906–7.

55 GSAA, GOV 2/5, p.283: minutes of Half-yearly Ordinary General Meeting of Governors, 26 March 1906, refer to the financial loss made by the class.

56 GSAA, GOV 2/6, p.71: minutes of School Committee, 25 September 1908.

57 Calendar, 1909/10, p.58.

58 GSAA, GOV 2/16, p. 33c: Robert Anning Bell, 'Report from Dr R. Anning Bell, RA, RSW, LL.D., March 1932', p.2, in minutes of Extraordinary General Meeting, 15 April 1932.

59 Anon., 'Studio-Talk', Studio, vol. 24, no. 106 (January 1902), pp.284–86.

60 Bell, op.cit. (1931) (note 13), p.1.
61 An illustration showing Bell's influence on his students appears in the copy by Meredith Williams of Bell's treatment of child angels in coloured gesso. See Anon., 'Studio-Talk', Studio, vol. 56, no. 234 (September 1912) p.318.
62 GSAA, DIR 5/21: Newbery to Anning Bell, 26 March 1914. Although Newbery and Bell were to act as the Scottish jury, they in fact contacted their preferred artists who then selected examples of their own work, which they sent separately to a jury in London. See also DIR 5/24, Newbery to Alfred Longden, 12 March 1914.
63 Musée du Louvre: Pavillon de Marsan: Exposition des arts decoratifs de grande-Bretagne et d'Irlande, Avril–Octobre 1914, Paris, 1914.
64 GSAA, DIR 5/21: Newbery to Anning Bell, 14 February 1914.
65 GSAA, DIR 5/26: Newbery to Isidore Spielmann, 7 April 1914. Students responsible for the shields were Ailsa Craig, Helen S. Johnston, Grace Melvin, Miss L. Miller, Elsie Morton, Helen Lamb and Mary Crawford. The tympanum was painted by three students who had worked at Possilpark: Helen S. Johnston, Josephine Cameron and Tom Gentleman, together with James Davie. Other students had 'traced' the tympanum, presumably transferring it from the original design (by Bell?). The sculpture student Alexander Proudfoot [fig. 7.21] had also produced a model of an angel for a 'staff head'.
66 Bell op.cit. (1931) (note 13), p.1. Referring to the Glasgow Style he wrote: 'It had many good qualities, often beautiful and unusual colour schemes and well distributed surface decoration; as, however, it was very limited in motives and repudiated all respect for tradition, it had few roots and was in a state of decline when I came to take charge'.
67 GSAA, DIR 5/27: Newbery to David Forrester Wilson, 15 June 1914. Wilson and another staff member, Allan Mainds, had received a grant from the governors to visit Paris.
68 GSAA, SEC 2: Newbery to Harry [Henry] Wilson, 27 March 1916.
69 Charles Holme (ed.), Arts & Crafts: a review of the work executed by students in the leading art schools of Great Britain and Ireland, London & New York, 1916, p.106.
70 GSAA, DIR 5/31: Newbery to J. Hislop Pettigrew, 27 September 1916.
71 Fra H. Newbery, 'Art in relation to technical education', Glasgow Evening News, 12 April 1893, p.4. Here Newbery states that one cannot 'have good art if the one end and aim be its production by the machine, for that can but end in the possession of an art that is at the level of the machine'.

Chapter Seven

1 Annual Report, 1909/10, p.19. The number given here is 800, but this appears to exclude anatomical casts, as well as animals and foliage.
2 Circular letter from the Council of the Schools of Design, quoted in Hugh Ferguson, Glasgow School of Art: the history, Glasgow, 1995, p.23.
3 Annual Report, 1910/11, pp.10 & 12.
4 Calendar, 1914/15, p.89.
5 NLS, Dep. 349/181: James Pittendrigh Macgillivray, Special Report on the Art Schools by Pittendrigh Macgillivray, Esq., RSA, Session 1904–1905, p.3.
6 Ibid.
7 Annual Report, 1905/06, pp.32–33.
8 F. H. Newbery, 'Sculpture Demonstrations by M. Lanteri at Glasgow', Scottish Art Review, vol. 1, no. 12 (May 1889), p.340.
9 William Buchanan (ed.), Mackintosh's Masterwork, Glasgow, 1989, p.23. In many ways, this was not so very different from the pedagogy espoused by the founder of art education in Britain, Sir Joshua Reynolds, who stated in the second of his Discourses that 'the history of errors, properly managed, often shortens the road to truth.' Sir Joshua Reynolds, Discourses on the Fine Arts, Edinburgh, 1840, p.7 [Discourse 2, 11 December 1769].
10 Newbery, op.cit. (note 8), p.340.
11 GSAA, GOV 2/10: draft of letter from Governors to Alfred Drury, in minutes of School Committee, 3 March 1915 (p.43c); minutes of Staff Committee, 10 May 1915 (p.60).
12 Benno Schotz, Bronze in My Blood, Edinburgh, 1981, p.57.
13 See Buchanan, op.cit. (note 9), p.14.
14 Annual Report, 1896/97, p.14; Annual Report, 1898/99, p.23.
15 Annual Report, 1898/99, p.22.
16 Anon., 'The Exhibition Sculpture. Proposed Statue of the King', Glasgow Daily Mail, 13 February 1901, p. 4e.
17 For example, the relief panel of a Mother and Child on the former Elder Cottage Hospital, Drumoyne Drive, Glasgow, 1902–03. See Kineton Parkes, The Art of Carved Sculpture, London, 1931, vol. 1, opp. p.123.

18 GSAA, GOV 2/4, pp.99–100: copy of letter from Kellock Brown to Newbery, 21 September 1896, in minutes of School Committee, 23 September 1896.

19 Anon., 'Men You Know – No. 1792', Bailie, vol. 69, no. 1792 (20 February 1907), pp.1 & 3; George Eyre-Todd, Who's Who in Glasgow in 1909: a biographical dictionary, Glasgow, 1909, pp.104–05.

20 For details see Ray McKenzie, Public Sculpture of Glasgow, Liverpool, 2002, pp.310–12.

21 Ibid., p.250.

22 Ibid., pp.247–67.

23 'The Glasgow Exhibition' ('From Our Special Correspondent'), The Times, 26 April, 1901, p.7a.

24 Glasgow International Exhibition 1901: Fine Art, Glasgow, 1901, n.p. The committee included the School governors J. J. Burnet, John Keppie and William Forrest Salmon; The Times, op.cit. (note 23).

25 See Glasgow Daily Mail: 13 February 1901, p.4e; 21 February 1901, p.2b-d; 26 April 1901, p.2b. See also Anon., 'Glasgow International Exhibition', Builders' Journal, vol. 13, no.328 (22 May 1901), pp.292–93.

26 GSAA, GOV2/4, p.139: minutes of Extraordinary Committee, 5 May 1897.

27 GSAA, GOV2/4, p.163: minutes of School Committee, 3 November 1897.

28 Annual Report, 1897/98, p.1.

29 Annual Report, 1905/06, p.6.

30 GSAA, SEC 35: James Pittendrigh Macgillivray, 'Report on School by Mr Pittendrigh Macgillivray, RSA, 7 Dec. 1904'.

31 Ibid., p.1.

32 Macgillivray, op.cit. (note 5), p.151.

33 Macgillivray, op.cit. (note 30), pp.4–5.

34 Ibid., p.6.

35 Ibid., pp.9–10.

36 GSAA, SEC 35: Report by Sub-committee on Sculpture, n.d. (7 October 1905).

37 Ibid., p.2.

38 Ibid., p.1.

39 Ibid., p.2.

40 GSAA, SEC 35: 'Copy of a Report by Sir R. Rowand Anderson, LL.D., on the Glasgow School of Art', 17 March 1906, p.1.

41 GSAA, DIR 5/4 (1), p.46: Newbery to Gray, 16 February 1909.

42 GSAA, GOV 2/8: report by Director presented to School Committee, 13 November 1912 (between pp.158 & 159).

43 GSAA, GOV 2/8, p.197: Sub-committee on Modelling, 3 February 1913.

44 GSAA, GOV 2/8, p.213: minutes of School Committee, 4 March 1913.

45 GSAA, GOV 2/9, p.17A: Governors to Johan Keller, 15 April 1913.

46 GSAA, GOV 2/9: report by Newbery to Sub-committee on Modelling, 1 April 1913 (between pp.3 & 4).

47 Ibid.

48 GSAA, GOV 2/9, p.3: minutes of Sub-committee on Modelling, 1 April 1913.

49 GSAA, DIR 5/4 (1), p.46: Newbery to Gray, 16 February 1909, p.2.

50 GSAA, GOV 2/10: report by Albert Hodge, 6 May 1915 (inserted at p.70d), p.1.

51 GSAA, GOV 2/10, p.96: minutes of Chairman's Committee, 29 October 1915.

52 Ibid.

53 GSAA, GOV 2/10, p.121: School Committee, 7 February 1916.

54 Schotz, op.cit. (note 12), pp.58–59.

55 George Rawson, Francis Newbery and the Glasgow School of Art, unpublished PhD thesis, Glasgow School of Art, 1996, p.331.

56 GSAA, DIR 5/28: Newbery to Mme Bourdon, 2 November 1916.

57 USA, GB 249 OE/16/1/2: 'Minutes of Joint Committee on the School of Architecture, March 1911 to June 1921', passim. See also Gavin Stamp, 'An Architect of the Entente Cordiale: Eugène Bourdon (1870–1916) – Glasgow and Versailles', Architectural Heritage, 15 (2004), pp.81 & 101.

58 Fergusson, op.cit. (note 2), p.138.

59 GSAA, GOV 2/11, p.171: minutes of Governors' Half-yearly Committee, 27 April 1920.

Chapter 8

1 North Kelvinside Public School was designed by the Glasgow architect Robert Alexander Bryden for the Maryhill School Board. GSA and the Technical College were consulted on the requirements of the School's Drawing and Manual Instruction rooms.

2 North Kelvinside joined the scheme in the 1915/16 academic year. GCASC, GSB minutes, D-EDI.I.19, p.234, 1915–16.

3 Teachers identified through appointment entries in school log books. John Moffat studied at GSA between 1891 and 1898, and had been visiting art master to North Kelvinside for one day a week since the school opened in 1896; Miss Walker joined as part-time staff

on 6 March 1916. GCASC, Agnes Street Primary Public School Log Books, D-ED7.153.2, p.133, 6 March 1916 and D-ED7.153.1, *passim*.

4 GCASC, D-ED7.153.1, 14 May 1908.

5 The Education Act of 1872 created school boards to implement a national system of compulsory education for all children between five and 12 years old in their designated area. The Glasgow area was covered by seven boards, from smaller ones such as Maryhill Parish and Springburn to the largest, Govan Parish (covering Glasgow's south side from Renfrew to Polmadie and extending north of the river to Kelvinside, Hillhead and Partick) and Glasgow (covering the densely populated central area of the city). The number of children they each had to provide for was equally wide-ranging: Springburn – 453; Maryhill – 1,451; Govan – 11,082 and Glasgow – 87,294.

6 Statistics compiled from www.scottisharchitects. org.uk [February 2009].

7 *Annual Report*, 1904/05, pp.9–10.

8 GSAA, GOV 2/4: minutes of School Committee, 22 February 1900 (p.336) and 8 March 1900 (p.337). The report covered the School Board's decision to halve all of their course fees, with a guarantee to reimburse the complete fee to pupils with an attendance rate of ninety percent or over. Drawing was the fourth most popular 'commercial and advanced' class, attracting 788 pupils in the last year. See also the *Glasgow Herald*, 20 February 1900, p.9.

9 GSAA, GOV 2/4, p.351: minutes of Extraordinary Members Meeting, 4 June 1900.

10 GSAA, GOV 2/4, p.364: minutes of School Committee, 14 Sept 1900.

11 GSAA, GOV 2/4, p.421: minutes of Chairman's Committee, 6 June 1901.

12 *Annual Report*, 1902/03, p.7; GSAA, GOV 2/5, p.125: minutes of School Committee, 26 May 1903.

13 *Annual Report*, 1903/04, p.9.

14 Statistics calculated from GSA Annual Reports of those years.

15 GCASC: minutes of the GSB in Committee, D-EDI.1.1.2, 19 October 1882, p.385; GPSB minutes, D-EDI.4.1.3, 8 August 1881, p.453.

16 *Annual Report*, 1884/85, p.4.

17 See Stuart MacDonald, *The History and Philosophy of Art Education*, London, 2004, esp. chapter 18, 'The Recognition of Child Art'.

18 SED, 'Memorandum on the Teaching of Drawing', n.d.

(1907), p.7, reprinted in Henry T. Wyse, *Modern Methods of Art Instruction*, Edinburgh, 1909, Appendix I.

19 *Ibid.*, p.8.

20 *Ibid.*, p.11.

21 GSAA, GOV 2/5, pp.21–22: minutes of School Committee, 22 October 1901.

22 *Annual Report*, 1901/02, pp.7–8.

23 GSAA, REG 10/55 (Article 91d Argyll and Lanarkshire courses): report by HMI Frank W. Young, 4 September 1902, p.4.

24 GSAA, GOV 2/5, pp.85–86: minutes of School Committee, 15 Oct 1902.

25 *Annual Report*, 1902/03, pp.7–8.

26 GSAA, REG 10/55 (Article 91d Argyll and Lanarkshire courses): report by HMI Frank W. Young for session 1902–03, dated 28 April 1903.

27 *Ibid.*, n.p.

28 GSAA, GOV 2/5, p.134: minutes of Chairman's Committee, 24 September 1903.

29 Letter from 'F', *Educational News*, 16 November 1901, p.810.

30 GCASC, D-EDI.4.4.4: GPSB, Triennial Report, March 1903, p.30. A letter from 'LG' in the *Educational News*, 23 November 1901, p.839, elaborates and enquires: 'We are told 24" [blackboard width] is the smallest space for Free-arm, and even that destroys the idea of freedom. With a class of 60, how is 'F' to get 120 feet of wall space round his room?'

31 The GSB had a request approved for such plant material from the Glasgow Corporation. See GCASC, C/1/31, p.1199: minutes of the Glasgow Corporation, Parks Department, Sub-committee on Parks, Art Galleries and Museums, 5 October 1904.

32 Letter from 'Fifer', *Educational News*, 15 March 1902, p.184.

33 GSAA, REG 10/55 (Article 91d Argyll and Lanarkshire courses): report by HMI Frank W. Young for session 1903/04, p.11

34 *Annual Report*, 1903/04, p.10. The subsequent session saw attendance at 608, with 70 diplomas awarded. The roll thereafter remained steady between 600 and 700 annually.

35 GSAA, REG 1 ('Teachers Courses 1901–40'): 1904/05, p.3.

36 Proposed on 27 May 1904 at a meeting of the Corporation's Parks Committee, the first competition took place in the autumn term of 1904 after consultation with the school boards and headmasters

regarding its implementation. See GCASC, C/1/31: minutes of the Glasgow Corporation, Parks Department, Sub-committee on Art Galleries and Museums, 27 May 1904 (p.803) and 28 June 1904 (p.936).

37 GCASC, C/1/34, p.530: minutes of the Glasgow Corporation, Parks Department, Sub-committee on Art Galleries and Museums, 29 December 1905.

38 All figures taken from information in GSA Annual Reports, 1896/97–1905/06.

39 GCASC, D-EDI.4.4: GPSB Triennial Report, March 1897, p.31.

40 Nairn was the Govan Board's Superintendent of Drawing from 1911 until his early retirement in 1913 and published his own practical guide to the 1907 memorandum on drawing: F. C. Nairn, A Scheme of Elementary Object Drawing for Day Schools. Being a practical guide on the lines of the recent memorandum on drawing issued by the Scotch Education Dept, Glasgow, n.d. (c.1907).

41 Margaret M. Harrison and Willis B. Marker (eds), Teaching the Teachers: The History of Jordanhill College of Education 1828–1993, Edinburgh, n.d. (c.1996), p.32.

42 GSAA, REG I ('Appendix to the Prospectus of the School of Art'), 1907/08, pp.1–5.

43 Fra Newbery 'Art, The School, The Teacher', Educational News, 2 April 1909, pp.332&334.

44 Prospectus, 1912/13, p.64. See also 'Appendix' (note 42), pp.1–3.

45 GSAA, REG I ('Teachers Courses 1901–40'): 1907–08, p.8

46 GCASC, D-EDI.4.4.1: GPSB Triennial Report, March 1879, p.19. Plain needlework included darning, mending, marking and knitting.

47 GCASC, D-ED.1.4.1.5, GPSB minutes, 17 November 1884, pp.80–86.

48 Ann Macbeth, 'A New Presentment of Sewing for Schools', Educational News, 20 May 1910, p.518 and 27 May 1910, p.548.

49 Ibid., p.518.

50 Ibid., p.548.

51 J. Taylor, 'The Glasgow School of Embroidery', Studio, vol. 50, no. 208 (July 1910) p.128.

52 Ibid., p.127.

53 See Liz Arthur, Textile Treasures at the Glasgow School of Art, London, 2005, pp.7–9, for a full account of the international interest the course generated and illustrated examples of work produced under the educational needlecraft scheme.

54 GCASC, D-ED7.275.5.2, pp.65–66, Shields Road Log Book: HM Inspector's report on disabled children's classes, 10 November 1909. One panel of the folding screen was published in Taylor, op.cit. (note 51), p.126.

55 Macbeth, op.cit. (note 48), p.548.

56 A letter from Newbery to Munro Fraser in Dumbreck remarked on a case of refusal: 'Miss Love, a fellow teacher has been at some pains to study the schemes of stitchery as enunciated by Miss Swanson. She has been forbidden by her Head Master to continue the schemes in her school'. See GSAA, DIR 5/6: Newbery to Fraser, 4 May 1911.

57 GSAA, DIR 5/8 (D-J): Francis Newbery to Dr Henry Dyer, 25 March 1912.

58 GSAA, DIR 5/6: letter of reference for Margaret Kennedy, 10 May 1911.

59 Ibid. See also Prospectus, 1909/10, p.52, and GSAA, Article 55 classes prospectus, (Teachers Courses), 1909/10, p.4.

60 Annual Report, 1851/52, p.12.

61 GSAA, GOV 2/7, p.97: minutes of Sub-committee on Design, 27 April 1910.

62 Prospectus, 1912/13, pp.59–60. By 1915 GSA had introduced further teacher-training courses to increase such skills, no doubt partly a response to the number of qualified male teachers now enlisted in the First World War. The 1915/16 Prospectus outlines the Article 47b course for teachers of educational handiwork and the Article 37c course for drawing and craft teachers.

63 Letter of reference for James McNeill, CSG(M) pp.1996.56.11, 24 October 1927.

64 GSAA, DIR 5/6: letter to Mr Marshall, Falkirk School Board, 27 March 1911.

65 GSAA, DIR 5/9: letter to Mr McDonald, SED, 12 November 1912, providing comments on teachers studying at GSA unsuccessful in gaining the Art Teacher's Diploma in 1912.

66 Newbery, op.cit. (note 43), pp.332 & 334.

67 Judges remarks, Glasgow Annual Schools Art Competition: GCASC, minutes of the Glasgow Corporation, Parks Dept, Sub-Committee on Art Galleries and Museums, vol. 42, 30 December 1909, p.484.

68 GSAA, DIR 5/6: letter to HMI J. T. Ewen, 2 June 1911.

69 GSAA, DIR 5/6: letter to F. Shirley Goodwin, Rector of Glasgow High School, 13 June 1911.

70 GCASC, D-EDI.4.7: GPSB Triennial Report, vol. 7, 1914–19, p.44.

List of Illustrations

2.10 David Muirhead Bone, *Kelvinhaugh Ferry*, lithograph, 1910 · 11 × 18 cm, reproduced in *Glasgow: Fifty Drawings*, Glasgow, 1911, plate 31.
GSAL

2.11 David Muirhead Bone, *Building the School of Art, Renfrew Street*, lithograph 12.5 × 9.5 cm, reproduced in *Glasgow: Fifty Drawings*, Glasgow, 1911, plate 41.
GSAL

2.12 David Muirhead Bone, *From Garnethill, Looking West*, lithograph · 18 × 12 cm, reproduced in *Glasgow: Fifty Drawings*, Glasgow, 1911, plate 40.
GSAL

2.13 James Smith, McLellan Galleries, Rose Street corner, 1855–56, altered by Burnet & Boston, c.1904.
Photograph by Ray McKenzie

2.14 David Muirhead Bone, *Drydock*, drypoint etching, 1899 · 23.8 × 18.7 cm.
Private collection

Chapter Three
The Performing School of Arts

3.1 Charles Rennie Mackintosh, Glasgow School of Art, north and east façades, 1899–1909.
Photograph by Ray McKenzie

3.2 Charles Rennie Mackintosh, Glasgow School of Art, west façade, 1907-09.
Photograph by Ray McKenzie

3.3 Charles Rennie Mackintosh, floor plans of Glasgow School of Art, from GSA *Prospectus*, 1907/08.
GSAA

3.4 Charles Rennie Mackintosh, plan of ground floor of Glasgow School of Art, pencil, ink and watercolour, November 1910 · 60.5 × 89 cm.
GSAA

3.5 Charles Rennie Mackintosh, drawing of 'wish-bones', identifying Honeyman & Keppie's competition entry, watercolour, 1896 · 9 × 11 cm.
GSAA

3.6 Charles Rennie Mackintosh, poster design for the Glasgow Institute of the Fine Arts, pencil, ink and watercolour on brown tracing paper, 1895 · 17.5 × 6.8 cm.
Hunterian Museum & Art Gallery, University of Glasgow

3.7 Francis H. Newbery, *The Building Committee of Glasgow School of Art*, oil on canvas, 1913–14 · 133 × 171 cm.
GSAA

3.8 Charles Rennie Mackintosh, letter on behalf of Honeyman, Keppie & Mackintosh to Building Committee, 15 March 1907.
GSAA

3.9 John James Burnet, former Glasgow Savings Bank, Ingram Street, Glasgow, with sculpture by George Frampton, 1894–99.
Photograph by Ray McKenzie

3.10 John James Burnet, Charing Cross Mansions, Glasgow, with sculpture by William Birnie Rhind, 1889.
Photograph by Ray McKenzie

3.11 Charles Rennie Mackintosh, the Library, Glasgow School of Art, 1910.
Photograph by Bedford Lemere
GSAA

3.12a Charles Rennie Mackintosh, drawing of proposed west (Scott Street) elevation, pencil, ink and watercolour, May 1907 · 58 × 81 cm (whole sheet).
GSAA

3.12b Charles Rennie Mackintosh, detail of drawing of proposed west (Scott Street) elevation, pencil, ink and watercolour, May 1907, 58 × 81 cm (whole sheet).
GSAA

3.13a Charles Rennie Mackintosh, drawing of west (Scott Street) elevation, pencil, ink and watercolour, November 1910 · 59 × 85 cm (whole sheet).
GSAA

3.13b Charles Rennie Mackintosh, detail of drawing of west (Scott Street) elevation, pencil, ink and watercolour, November 1910 · 59 × 85 cm (whole sheet).
GSAA

3.14 Charles Rennie Mackintosh, west doorway of Glasgow School of Art, 1909.
Photograph by T. & R. Annan & Sons
GSAA

4.25 'Mural Decorations in a Glasgow Public Library', *Studio*, vol. 61, no. 252 (April 1914), p.254.
GSAL

4.26 Archibald McGlashan with fellow students at work on *Geography* for Possilpark Library, early 1913.
Photographer unknown
Private collection

4.27 Helen Johnston, *Art* (detail), oil on canvas, 1913
162 × 51 cm (full size), Possilpark Library, Glasgow.
Photograph by Ray McKenzie

4.28 Archibald McGlashan, *Eve* (study after Titian's *The Fall of Man* (c.1570) in the Prado, Madrid), oil on canvas, 1914
119.5 × 96.5 cm.
GSAA

4.29 Francis H. Newbery, *A Cord*, oil on canvas, c.1912
30.5 × 38 cm.
GSAA

4.30 Robert Sivell, *My Parents and Family*, oil on canvas, 1920
176 × 267.8 cm.
Aberdeen Art Gallery and Museums Collections

4.31 William McCance, *Portrait of Agnes Miller Parker*, pencil and charcoal on paper, 1920
35.3 × 24 cm.
CSG(M)
Copyright Margaret McCance

4.32 Archibald McGlashan, *Day*, photograph of painting (untraced).
Private collection

4.33 Archibald McGlashan, *Landscape with Figures*, photograph of painting (untraced).
Private collection

4.34 William McCance, *The Engineer, his Wife and Family*, linocut, 1925 · 11.5 × 7.4 cm.
Hunterian Museum & Art Gallery, University of Glasgow
Copyright Margaret McCance

Chapter Five
Tradition and Evolution

5.1 Eugène Bourdon, elevation of an unexecuted design for a university or school building, pencil, ink and watercolour, 1890s
63.5 × 90.5 cm.
GSAA

5.2 Eugène Bourdon, the plan of a design for a Palais de Justice, pencil, ink and wash, 1894 · 64.6 × 64.6 cm.
GSAA

5.3 Henri Fromage, elevation of a design for Un Hôtel des Postes et Télégraphes, from *Les Médailles des Concours d'Architecture de l'École Nationale des Beaux-Arts à Paris. XVe Année (1912–1913)*, Paris, 1913, plate 22.
GSAL

5.4 Henri Fromage, plan of a design for Un Hôtel des Postes et Télégraphes, from *Les Médailles des Concours d'Architecture de l'École Nationale des Beaux-Arts à Paris. XVe Année (1912–1913)*, Paris, 1913, plate 24.
GSAL

5.5 W. B. J. Williamson, plan of a design for a Shipbuilding Yard, pencil, ink and watercolour, 1909
57 × 77.5 cm.
GSAA

5.6 Richard M. M. Gunn, design for the façade of a Colonial Parliament House, pencil, ink and watercolour, 1908–09 · 57.8 × 78 cm.
GSAA

5.7 Alex T. Scott, design for the façade of a Colonial Parliament House, pencil, ink and watercolour, 1908–09 · 55.2 × 77.5 cm.
GSAA

5.8 Alex T. Scott, Design for Law Courts, pencil, ink and watercolour, 1905–06
53.5 × 75 cm.
GSAA

5.9 Page from Julien Guadet, *Éléments et théorie de l'architecture: Cours professé à l'École nationale et spéciale des beaux-arts*, Paris, 1901–04, vol. 1.
GSAL

5.10 William Gourlay, design for a Theatre Façade, pencil and watercolour, 1912–13
52 × 72.7 cm.
GSAA

5.11 Anonymous Glasgow School of Architecture student, sections of a Scottish Hall, pencil, ink and watercolour, 1912–13 · 58 × 76.7 cm.
GSAA

Chapter Seven
'Hope in Honest Error'

8.12 Frances Macdonald
 (designer), Peter Wylie
 Davidson (maker), Dux in
 Art medal for the High
 School of Glasgow, bronze,
 1911 · 6.5 × 6.5 × 0.3 cm.
 North Ayrshire Museum © North
 Ayrshire Council Museums Service

8.13 Jessie Marion King
 presenting gold medals at
 the annual School Children's
 Drawing Competition at
 Kelvingrove Art Gallery and
 Museum, *Glasgow Daily Mail
 and Record*, 27 March 1926.
 Glasgow University Library,
 Special Collections

Appendix

Hugh Munro, 'Suggested Costume
Guide No. 1: Le Comte Fra
Nooberie', illustration from
St Mungo (1897).

Glasgow School of Art in the Early Twentieth Century

List of Works in Exhibition

The Mackintosh Building

1 Francis Henry Newbery (1855–1946), *Glasgow School of Art Building Committee*, oil on canvas, 1913–14 133 × 171 cm.
GSAA

2 Charles Rennie Mackintosh (1868–1928), Glasgow School of Art, plan of basement floor, ink and watercolour, November 1910 59.5 × 90.5 cm.
GSAA

3 Charles Rennie Mackintosh, Glasgow School of Art, plan of ground floor, ink and watercolour, November 1910 60.5 × 89 cm.
GSAA

4 Charles Rennie Mackintosh, Glasgow School of Art, plan of first floor, ink and water-colour, November 1910 60.8 × 110 cm.
GSAA

5 Charles Rennie Mackintosh, Glasgow School of Art, plan of second floor, ink and watercolour, November 1910 68 × 80 cm.
GSAA

The Department of Drawing and Painting

6 Francis Henry Newbery, *In Lyonesse*, oil on canvas, c.1916 89.5 × 89.5 cm.
Private collection

7 Francis Henry Newbery, *A Cord*, oil on canvas, c.1912 30.5 × 38 cm.
GSAA

8 Jean Delville (1867–1953), *L'Amour des Âmes*, tempera on canvas, 1900 · 238 × 150 cm.
Community Museum of Ixelles, Brussels, Belgium

9 Jean Delville, *The New Mission of Art: a study of idealism in art*, with introductory notes by Clifford Bax and Edward Schuré (London, 1910) 22.5 × 15.5 × 3 cm.
GSAL

10 Paul Artôt (1875–1958), *Les Poissons Rouges*, oil on canvas, c.1911 · 91 × 71 cm.
Private collection

11 Paul Artôt, *Crépuscule*, tempera on cardboard, c.1906 · 122 × 77 cm.
Private collection

12 James Morton Dunlop, *Anatomical Diagrams for the Use of Art Students, Arranged with Analytical Notes*, with an introductory preface by John Cleland (London, 1899) 26.7 × 37.3 cm.
GSAL

13 William Gray (fl.1890–1911), drawing of plaster cast of *Apollo Sauroctonos*, red chalk on paper, 1910–11 56 × 76.6 cm.
GSAA

14 *Apollo Sauroctonos*, plaster cast of a 1st or 2nd century AD Roman marble copy in the Louvre, Paris, of an original by Praxiteles 165 cm high.
GSAA

15 William MacArthur (fl.1885–1906), *Two Male Nudes Driving a Wheel*, pencil on paper, 1906 86.5 × 91 cm.
GSAA

16 *Two Wrestlers*, plaster cast of a Roman marble copy in the Uffizi, Florence, of a Hellenistic bronze original 450 cm high.
GSAA

17 Georges-Marie Baltus (1874–1967), *Titania*, tempera on canvas, 1913 80 × 80 cm (excluding frame).
Private collection

18 Georges-Marie Baltus, *The Technics of Painting: an elementary guide for students*, with an introduction by Fra. H. Newbery (Glasgow, 1912) 18.8 × 13 × 1 cm.
GSAL

19 Maurice Greiffenhagen
 (1862–1931), Nude, oil on
 canvas, 1924 · 111 × 91.5 cm.
 GSAA

20 Maurice Greiffenhagen,
 Portrait of a Lady, chalk on
 paper · 24 × 18 cm.
 GSAA

21 Sir Walter Scott, Ivanhoe:
 retold for children by Alice F.
 Jackson, illustrated by
 Maurice Greiffenhagen
 (London, c.1906), cover
 20 × 15.2 × 3 cm.
 GSAL

22. Maurice Maeterlinck, The Blue
 Bird: a fairy play in six acts,
 illustrated by Frederick
 Cayley Robinson (London,
 1911), cover · 26 × 20.5 cm.
 GSAL

23 Ralph Waldo Trine, In Tune
 with the Infinite: fullness of
 peace, power and plenty,
 illustrated by Frederick
 Cayley Robinson (London,
 1926) · 19.7 × 14 × 2.8 cm.
 GSAL

24 William Somerville Shanks
 (1864–1951), Male Model,
 pencil and chalk on paper,
 c.1910 · 59.5 × 44.8 cm.
 GSAA

25 Archibald McGlashan
 (1888–1980), Study of a
 Bearded Man, pencil on paper,
 c.1910 · 35.2 × 31.5 cm.
 GSAA (by permission of Agnes
 Gillies)

26 Archibald McGlashan,
 Male Nude, pencil on paper,
 c.1910 · 29.2 × 55.5 cm.
 GSAA (by permission of Agnes
 Gillies)

27 William Gray, Reclining
 Female Nude, pencil on paper,
 c.1913 · 38 × 56.2 cm.
 GSAA

28 Archibald McGlashan,
 Eve, (copy after Titian's The
 Fall of Man in the Prado,
 Madrid), oil on canvas, 1914
 119.5 × 96.5 cm.
 GSAA (by permission of Agnes
 Gillies)

29 Tom Gentleman
 (1892–1966), Bullfight in
 Madrid with Picador Kem,
 oil on canvas, 1921
 126 × 92 cm.
 Private collection (by permission
 of Hugh Gentleman)

30 Tom Gentleman, Horses being
 entrained onto horseboxes during
 World War 1, pencil high-
 lighted with watercolour
 wash on heavy handmade
 French paper, date unknown
 21 × 29 cm.
 Private collection (by permission
 of Hugh Gentleman)

31 Robert Sivell (1888–1958),
 My Parents and Family,
 oil on canvas, c.1919
 176 × 267.8 cm.
 Aberdeen Art Gallery

32 James Cowie (1886–1956),
 Two Girls, watercolour on
 paper, c.1920 · 17.2 × 17.5 cm
 (with frame 43.7 × 42.5 cm).
 Aberdeen Art Gallery

33 William McCance
 (1894–1970), Portrait of Agnes
 Miller Parker, pencil and
 charcoal on paper, 1920
 35.2 × 24 cm.
 CSG(M) (by permission of
 Margaret McCance)

34 Agnes Miller Parker
 (1895–1980), Stevedores,
 wood engraving on Japanese
 paper, date unknown
 14.9 × 9.7 cm.
 Hunterian Museum and Art
 Gallery, University of Glasgow (by
 permission of Margaret McCance)

35 Agnes Miller Parker, Pig-sty,
 wood engraving on Japanese
 paper, date unknown
 10 × 7.5 cm.
 Hunterian Museum and Art
 Gallery, University of Glasgow (by
 permission of Margaret McCance)

36 Susan Fletcher Crawford
 (1865–1918), In the Piazza,
 etching on paper, c.1902
 23.5 × 7 cm.
 CSG(M)

37 Susan Fletcher Crawford,
 Devorgilla's Bridge, Dumfries,
 etching on paper, date
 unknown · 12.7 × 30.5 cm.
 CSG(M)

38 David Muirhead Bone
 (1876–1953), Barony Church,
 Glasgow, pencil on paper,
 date unknown
 25.5 × 32.4 cm.
 CSG(M)

39 David Muirhead Bone,
 Glasgow: Fifty Drawings
 (Glasgow, 1911)
 39 × 30.5 × 4.5 cm, open at
 plate 41, Building the School of
 Art, Renfrew Street, 1908,
 lithograph · 12.5 × 9.5 cm.
 GSAL

The Department of Modelling and Sculpture

40 Archibald Dawson (1894–1938), *Betty*, bronze, 1923 · 29.2 cm high.
CSG(M)

41 John Tweed (1869–1933), *Nana*, bronze, date unknown 45 cm high.
CSG(M)

42 Percy Herbert Portsmouth (1874–1953), *Male Figure*, bronze, dat unknown 102 cm high.
GSAA

43 Archibald MacFarlane Shannan (1850–1915), *Portrait Bust of Fra H. Newbery*, bronze, 1895 · 62 cm high.
GSAA

44 Archibald Dawson (1892–1938), *Portrait Bust of John Morrison Groundwater*, bronze on marble stand, c.1931 · 46.5 cm high.
GSAA

45 William Reid Dick (1879–1961), *Portrait Bust of Robert Anning Bell*, bronze, 1930 · 36 cm high.
CSG(M)

46 William Reid Dick, *Portrait Bust of Patrick Smith Dunn*, bronze, c.1930 · 64 cm high.
GSAA

47 Édouard Lanteri, *Modelling: a guide for teachers and students* (London, 1902) 24.7 × 21 × 2.5 cm.
GSAL

Design

48 Leonardo Bistolfi (1859–1933), poster for the First International Exhibition of Modern Decorative Art, Turin, 1902 (designed 1901), lithograph, approx. 110 × 144.5 cm.
GSAA

49 Emile Zola, *Le Rêve*, illustrated by Carlos Schwabe, green leather binding with design in yellow gold by Jessie Marion King and John Macbeth, date unknown 29.3 × 19.9 × 3 cm.
Hunterian Museum and Art Gallery, University of Glasgow

50 *Album von Dresden und Sachsische Schweiz* (Berlin, n.d.), cover by Jessie Marion King, date unknown · 27.3 × 34.3 × 1 cm.
GSAL

51 Annie French (1872–1965), sketchbook, pen and ink, pencil and watercolour on paper, date unknown 17.7 × 11.5 cm.
CSG(M)

52 Jessie Marion King (1875–1949), bookplate *Ex Libris: Neugealtach E. A. Taylor*, paper, date unknown 15.4 × 7.4 cm.
CSG(M)

53 Jessie Marion King, bookplate *Ex Libris: JMK, Wilding Things*, paper, date unknown 14.2 × 13.2 cm.
CSG(M)

54 Jessie Marion King, menu card for *Miss Cranston Lunch and Tea Rooms*, printing ink on paper, date unknown 25.5 × 19.4 cm.
CSG(M)

55 Ann Macbeth (1875–1948), banner, coarse canvas with linen appliqué embroidered with wool and silver gilt threads, glass beads and buttons, early 1900s 65 × 235 cm.
GSAA

56 Jessie Wylie Rowat Newbery (1864–1948), design for a pulpit fall, pencil and watercolour on paper, date unknown · 35.5 × 49.7 cm.
GSAA

57 Unknown Saturday student (after Ann Macbeth), yoke and front of a blouse, orange velvet with embroidery in floss silk threads, 1910–20, 69 × 46 cm.
GSAA

58 Grace Wilson Melvin (1892–1977), green linen bag, linen lined with white silk and drawstring ribbons of pink silk embroidered with floss silk threads, c.1918 38 × 28 cm.
GSAA

59 Grace Wilson Melvin, collar, black velvet trimmed with rabbit fur and embroidered with silk thread, decorated with glass beads, c.1912 23.5 × 22.8 cm.
GSAA

60 Grace Wilson Melvin, baby's
coat and bonnet, cream-
coloured flannel sewn with
floss silk thread, mother-of-
pearl buttons and ties of
pink silk cord (coat); cream-
coloured flannel with silk
ribbons sewn with pink floss
silk and purple wool
threads, crown to neck edge
(bonnet), c.1918 · 16.5 cm.
GSAA

61 Margaret De Courcy Lewth-
waite Dewar (1878–1959),
Park School trophy shield,
metal and enamel, date
unknown · 47 × 35.7 cm.
CSG(M)

62 Jessie Marion King, hand
mirror, silver and enamel,
date unknown
12.5 × 27 × 2 cm.
CSG(M)

63 Jessie Marion King, pendant
on chain, silver enamel,
date unknown · 3.5 cm high
(pendant), 24 cm long
(chain).
CSG(M)

64 Jessie Marion King, oval
waistbuckle, silver with
coloured enamel, date
unknown · 5.5 × 7.5 cm.
CSG(M)

65 Jessie Marion King, oval
waistbuckle, silver with
coloured enamel, date
unknown · 4.2 × 8.7 cm.
CSG(M)

66 Jessie Marion King, square
waistbuckle, silver with
coloured enamel, date
unknown · 5.5 × 6 cm.
CSG(M)

67a & b
James Porteous (fl.1886),
two designs for wallpaper
body colour on brown paper,
date unknown · 101 × 75.8 cm
& 76.2 × 84.3 cm.
GSAA

68 Ernest Archibald Taylor
(1874–1951), design for a
fireplace, ink, watercolour
and silver paint on paper,
date unknown · 63 × 47.8 cm.
CSG(M)

69 Ernest Archibald Taylor,
design for a sideboard and
chair, pencil, ink and
watercolour on paper, date
unknown · 47.8 × 63 cm.
CSG(M)

70 M. P. Verneuil, 'Adolphe
Giraldon', Art et Décoration,
vol. 21, 1907
29.2 × 22 × 5 cm.
GSAL

71 William Edward Frank
Britten (1848–1916), 'The
Mosaics in the Dome of
St Paul's Cathedral',
Architectural Review, vol. 2,
1897 · 32.7 × 23 × 2.5 cm.
GSAL

72 William Edward Frank
Britten, 'Some thoughts on
Decorative Art: the Cartoons
at South Kensington',
Architectural Review, vol. 1,
1897 · 32.7 × 23 × 2.5 cm.
GSAL

73 Moira O'Neill, The Elf-Errant:
a story for children, illustrated
by W. E. F. Britten (London,
1894) · 19.7 × 15 × 2.2 cm.
Private collection

74 Robert Anning Bell
(1863–1933), Female Head,
brown chalk on white paper,
date unknown · 47 × 28 cm.
GSAA

75 Robert Anning Bell
(1863–1933), Stained Glass
Cartoon, pencil and
watercolour, c.1909
241 × 62.8 cm (with frame
246.8 × 68.6 cm).
GSAA

76 Poems by Percy Bysshe Shelley,
introduction by Walter
Raleigh, illustrations by
Robert Anning Bell (London,
1910) · 20.9 × 15 × 3 cm.
Private Collection

77 Walter Crane (1845–1915),
banner, worked by Mary
Frances Crane, pencil on
linen ground with silk, wool,
cotton and gold thread, 1893
166 × 87 cm.
GSAA

78 Walter Crane, poster for the
Exhibition of Arts and Crafts
of Great Britain and Ireland,
Paris, 1914 · 71 × 48.3 cm.
Private collection

The Glasgow School of Architecture

79 Eugène Bourdon
(1870–1916), design for Law
Courts (plan), pencil, ink
and wash on paper, 1894
64.6 × 64.6 cm.
GSAA

80 Eugène Bourdon, design for
Law Courts (section), pencil,
ink and watercolour on
paper · 45 × 100 cm.
GSAA

81 Eugène Bourdon, Hippo-
drome, as a Study of the Orders,
pencil, ink and watercolour
on paper · 62.5 × 93 cm.
GSAA

82 Eugène Bourdon, Étude of
Park and Loggias, pencil, ink
and watercolour on paper
36.5 × 55 cm.
GSAA

83 Richard McLeod Morrison
Gunn (1889–1933), design
for a Colonial Parliament,
pencil, ink and watercolour
on paper · 57.8 × 78 cm.
GSAA

84 Alexander Thomson Scott
(1887–1962), design for a
Colonial Parliament, pencil,
ink and watercolour on
paper, c.1910
55.2 × 77.5 cm.
GSAA

85 William Gourlay
(fl.1890–1913), design for a
theatre façade, pencil, wash
and watercolour on paper,
c.1913 · 52 × 72.7 cm.
GSAA

86 Alexander Thomson Scott,
design for Law Courts,
pencil, ink and watercolour
on paper, c.1910
53.5 × 75 cm.
GSAA

87 Copies of Glasgow School of
Architecture Calendar,
1906/07 and 1910/11
24.5 × 15.3 × 0.5 cm.
GSAA

88 Julien Guadet, Cours d'archi-
tecture (Paris, 1901–04) 4 vols,
vol. 1 · 26.6 × 20.5 × 4.8 cm.
GSAL

89 Charles Gourlay, The
Construction of a House
(London, 1910)
33 × 24.6 × 2.3 cm.
GSAL

Medals and Certificates

90 Allan Douglas Mainds
(1881–1945), GSA Diploma,
etching, c.1907
80.5 × 57.4 cm (image size
64.5 × 41.2 cm).
GSAA

91 Jules Clément Chaplain
(1839–1909), Paris
International Exhibition Medal,
bronze, 1900 · 6.4 cm
diameter.
GSAA

92 Unknown designer, Bram
Stoker Medal, silver, c.1903
4 cm diameter.
GSAA

93 Peter Wylie Davidson
(1870–1963), Glasgow School
of Art Medal, brass, c.1910
6.2 × 8.5 cm.
GSAA

94 Unknown designer, Evening
School Medal, silver, 1913–14
4.4 × 7.8 × 0.4 cm.
GSAA

95 Alexander Proudfoot
(1878–1957), Newbery Medal,
bronze, 1920
6.3 cm diameter.
GSAA

96 Jessie Marion King and Peter
Wylie Davidson, Glasgow
School of Art Lapel Badge,
silver, c.1902 · 2.8 × 3 cm.
GSAA

Social Life

97 Margaret De Courcy
Lewthwaite Dewar and Ann
Macbeth, montage of
costume designs for The
Masque of the City Arms,
photographs, pencil, ink and
watercolour, 1903
111.7 × 66 cm.
GSAA

98 Francis Henry Newbery,
The Masque of the City Arms
(Glasgow, 1905)
27.7 × 13.5 cm.
GSAA

99 David Broadfoot Carter
(fl.1879–1905), ticket for The
Masque of the City Arms, 1905
21.4 × 31.1 cm.
GSAA

100 Francis Henry Newbery,
The Birth and Growth of Art: a
Symbolistic Masque (Glasgow
1909) · 28 × 16.7 cm.
GSAA

101 Glasgow School of Art,
Official Opening Programme
(Glasgow, 1909)
26 × 24.5 cm.
GSAA

102 Glasgow School of Art, *Calendar*, 1909/10, open at pp.16–17
24.5 × 15.1 × 0.5 cm.
GSAA

103 Dorothy Carleton Smyth (1880–1933), *Art Club Conversazione: programme*, 1901 · 25.7 × 14.5 cm.
GSAA

104 William J. Wright (fl.1884–1904), *Art Club At Home: programme*, 1904
25 × 16.3 cm.
GSAA

105 Archibald Elliot Haswell Miller (1887–1979), *Art Club at Home: programme*, 1909
23.8 × 16.3 cm.
GSAA

106 Maurice Greiffenhagen (1862–1931), *Glasgow Art Students' Tryst for Belgium and the Red Cross: programme*, 1915
14 × 9 cm.
GSAA

107 Unknown designer, *Two Persian Plays: programme*, 1917
21.5 × 26.4 cm.
GSAA

Teacher Education

108 Annie French, *Primary School Teacher's Certificate in Drawing*, date unknown · 39 × 55.2 cm.
GSAA

109 Frances Macdonald McNair (1873–1921) and Peter Wylie Davidson, *High School of Glasgow: Dux in Art/Newbery Medal*, brass, date unknown
4.8 × 0.7 × 11.6 cm.
GSAA

110 Margaret Swanson and Ann Macbeth, *Educational Needlecraft* (London, 1911)
21.3 × 17.2 × 1.5 cm.
GSAL

111 Peter Wylie Davidson, *Educational Metalcraft: a practical treatise on repoussé, fine chasing, silversmithing, jewellery, and enamelling*, with a foreword by Fra H. Newbery (London, 1913)
21.5 × 17 × 1.5 cm.
GSAL

112 F. C. Nairn, *A Scheme of Elementary Object Drawing for Day Schools: being a Practical Guide to the recent Memorandum on Drawing issued by the Scotch Education Department* (Glasgow, c.1908)
28 × 19.2 × 5 cm.
GSAL

113 Henry Taylor Wyse, *Modern Methods of Art Instruction* (Edinburgh, 1909)
21.7 × 14.3 × 2.5 cm.
GSAL

Chronology

1753 Robert Foulis opens a private school of art and design in Glasgow, predating the Trustees' Academy in Edinburgh by seven years, and the Royal Academy in London by 15.

1835 Select Committee on Arts and Manufactures establishes blueprint for a UK system of schools of design.

1845 Glasgow Government School of Design is opened in Ingram Street on 6 January, under the control of the Board of Trade.

1852 The School is placed under the control of the Department of Science and Art, South Kensington, London.

1854 The School is renamed as Glasgow School of Art.

1861 Founding of Glasgow (later Royal Glasgow) Institute of the Fine Arts.

1869 The School moves to new premises in the Corporation Buildings (McLellan Galleries) on Sauchiehall Street, with entrance on Rose Street; receives major bequest from the Glasgow engraver James Haldane and is renamed the Glasgow School of Art and Haldane Academy.

1883 Mackintosh enrols as an evening student at GSA.

1885 Appointment of Francis Henry Newbery as Headmaster; he establishes a Vacation Sketching Scheme, which later becomes the Glasgow School of Art Club.

1886 Foundation of Glasgow and West of Scotland (later Royal) Technical College.

1887 Haldane Travelling Bursary established; James (later Sir James) Fleming elected Chair of the Board of Governors.

1888 Glasgow International Exhibition in Kelvingrove Park.

1890 Mackintosh wins Alexander Thomson Studentship, enabling him to visit Italy in 1891.

1893 Newbery opens a suite of 'technical studios' teaching Arts and Crafts subjects.

1894 Mackintosh enrols at GSA for the last time; GSA Club exhibits work in an Arts and Crafts idiom for the first time.

1896 Architectural competition to design a new School building is announced and the commission is awarded to Honeyman & Keppie, for whom Mackintosh works as an assistant.

1897 GSA awarded the highest number of medals in the UK under the South Kensington system.

1898 Foundation Stone of the new building on Renfrew Street laid on 25 May; Johan Keller appointed as Master of Modelling.

1899 Outbreak of the Boer War in October. Control of GSA passes from the Department of Science and Art to the SED; first half of new building is opened on 20 December.

1900 School wins gold medal at the Paris Exposition Universelle; Jean Delville is appointed as Professor of Painting.

1901 Queen Victoria dies on 22 January and is succeeded by Edward VII; Glasgow International Exhibition opens in Kelvingrove Park on 2 May, with major presence by GSA and sculpture exhibition organised by Fra Newbery. The School is designated as a Central Institution with power to award diplomas and certificates; 'Article 91D' (later 'Article 55') classes for Day School Teachers commence.

1902 Staff and students exhibit at the First International Exhibition of Modern Decorative Art, Turin; Paul Artôt is appointed as Master of the Antique. The Boer War ends in May.

1903 Glasgow School of Architecture founded in conjunction with the Glasgow and West of Scotland Technical College (now University of Strathclyde).

1904 Adolphe Giraldon is appointed as Professor of Design and Decorative Art and Eugène Bourdon as Professor of Architecture. GSA exhibits at St Louis, USA.

1905 Staff and students collaborate on a performance

of *The Masque of the City Arms* on 30 March and 1 April.

1906 Mackintosh redesigns west portion of School; Jean Delville returns to Brussels and is replaced by Maurice Greiffenhagen as Professor of Painting.

1907 The first Diplomas are awarded; construction of second half of Mackintosh Building begins.

1908 William Edward Frank Britten is appointed as Professor of Design and Decorative Art; the School purchases its first 'Type Writing Machine'.

1909 Completed Mackintosh Building is opened on 15 December; performance of *The Birth and Growth of Art, a Symbolistic Masque* on 15, 17 and 20 December.

1911 Scottish Exhibition of National History, Art and Industry, Kelvingrove Park. Robert Anning Bell is appointed as Professor of Design and Decorative Art.

1913 Frederick Cayley Robinson is appointed as Professor of Composition.

1914 Outbreak of the First World War (the 'Great War'); Newbery suffers physical and mental breakdown; Mackintosh leaves Glasgow for London.

1915 Sir James Fleming dies in May. The School contributes to the war effort by teaching military sketching, running free classes for limbless soldiers, providing graphic designs for printed War Bonds and staging theatrical events to raise funds for the Red Cross and other charities.

1916 Death of Professor Eugène Bourdon at the Battle of the Somme. The School acquires, for a mere for £3,000, the site along entire stretch of Renfrew Street opposite the Mackintosh Building to prevent the construction of buildings that might obstruct light from the Painting studios. Written examinations in the history of art are introduced for Diploma students.

1917 Newbery suffers another, more serious breakdown.

1918 Newbery retires in May; Armistice in November brings First World War to an end.

1921 The Newbery Medal is awarded for the first time.

1923 The School installs a 'cinematograph'.

1928 Mackintosh dies on 10 December in London, after spending the last five years of his life in the south of France.

1938 Empire Exhibition (Scotland), Bellahouston Park, Glasgow.

1939 Outbreak of the Second World War. Staff and students are put on nightly 'fire-watching' rotas, and two-thirds of the Mackintosh Building is occupied by the Red Cross as a hospital supply depot and store.

1940 Mackintosh Building narrowly escapes damage from air raids.

1945 Conclusion of the Second World War.

1946 Newbery dies on 18 December, aged 91, in Corfe Castle, Dorset.

1963 Opening of Foulis Building, designed by Keppie, Henderson & Partners, to provide studio space for Graphic Design, Printmaking, Bookbinding, Interior Design, Industrial Design and Mural Decoration.

1970 Opening of Newbery Tower, designed by Keppie, Henderson & Partners, to house the Textiles and Embroidery and Weaving Departments.

1978 Opening of Bourdon Building, designed by Keppie, Henderson & Partners, to accommodate the Mackintosh School of Architecture and the Planning Department.

1979 The Diploma in Art is replaced by the BA Hons Degree validated by the Council for National and Academic Awards.

1997 GSA graduate Douglas Gordon wins the Turner Prize.

2008 GSA is allocated £50m for development of new building on site of Newbery Tower and Foulis Building.

2009 Programme of centenary celebrations begins in the autumn, including the opening of the exhibition *The Flower and the Green Leaf: Glasgow School of Art in the Early Twentieth Century* on 26 November.

Contributors

ALISON BROWN is Curator of European Decorative Art from 1800, Glasgow Museums, Culture & Sport Glasgow. She has curated a number collection displays and temporary exhibitions for Glasgow Museums, including the Charles Rennie Mackintosh and Glasgow Style Gallery at Kelvingrove Art Gallery and Museum, as well as permanent displays at Scotland Street School Museum. Her published articles include 'Mighty Oaks from Little Acorns Grow. Deciphering the ornament at Scotland Street School', *Charles Rennie Mackintosh Society Journal* (Spring & Autumn 2006), and 'Reassessing Mackintosh's Design of the Willow Tearooms', which appeared in the same periodical in December 2008.

RAY MCKENZIE is Senior Lecturer in the Department of Historical and Critical Studies, Glasgow School of Art, where he has taught the history of art since 1976. His publications include *Sculpture in Glasgow: an illustrated handbook*, Foulis Archive Press, 1999, and *Public Sculpture of Glasgow*, Liverpool University Press, 2002, which was joint winner of the Saltire Society award for research book of the year, 2002. He is also a co-editor of *The State of the Real: Aesthetics in the Digital Age*, Tauris, 2007.

DR ROBERT PROCTOR is Lecturer in History of Architecture at the Mackintosh School of Architecture, Glasgow School of Art. He studied at Edinburgh and Cambridge Universities, writing his doctoral thesis on the architectural history of the department store in Paris from 1855 to 1914. His published writing includes work on the architect René Binet, and his edited edition of Binet's *Esquisses Décoratives*, entitled *René Binet: From Nature to Form*, was published by Prestel in 2007. More

recently he has worked on the mid-20th-century architectural firm of Gillespie, Kidd & Coia, on which he has published articles in *Architectural History* and the *Journal of the Society of Architectural Historians*, and he is now working on a project on modern British church architecture.

DR GEORGE RAWSON is the former Fine Art Librarian at Glasgow School of Art and is now an independent art historian based in Glasgow. He is a specialist in 19th-century art education, and wrote his doctoral thesis on the life and work of Francis Henry Newbery. He has recently been researching Mackintosh's formative years as a student at Glasgow School of Art, and the influence of his early sketching tours in Scotland, Italy and the West Country on his work as an architect and designer.

JOHNNY RODGER has written several works of fiction, including *The Auricle*, *g haun(s) Q*, and *redundant*, both published by Dualchas. He writes criticism for numerous magazines, journals and newspapers, and has authored several full-length critical works, including *Contemporary Glasgow*, which was published by Rutland Press in 1999. He has also edited the monograph *Gillespie, Kidd & Coia 1956–87*, RIAS, 2007, and the collection *Fickle Man: Burns in the 21st Century*, Sandstone Press, 2009. He is editor of *The Drouth*.

Index

Arts of Resistance: Poets, Portraits and Landscapes of Modern Scotland

Alan Riach and Alexander Moffat, with contributions by Linda MacDonald-Lewis

ISBN 1 906817 18 9 PBK £16.99

The role of art in the modern world is to challenge and provoke, to resist stagnation and to question complacency. All art, whether poetry, painting or prose, represents and interprets the world. Its purpose is to bring new perspectives to what life can be.

ALEXANDER MOFFAT and ALAN RIACH

… an inspiration, a revelation and education as to the extraordinary richness and organic cohesion of 20th-century Scottish culture, full of intellectual adventure… a landmark book.

TIMES LITERARY SUPPLEMENT

Scottish Photography: A History

Tom Normand

ISBN 1 906307 07 5 HBK £29.99

Scotland has made a rich contribution to the art of photography throughout the world. Beginning with the stellar images of Hill and Adamson, and progressing through the vivid landscape and documentary traditions, Scottish photographers have created a resonant and dramatic photographic culture. Today, the radical experimentation of contemporary Scottish photographers continues to push photography to new heights, and towards assuring its own status as an art form.

A stimulating, remarkably comprehensive account of a fascinating subject.

NORTHERN EXPOSURE

Monsieur Mackintosh: Charles Rennie Mackintosh in Roussillon

Robin Crichton

ISBN 1 905222 36 X PBK £15.00

In 1923, Charles Rennie Mackintosh and his wife Margaret Macdonald went on holiday to Roussillon, in the South of France, to rest and recuperate. Her health was poor and as an architect and designer he had become outmoded. They were enchanted. The holiday became a permanent stay and Mackintosh rapidly developed his talents as an artist. They spent the last and possibly the happiest years of their life together in this earthly paradise that is Roussillon.

… [A] beautifully illustrated book… Crichton's bilingual French–English text draws on Mackintosh's own letters and journals to offer some touching insights into the restorative capacities of both travel and art.

THE SCOTSMAN

The Quest for Charles Rennie Mackintosh

John Cairney

ISBN 1 905222 43 2 PBK £8.99
ISBN 1 842820 58 3 HBK £16.99

For the last 30 years John Cairney has been on a personal quest to find the complex man behind the façade that was Charles Rennie Mackintosh, architect and artist. Though recognised even in his own day as a genius, he was by no means a pre-Raphaelite plaster-cast saint of high morals and mystic vision. He was a flesh and blood charmer, who attracted women as much as he irritated men, enjoyed a drink to a sometimes excessive degree and was known for his explosive temper and black moods. He was all artist, but also all man, with the advantages and disadvantages of both.

… it makes for grand reading and for a stronger sense of the man than can be found in most of the more scholarly tomes.

SUNDAY HERALD

Luath Press Limited
committed to publishing well written books worth reading

LUATH PRESS takes its name from Robert Burns, whose little collie Luath (*Gael.,* swift or nimble) tripped up Jean Armour at a wedding and gave him the chance to speak to the woman who was to be his wife and the abiding love of his life. Burns called one of 'The Twa Dogs' Luath after Cuchullin's hunting dog in *Ossian's Fingal*. Luath Press was established in 1981 in the heart of Burns country, and is now based a few steps up the road from Burns' first lodgings on Edinburgh's Royal Mile. Luath offers you distinctive writing with a hint of unexpected pleasures.

Most bookshops in the UK, the US, Canada, Australia, New Zealand and parts of Europe either carry our books in stock or can order them for you. To order direct from us, please send a £sterling cheque, postal order, international money order or your credit card details (number, address of cardholder and expiry date) to us at the address below. Please add post and packing as follows: UK – £1.00 per delivery address; overseas surface mail – £2.50 per delivery address; overseas airmail – £3.50 for the first book to each delivery address, plus £1.00 for each additional book by airmail to the same address. If your order is a gift, we will happily enclose your card or message at no extra charge.

Luath Press Limited
543/2 Castlehill
The Royal Mile
Edinburgh EH1 2ND
Scotland
Telephone: 0131 225 4326 (24 hours)
Fax: 0131 225 4324
email: sales@luath.co.uk
Website: www.luath.co.uk